Adelaide Alsop Robineau

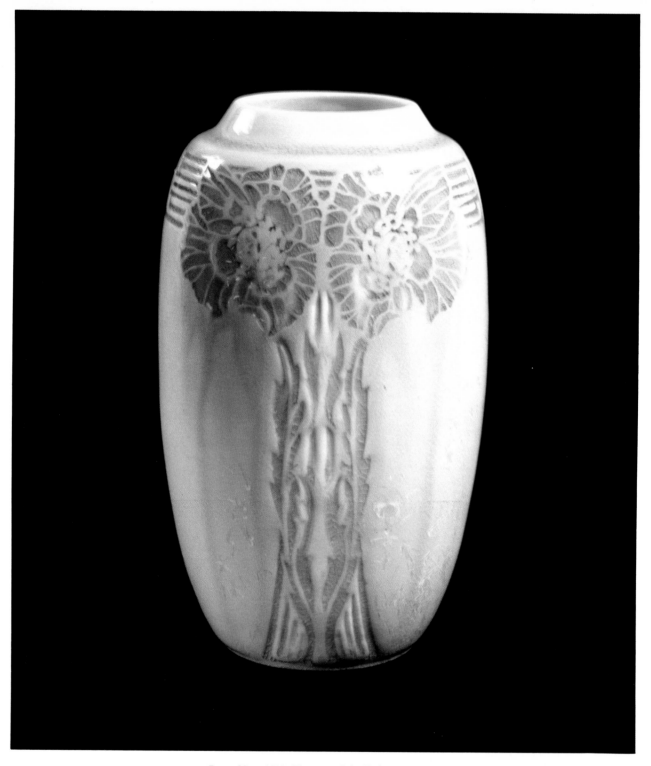

Poppy Vase, 1910. Photograph by Robert Lorenz.

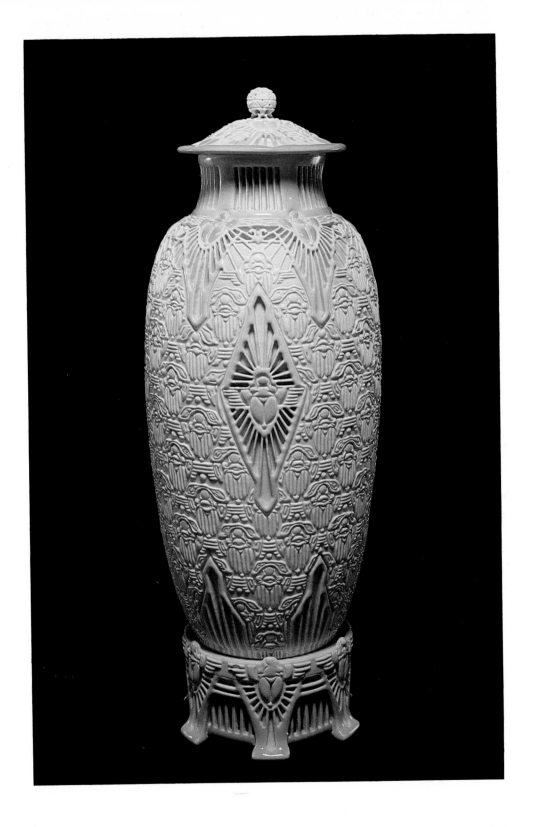

Publication of this work was made possible by a grant from the
National Endowment for the Arts. Matching funds were provided
by the Rosamund Gifford Charitable Corporation and the
children of Adelaide Alsop Robineau.

Library of Congress Cataloging in Publication Data
Main entry under title:

Adelaide Alsop Robineau: glory in porcelain.

Bibliography: p.
Includes index.
1. Robineau, Adelaide Alsop, 1865?–1929. 2. Potters
—New York (State)—Biography. I. Weiss, Peg.
II. Everson Museum of Art.
NK4210.R53A84 738'.092'4 81-9107
ISBN 0-8156-2249-X AACR2
ISBN 0-8156-0171-9 (pbk.)

Manufactured in the United States of America

To

the memory of

Anna Wetherill Olmsted

(1889– 1981)

MARTIN EIDELBERG is Professor of Art, Rutgers University, a contributor to *The Arts and Crafts Movement in America, 1876–1916,* and editor of *Decorative Arts Newsletter.*

PAUL EVANS is author of *Art Pottery of the United States: An Encyclopedia of Producers and Their Marks* and Western Division Editor of *Spinning Wheel.*

LESLIE GORMAN is former assistant curator/registrar, Everson Museum of Art, and assistant editor of *Everson Museum of Art Introduction to the Collections* and *Twenty-six Contemporary Japanese Potters.*

PHYLLIS IHRMAN studied at Wayne State University and the Center for Creative Studies, Detroit, and is a studio potter with much work in single-fire and crystalline glazing.

FREDERICK HURTEN RHEAD was a leading figure and critic of the artware and ceramics industries until his death in 1942.

PEG WEISS is Adjunct Professor of Fine Arts, Syracuse University, and Guest Curator, Guggenheim Museum, New York. Author of numerous art historical articles and reviews for *The Burlington Magazine, Arts Magazine, Art News, Pantheon,* and many exhibition catalogs, Dr. Weiss is also the author of *Kandinsky in Munich: The Formative Jugendstil Years.* The recipient of an NEH Fellowship for Independent Study and Research for 1981–82, Dr. Weiss also serves on the Landmark Preservation Board of the City of Syracuse.

RICHARD ZAKIN studied at State College of Ceramics, Alfred University, and teaches ceramics at the State University of New York College at Oswego. He is author of *Electric Kiln Ceramics: A Potter's Guide to Clays and Glazes.*

Contents

Color Plates

Foreword

ECAUSE ITS FIRST IMPORTANT ACQUISITION OF CERAMICS was the collection of Adelaide Alsop Robineau's porcelains in 1916, interest in ceramics as art rather than simply as a craft seemed appropriate to the Everson Museum from the beginning. The Museum's commitment to exhibiting and collecting ceramics since that time has been influenced by the fine qualities of its initial superlative purchase and by the lasting impression of Robineau's work.

The Museum was touched not only by Robineau's lovely porcelains but also by the attitude they represented. In almost no other age has such tireless individual craftsmanship and virtuosity—pioneering mastery and control of such a fragile medium as porcelain—seemed possible, except perhaps during the Middle Ages. If "technique is really personality" as Oscar Wilde suggested, Robineau must have been indomitable in spirit, infinitely patient, tireless, and refined.

If it has taken some time to publish a volume on Robineau, it has not been due to lack of esteem in Syracuse or in circles of ceramic artists and collectors. It has taken the general public time to think of ceramics as "fine art" and to acquaint itself with a ceramic artist whose body of extant work is as small as it is extraordinary. Since so much of it has remained in this appreciative museum, its fame has not spread as widely as it might have were it more dispersed. For some time the Everson has been intent on publishing this book and exhibiting a greater collection of Robineau in a more informative way.

This book, edited by Dr. Peg Weiss of Syracuse University, combines the solicited contributions of other notable scholars in the field of ceramics. Dr. Martin Eidelberg's contribution to arranging the exhibition that coincides with the publication of this volume is noted with additional appreciation.

The Everson's desire to place Robineau's work in perspective as well as to give greater detail regarding the fascinating achievement of her art has finally been fulfilled.

Syracuse, New York
Spring 1981

RONALD A. KUCHTA
Director
Everson Museum of Art

ix

Preface

ALTHOUGH ADELAIDE ALSOP ROBINEAU achieved international recognition as a superb artist and craftsman during her lifetime, that recognition was confined to a relatively small group of her professional peers and was celebrated only in exhibition catalogs and professional publications such as journals devoted to the decorative arts. This book is the first to present Robineau's life and work in a comprehensive way to the public at large. Appropriately, its appearance nearly coincides with the fiftieth anniversary of the landmark memorial exhibition of her porcelains at New York's Metropolitan Museum in 1930.

My wish to present a genuine re-evaluation of Adelaide Robineau's life and work within the context of her times resulted in the collaborative nature of the present volume. As curator of the Everson Museum from 1974 through 1979, I was in an especially advantageous position to study the archival material on Robineau collected over the years, which provided much of the biographical background presented in Chapter 1. For a scholarly evaluation of Adelaide Robineau's early development as an artist, I turned to Professor Martin Eidelberg of Rutgers University, whose art historical expertise in the field of the decorative arts is well known and whose enthusiastic response produced Chapter 2, "Robineau's Early Designs." Professor Eidelberg has traced many of the sources of her inspiration and discovered hitherto unknown factual material concerning her earliest experiments in porcelain. Paul Evans, author of *Art Pottery of the United States: An Encyclopedia of Producers and Their Marks,* whose interest in Robineau extends back over many years, offered to edit the Robineau material in Frederick Hurten Rhead's "Chats on Pottery," which originally appeared in an obscure publication hitherto extremely difficult to find; this became Chapter 3. But all of this historical effort left Robineau's real technical accomplishments in the dark. A section on her technique and working methods seemed requisite. Professor Richard Zakin of the State University of New York College at Oswego, a professional ceramist himself with many exhibitions to his credit, whose deep admiration of Robineau's work ultimately led to his rediscovery of the artist's glaze formulae in the archives of Ohio State University, agreed to provide this material for Chapter 4. He in turn invited a fellow ceramist, Phyllis Ihrman of Farmington Hills, Michigan, whose specialty is

crystalline glaze technique, to provide an explication of Robineau's unique crystalline glazes in Chapter 5.

Besides historical and technical information, I also wished to provide as complete a documentation as possible of Robineau works in public collections in the United States today. Thus the Inventory, compiled by Leslie Gorman of Syracuse, is intended to do this and, one hopes, to stimulate further information about Robineau sources yet unknown.

This book has been nearly half a century in the making, and during that time a great many people have contributed to its ultimate realization. While it would be impossible to acknowledge each and every one individually, I would like here to express my gratitude to all those who have, to paraphrase the slogan of *Keramic Studio,* "kept the fire alive" through their interest in the Robineau collection and in this project.

To the memory of Fernando A. Carter, who died in 1931, and to Anna Wetherill Olmsted, second and third directors of the Syracuse Museum of Fine Arts, we all owe our greatest debt of gratitude. Without their perspicacity, sensitivity, and vision this book might never have come to be. It was Carter, director of the museum from 1911 to 1931, who in 1916 agreed to purchase a representative group of some thirty-two Robineau porcelains from the artist herself, and who thus established the Syracuse museum as a center for the future exhibition and study of her work which has resulted in the present book. It was Anna W. Olmsted, his able successor and director from 1931 to 1957, who founded the Ceramic National Exhibitions in memory of Robineau, and who in fact initiated the original plan to publish a book on the artist. Thus by the early 1930s, the scene had been set for the re-evaluation and reappreciation of the work of Adelaide Alsop Robineau celebrated in this volume.

In 1934, Olmsted began collecting material for the Robineau book she hoped to publish, soliciting manuscripts from the artist's friends, students, colleagues, and admirers, including the noted critic Royal Cortissoz. Unfortunately the Depression years were not a propitious time for publishing a book about an artist whose work was little appreciated outside her profession — a book which would require expensive color plates. Although Olmsted pursued her project with characteristic energy and fervor, it could not be realized during her tenure. Nevertheless, the material she collected was carefully preserved and today has contributed substantially to our knowledge of Robineau's work and personality.

My next acknowledgment must be to the children of Adelaide and Samuel Robineau, who have kept their parents' memory alive by means of their continuing interest in the exhibition of the Robineau porcelains. In 1967, when the new Everson Museum building by I. M. Pei was under construction, the Robineau family contributed a major donation for a special gallery dedicated to the perma-

nent exhibition of the ceramic arts. This generous gift by Maurice Robineau, Priscilla Robineau Kelly, and Elisabeth Robineau Lineaweaver stimulated further interest in Robineau and helped to keep her work before the public eye. In 1979, Mr. and Mrs. Edward Beadel and the Robineau family provided a gift for the construction of special display cabinets for the Robineau porcelains; a representative selection from the Robineau collection is always exhibited in these cases or in the Robineau Gallery. And ever since the inception of this publication project, Elisabeth R. Lineaweaver, today the last surviving Robineau child, has maintained a lively interest in it. I am especially grateful to her for so graciously devoting many hours to answering questions and ferreting out family photographs and even contributing a personal memoir for the museum's archives. I am also grateful to Mrs. Dana Kelly, the daughter-in-law of Priscilla Robineau Kelly, for her enthusiastic encouragement as well as for sharing treasured family photo albums.

To all those who contributed their scholarship and expertise to this book I am extremely grateful. Professor Martin Eidelberg not only provided Chapter 2, but also generously shared insights and information as to the location of Robineau works. To Professor Richard Zakin and to Phyllis Ihrman I am enormously indebted for their willingness to share highly technical information about Robineau's working methods with a wide audience. I also wish to acknowledge with gratitude the work of Paul Evans for his careful and expert editing of Frederick Rhead's "Chats on Pottery," which appears as Chapter 3, and which has further enhanced our contextual understanding of Robineau's place in American ceramics. To Leslie Gorman, my able assistant, I am immensely grateful for her consistent attention to detail in every phase of this project, but especially for her expert creation of the first complete inventory of Robineau works in public collections in this country.

Professor Robert Judson Clark of Princeton University, organizer of the landmark exhibition "The Arts and Crafts Movement in America," has generously given his encouragement and moral support since the inception of this project, and I am deeply grateful. To Professor Coy Ludwig, Director of Tyler Art Gallery at the State University of New York College at Oswego, I am also indebted for his encouragement of my efforts.

A special debt of gratitude is owed to Cleota Reed for her early work in making the first professional inventory of Robineau porcelains in the collection of the Everson Museum; without her preliminary work, our present inventory would have been far more difficult. To Professor Emeritus Margaret Fetzer of Ohio State University I am particularly grateful not only for her immense help in the present inventory, but also for her zealous guardianship of the Robineau porcelains in her care over so many years.

Thanks are also due the many museum professionals who generously responded to our queries, providing information and photographs: Lynn Springer,

formerly of the St. Louis Art Museum, now at the Chicago Art Institute; J. Jefferson Miller of the Smithsonian's National Museum of History and Technology; Nancy Rivard of the Detroit Institute of Arts; John Gerard of the Cranbrook Academy of Art/Museum, and his predecessor Mary Riordan, whose enthusiasm was a source of special inspiration; Marie Elwood of the Nova Scotia Museum, Halifax; Frances G. Safford of the Metropolitan Museum of Art; and Thomas W. Brunk of the Pewabic Pottery, Michigan State University. Linda Ballard, of the University City Public Library, graciously supplied important information from that collection. Among the many others who have shared their knowledge of Mrs. Robineau with us I would especially like to thank her former associates and students Ruth Randall, Helen Williams, Montague Charman, Naomi Case, Lewis Light, Abigail Bigelow, Walter K. Long, Hilda Putziger Levy, and Miriam M. Pittman, all of whom either studied with Robineau or knew her professionally. To Richard V. Smith I wish to express special appreciation for his active interest in the Robineau collection of the Everson Museum over many years and for his many helpful suggestions. For her superb photography I wish to thank Jane Courtney Frisse of Syracuse, who is responsible for most of the photographs in this book, including those of the Robineau home and most of the copy work from *Keramic Studio* and other archival sources, as well as the photographs of Robineau porcelains in the Everson collection. I should also like to express my gratitude to the present owners of the Robineau house, Mr. and Mrs. David Allen, for their patience and generosity in allowing repeated visits for research and photography. I am also grateful for the expert and efficient help of typists Carole Burke and Jane Frost.

Despite all of our efforts, we realize that there remains much to be accomplished. Adelaide Robineau's career as editor of *Keramic Studio* has yet to be fully explored, and her later work and that of her students remains to be thoroughly evaluated. Thus it is hoped that this book will stimulate not only renewed interest in the work of Adelaide Robineau, but also further research, and ultimately the complete historical evaluation she so richly deserves.

A grant from the crafts program of the National Endowment for the Arts helped to make this book possible, and I am especially grateful to Eudorah Moore and John McLean of the NEA, and to Elena Canavier, Ms. Moore's predecessor, for their enthusiasm and encouragement over a period of several years. I am also grateful to Mrs. Henry D. Sharpe for her kind assistance and for a very generous publication grant from a donor who wishes to remain anonymous.

Syracuse, New York Peg Weiss
Spring 1981

Adelaide Alsop Robineau

1. Adelaide Alsop Robineau in her studio.

1

Adelaide Alsop Robineau

SYRACUSE'S UNIQUE GLORY

PEG WEISS

Syracuse has *at least* two unique boasts to make: There is the salt which gives its savor. And there are the Robineau Porcelains!...And when the Syracuse Art Museum is quoted in future as having a fine example of the work of this or that artist it will be added that Syracuse's unique glory is its collection of the porcelains of its towns-woman the only individual maker of art porcelain in this country one of the few—the *very* few in the world and the only *woman* to attain such prominence in ceramics. All of which sounds very conceited from me but which is true nevertheless.[1]

THUS ADELAIDE ALSOP ROBINEAU, who had lived and worked in Syracuse, New York, since the 1880s, compared the reputation of Syracuse's salty origins to that of her own incomparable porcelains in a letter addressed to Fernando Carter, director of the Syracuse Museum of Fine Arts, in the autumn of 1915. By that time, Adelaide Robineau's work had already been awarded first prizes in international competitions, and her reputation amongst her peers was firmly established. *Keramic Studio,* the magazine she had founded in Syracuse and which she still edited, enjoyed a national circulation. Yet, as her letter to Carter clearly implied, she perceived herself in the role of the prophet scorned in her own land, as she sought to persuade the board of the museum to purchase a modest selection of her porcelains. Her bold move to insure that her work be represented in the collections of the local museum was the result of a zesty temperament, public spirit, and justifiable pride in her own achievements. Within months, thirty-two exquisite Robineau porcelains entered the museum's collection; among them were the *Poppy Vase,* the *Crab Vase,* and the *Lantern* (Frontispiece, Plates 2, 3).

Just fifteen years later and a little more than a year after her death in 1929, another major group of forty-four Robineau porcelains, including the famous *Scarab Vase* (Color plate **3**), was purchased by the museum from Samuel Robineau,

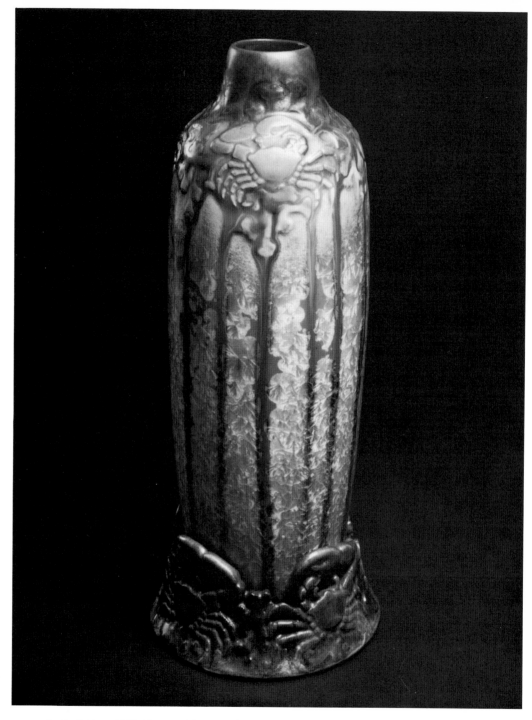

2. *Crab Vase*, 1908. Everson Museum of Art, 16.4.2 a-b (see Inventory 186). Photograph by Jane Courtney Frisse.

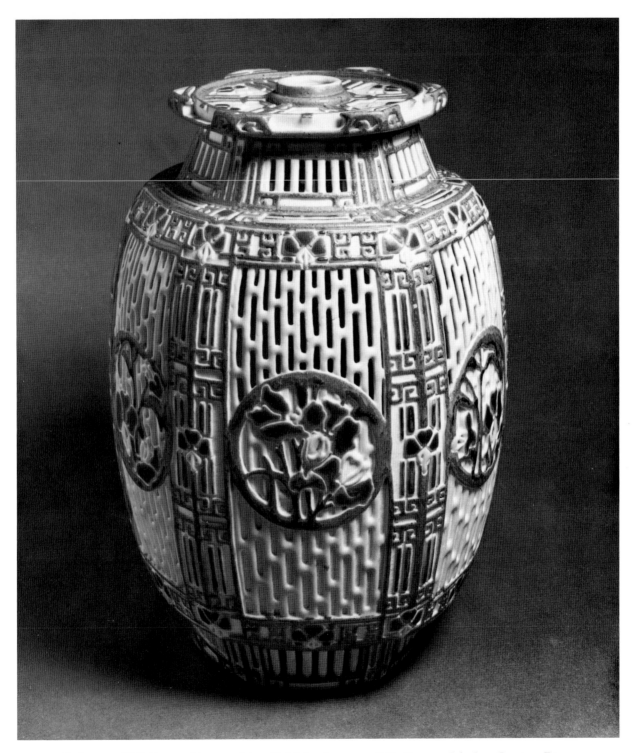

3. *Lantern*, 1908. Everson Museum of Art, 16.4.5 (see Inventory *189*). Photograph by Jane Courtney Frisse.

who donated the *Cinerary Urn* (Plate 108) at the same time. Today, the Robineau porcelains are considered all but priceless; Adelaide Alsop Robineau is celebrated as one of America's most important art potters; and indeed, as the artist herself predicted, the city of Syracuse does consider its collection of Robineau porcelains a "unique glory," although its salt resources have long since vanished.[2]

The city of Syracuse had in fact been founded as the direct result of rich salt deposits discovered in and around nearby Onondaga Lake, a resource that had been known and exploited by the Iroquois long before the appearance of white settlers in the seventeenth century. Salt had brought trade and industry, roads and the Erie Canal to Syracuse. Thus a Syracusan needing a simile for success might logically call upon the fame of the city's most prominent natural feature.

By the time Adelaide Robineau settled permanently in Syracuse at the turn of the century, the city was a thriving crossroads of upstate New York, boasting a population of more than 108,000, a distinguished university particularly noted for its art and music faculties, more than a dozen businesses and industries offering a wide variety of wares from electrical traffic control equipment to fine commercial china, and a museum presided over by a founding member of New York City's Metropolitan Museum of Art. This remarkable gentlemen was George Fisk Comfort, noted philologist and first Dean of the College of Fine Arts at Syracuse University, whose rousing speech to a group of concerned New York artists and businessmen at the Union League Club in 1869 had precipitated the founding of the Metropolitan Museum of Art. In 1896, he was instrumental in founding the Syracuse Museum of Fine Arts, serving as director until his death in 1910.[3]

Linked by railroad and the Erie Canal with Albany and the Hudson River to the east and with Rochester and Buffalo to the west, the metropolis of Syracuse also provided a stopping-off point for travellers and goods headed south to Philadelphia or north to Montreal. Although the salt extracted from nearby Onondaga Lake which had provided the town's first commerce (and inspired the name for its main thoroughfare, Salina Street) was by then nearly depleted, and the great Erie Canal, which still moved barges through the middle of downtown's Clinton Square, had already been upstaged by the railroad, Syracuse still enjoyed the reputation of a flourishing boom town, attracting investors and settlers accordingly.

When the Alsops first came to Syracuse in the 1880s, they found a city appealing both by virtue of its advantageous location and by virtue of its lively cultural climate. From an architectural point of view, Syracuse presented a good face to the world. Architect Horatio Nelson White had provided a dignified Second Empire look to the downtown area with his 1867 Onondaga County Bank Building on Water Street, flanking the canal, and an equally sedate façade for Syracuse University's first building, the Hall of Languages, erected in 1873 on a hill

overlooking the city. White's associate Archimedes Russell had further eclectisized the landscape with perhaps the grandest Neo-Romanesque building in the north-eastern United States, Crouse College for Women, actually the seat of Syracuse University's arts faculty, erected in 1887–89. Russell was eventually to provide the city with a plethora of architectural landmarks in styles from High Victorian Gothic to Queen Anne to Beaux Arts, with a dazzling virtuosity that still enhances the city's skyline.

Whether because of its general prosperity which promoted an unusual degree of architectural activity, or by mere happenstance, Syracuse had in fact become a vigorous hub of Arts and Crafts industry. Thus when Adelaide Alsop Robineau and her husband Samuel decided to establish their Arts and Crafts-oriented magazine, *Keramic Studio,* in Syracuse just before the turn of the century, they became acquainted with Gustav Stickley, who had settled in Syracuse in 1894, and who had already opened his United Crafts workshops in the suburb of Eastwood.[4] Within three years of the founding of *Keramic Studio,* Stickley began publication of his own magazine, *The Craftsman.* These two nationally circulated magazines soon established Syracuse as a nerve center for the Arts and Crafts Movement in America, crystallizing for readers across the country an aesthetic philosophy initiated by the Englishman William Morris in the middle of the nineteenth century and reaching its zenith in the international style of the century's turn known as Art Nouveau. The style had swept America as well in the graphic designs of Will Bradley and in the interior decorations of Louis Comfort Tiffany whose work was already internationally acclaimed.

Upstate New York had in fact become something of a focal point for the movement in America. Elbert Hubbard had made the pilgrimage to Morris' Kelmscott Press in England by 1894, and had returned to found the Roycroft community at East Aurora near Buffalo. And in 1898, Stickley followed suit, visiting three of England's great Arts and Crafts Movement architects—Charles F. A. Voysey, Charles R. Ashbee, and W. R. Lethaby, all disciples of William Morris. The first issue of his *Craftsman* magazine was dedicated to Morris and designed to emulate the quality books of the Kelmscott Press. In Rochester, New York, the brilliant architectural designer Harvey Ellis, another Morris enthusiast, had al-ready established a national reputation for the beauty and acuteness of his ideas and his renderings. Ellis eventually gravitated to Syracuse as well, joining Stickley's United Crafts workshop and publishing his exquisite architectural renderings in the pages of *The Craftsman* magazine from 1902 until his untimely death in 1904. Ellis' colleague and friend Claude Bragdon of Rochester was to carry the style into the twentieth century, coming into his own later as an exponent of design principles linking the romanticism of Morris to the new romanticism of technology in the style that was to become known as Art Deco.[5]

Within a few years of the Robineau-Stickley-Ellis conjunction, yet another exponent of Arts and Crafts architecture opened a practice in Syracuse. Ward Wellington Ward incorporated the Morris ideal of a totally designed environment into his work by commissioning stained glass produced by Syracusan Henry Keck (a former apprentice of Tiffany Studios) and the artfully designed ceramic tiles of Henry Ward Mercer.[6]

Thus Syracuse seems to have offered a fertile ground for an unusual constellation of architecture, fine design, and quality craft. It was an environment well suited to the needs and talents of Adelaide Robineau, who was to achieve international renown for the pottery she produced and for the magazine she founded and edited there.

Adelaide Beers Alsop was born in Middletown, Connecticut, on April 9, 1865. Her father, Charles Richard Alsop, was an engineer and sometime steamboat captain, who, it was said, was a very clever inventor but a poor businessman. Being of an impractical nature, he quickly dissipated the inheritance he had received from his father, as well as half the small capital which his wife, the former Elisabeth Gould Beers of Fairfield, Connecticut, possessed. This misfortune led eventually to a separation, Elisabeth Alsop electing to live apart from her husband with her three surviving daughters. Adelaide, the eldest of three (Plate 4), and of a responsible and independent character, determined to learn a trade by which she could support herself and help provide for the education of her sisters, Clarissa and Amie.

Artistically talented, Adelaide first turned to the decoration of porcelain, teaching herself the technique from books. She was soon proficient enough to become a teacher of porcelain painting, a career she later pursued for several years with a position at St. Mary's Hall school in Faribault, Minnesota, the school from which she herself had graduated in 1884. The family had moved to Moorhead, Minnesota, across the river from Fargo, North Dakota, during this period of Adelaide's life, still following, as Samuel later recalled, "the erratic fortunes" of her father, who was at that point employed as an engineer on a steamboat on the Red River.

But in 1885, Charles moved his family to Syracuse, New York, apparently to join his younger brother, Francis (Frank), who was associated with the Wolfe Stove Manufacturing Company there. By 1886, the brothers had established the Syracuse Stove Company, and Charles also listed himself as vice-president of the Syracuse Manufacturing and Power Co. By 1888, however, Charles had established his own Alsop Furnace & Stove Company together with his wife, Elisabeth, while Adelaide, now twenty-three, had rented her own quarters in West Onondaga Street, and listed herself in the city directory as Addie B. Alsop, artist. However, Charles again followed the lure of adventure, leaving Syracuse with his family the following year for a return to the Midwest. In 1896, after an ultimate separation

4. Adelaide Alsop, 1880. Fifteen years old.

from her husband, Elisabeth Alsop returned to Syracuse where she and her daughters, Addie, Amie (now a music instructor), and Clarissa, took up residence at 1510 Mulberry St. Uncle Frank Alsop was now a salesman for the Syracuse Stove Works. Since his widowed mother, Margaret E., had lived with him since 1885, one may speculate that Adelaide's own mother returned to the Syracuse area in order to be near her children's grandmother and uncle.

Adelaide then decided to further her artistic education and thereby perhaps enhance her income as a teacher of porcelain painting, by going to New York City. There she studied painting for a time with William Merritt Chase at his Shinnecock, Long Island, school. During this period, her watercolors were accepted twice for the annual exhibitions of the National Academy, and she also exhibited miniature paintings on ivory on several occasions. However, her circumstances were such that she was forced to relinquish all but her china decoration work, by which she could earn a modest but steady income (Plate 5).[7]

5. Adelaide Alsop Robineau, porcelain painting, 1899. Inscription on the back reads: "The painting on this tray was done by Adelaide Alsop Robineau in my presence, Alice M. Edgar."

At that time, porcelain painting had come to be considered a respectable profession for young ladies of artistic talent. Spurred by the example of the great Centennial Exhibition at Philadelphia in 1876 and the writings of John Ruskin and William Morris, not to mention Charles Locke Eastlake's immensely popular *Hints on Household Taste* (six American editions by 1881), the American Arts and Crafts Movement had caught on across the country, nurturing a new interest in the craft of porcelain design and decoration. In Cincinnati, Ohio, Mary Louise McLaughlin had already published a widely read book on china painting by 1877, and two years later she formed the Cincinnati Women's Pottery Club, which had an enormous influence in encouraging other women to enter the profession. At almost the same time, Maria Longworth Nichols (later Storer) also began to experiment in the field; the influential book, *Pottery: How it is Made, its Shape and Decoration,* was published by her husband with her illustrations in 1878. Her efforts resulted in the creation of the famous Rookwood pottery in 1880, a firm which grew within a

decade from a one-woman operation to a company employing as many as two dozen decorators at once and producing more than 10,000 pieces of art pottery a year. The same decade had seen the flowering of numerous Rookwood imitators and competitors—Weller, Roseville, J. B. Owens, and many others—while quite independently formed studios founded in other parts of the country also gained impetus.[8]

From the beginning, women had been instrumental in the sudden growth of the art pottery industry, as initiators, designers, and decorators, but also as consumers. The tastefully decorated home of the era required the grace of tastefully designed handicrafts, and art pottery provided an important element in that *Gesamtkunstwerk,* that total work of art; it could be at once *objet d'art,* utilitarian vessel, and, in the form of tile, relief, or sculpture, even architectural embellishment. Although at first confined largely to the decoration of ready-made pottery— throwing and firing having been considered too physically demanding—women gradually began to assert their own creativity at the wheel, and soon the introduction of smaller and more efficient kilns for home use was to encourage them to produce hand-built pottery of their own. Robineau had begun her career at an auspicious moment when both supply and demand were increasing rapidly and equally. Talented, industrious, disciplined, and blessed with a rare aesthetic genius, Adelaide Alsop was a woman in the right place at the right time.

During her years in Minnesota, she had met an enterprising gentleman named Samuel Edouard Robineau (Plate 6), a Parisian by birth, who shared her enthusiasm for fine porcelain. Indeed, Robineau was something of an entrepreneur, as well as a collector and connoisseur of Oriental ceramics.[9] According to his own somewhat ambiguous account, he had held farming interests in North Dakota but was "free to come East during the long dead winter season of the Northwest." By this time Adelaide's professional interest in the work of china decoration had taken on a new dimension. She was determined to launch a periodical that might serve to elevate the standards of design and craft amongst her colleagues. It was to be, Samuel recalled, a "purely technical magazine with designs and articles by the best artists in the country."

At the same time, he apparently recognized something even more valuable in Adelaide herself (Plate 7). On March 4, 1899, at the age of thirty-four, Adelaide Alsop married Samuel Robineau, and they celebrated by becoming business partners as well. Within days of their marriage, the firm of Keramic Studio Publishing Company was incorporated in New York City with Samuel Robineau as president, Adelaide Robineau as editor, and a Syracuse friend of the Alsops, George H. Clark, as manager. Anna B. Leonard, a well-known china decorator, served as a fourth member of the corporation and as co-editor until 1903. Samuel Robineau invested all the capital that was necessary, $1,000 "to make a beginning," and the first number of *Keramic Studio* (Plate 8) appeared in May 1899. While the

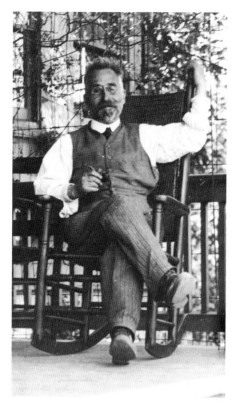

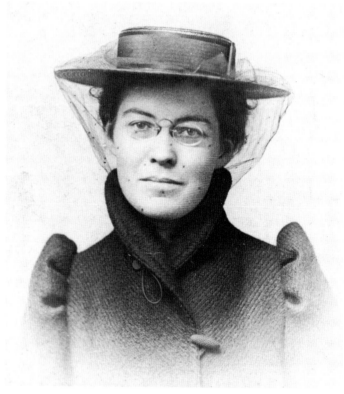

6. Samuel Edouard Robineau at Four Winds, ca. 1915.

7. Adelaide Alsop Robineau, ca. 1900.

Robineaus continued to reside in New York City for a time, the printing and engraving were managed in Syracuse by Clark, who had connections with the printing business there.

Judging from an old photograph in the family album (Plate 9), the Robineaus kept a suitably Bohemian apartment in New York. The Art Nouveau magazine covers and posters on the wall, the artistically draped fish net, and the hint of a Navajo rug on the floor provide some clues as to their somewhat avant-garde tastes. The apartment was at 114 East 23rd Street, and apparently theirs was considered an exemplary artist's residence since it was even mentioned in an article describing a tour of craftsmen's studios published in the pages of *The Modern Priscilla* in October of 1899.

Meanwhile, according to Samuel's memoir, *Keramic Studio* became an "instantaneous" success, and he recouped his investment within the first year.[10] In 1901, the Robineaus moved permanently to Syracuse.

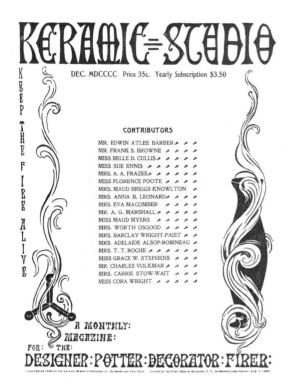

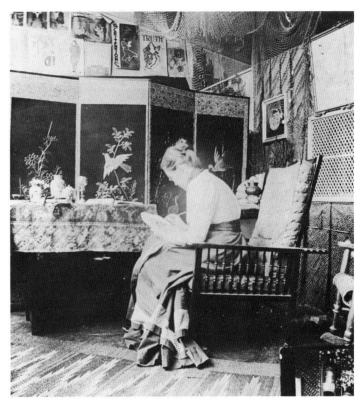

8. Cover, *Keramic Studio, A Monthly Magazine for the Designer, Potter, Decorator, Firer* (December 1900).

9. Adelaide Alsop Robineau engaged in porcelain painting in the Robineaus' apartment on East 23rd St., New York City, ca. 1900.

Keramic Studio in fact became the mainstay of the Robineau's economic existence, sustaining them even during the difficult years of World War I, when other arts-oriented enterprises faltered or even failed altogether.[11] But its success was not won without tremendous effort and commitment. Adelaide herself contributed editorial comment, articles, or designs to almost every issue year after year. She marshalled the forces of her fellow craftsmen, publishing over the years important articles by such major craft figures as Charles Volkmar, Charles Binns, Taxile Doat, Hugo Froelich, Frederick Hurten Rhead, Kathryn Cherry, Mary Chase Perry, Albert Heckman, Bonnie Cashin, and many others. The magazine provided regular reviews of crafts exhibitions, reports from clubs and societies, articles on all areas of craftwork, both "how to" and historical, answers to readers' technical questions, and criticisms of their work; it even sponsored design competitions on a regular basis. Perhaps its greatest appeal, however, lay in its lavish use of illustrations. Both the black and white cuts and the regular color plates were

generally of high quality (sometimes even sporting expensive gold or silver inks for special effects). Many of the designs illustrated were accompanied by detailed instructions for the benefit of the china painter, to whom the magazine most specifically addressed itself.

Over the years Adelaide Robineau exhorted and encouraged her readers, urging them gently but firmly on toward a more sophisticated appreciation of art in general, while at the same time catering to the tastes and needs of the amateur. As the battle between naturalistic design and what Robineau called "conventionalized" design raged and intensified, Robineau tried to steer a middle course, providing examples of both types of design, and publishing irate letters representing both sides of the quarrel on the editorial pages of her magazine. Though she carefully refrained from talking down to her readers, her own bias toward "conventionalized" design is clearly apparent in her frequent editorials on the subject, as for example in the following statement from the February 1912 issue: "The conventional in decoration is an effort to express symbolically a part of the abstract *truths* of the beauty of nature. One who aspires to the naturalistic can never approach the grand total of truths contained in nature, that is the work of the Creator alone."

Robineau's editorial stance was direct and personal. Notes concerning the travels or adventures of her colleagues were frequently published in the magazine. Indeed, the pages of *Keramic Studio* announced most of the major events of the Robineau's personal lives, including the birth of the first Robineau child, a son, Maurice, in 1900. This personal touch gave the magazine an appealing warmth and special character so that, while the subscriptions never rose much above 6,000, this figure came to represent an intensely loyal readership. In fact, as the magazine aged, retaining its quaintness and some of its old-fashioned qualities, its readership aged with it. After World War I, the discrepancy between the now rather dated stance of the magazine and trends in the design world became more obvious. The "modernistic," as Adelaide called it, crept only slowly into the pages of *Keramic Studio,* a bit uncomfortably "Deco" in the midst of the traditional orange blossoms and violets of the older-generation china painting designs.[12] Yet Adelaide's keen personal awareness of change in the world of design is confirmed by her head-on confrontation with the "isms" of the day in an editorial published in the March 1917 issue in answer to Frederick Hurten Rhead's criticism that *Keramic Studio* was not keeping up with the trends of the time: "We let the new movements filter through," she countered, "in the influence shown in the work of our leading decorators, so that when it finally reaches our public it is sufficiently diluted and pre-digested to be accepted without too great a shock to the uninitiated."[13] Further, Adelaide was an interested and critical visitor to the 1925 Paris Exhibition

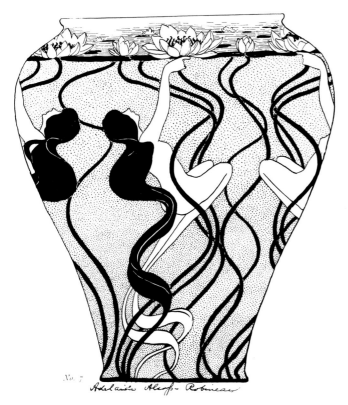

10. Adelaide Alsop Robineau, sketch of vase with decoration of nymphs and water lilies, *Keramic Studio* 2, no. 6 (October 1900):122.

11. Adelaide Alsop Robineau, sketch of vase with figure and orchid motif, *Keramic Studio* 2, no. 10 (February 1901):219.

of Decorative and Industrial Arts, publishing a ten-part series on the Expo in *Keramic Studio.*[14]

But by the middle 1920s, when she was teaching at Syracuse University and beginning to feel her sixty years, Adelaide began to speak of passing the magazine on to younger hands. In 1924, its name was changed to *Design,* and in January 1928, Robineau invited inquiries from qualified applicants for the editorial position.[15]

Although she faithfully continued to encourage and exhort her fellow porcelain painters, regularly publishing her own designs in *Keramic Studio* (Plates 10, 11, Color plate **1**), Adelaide herself had early begun to despair of the limitations imposed by the repetition of rote patterns on commercially produced forms. Already by 1900, she longed to create new forms herself. Samuel Robineau later recalled in a rather poignant memoir her first attempt as a potter:

12. Bowl, 1901. First piece of pottery made by Adelaide Alsop Robineau. Private collection.

Here is how the thing began. Mrs. R. did not like china painting and had always wanted to do better, but did not know how to start. In 1901 one day she went to visit her friend Chas. Volkmar in his little pottery in New Jersey, and there she took a little clay and made by hand a shapeless little cup, then decorated it with three carved beetles on the edge. Volkmar baked it and later in her own pottery Mrs. R. marked the date 1901, her initials A.R. and glazed the cup in blue and beetles in white. I have the piece yet, it is very interesting not only because of the date, the first piece of pottery she made, but because in that decoration of beetles she instinctively and unknowingly showed the kind of carved decoration in relief which she was going to use so much later on (Plate 12).[16]

Before long the excitement engendered by this experience found expression. A catalyst appeared in the guise of a series of articles on the making of *grand feu* or high-fire porcelain by the famous Sèvres master Taxile Doat. The Robineaus had apparently been in touch with Doat by 1902, and Samuel Robineau had undertaken to translate the series for the readers of *Keramic Studio*. The articles began appearing in May of 1903.[17] Adelaide had in fact already determined to create works in high-fire porcelain for herself. With typical élan she had quickly enrolled for a summer course with Charles Binns at his pottery school in Alfred, New York.[18] And, with an equally characteristic demonstration of support and interest, Samuel Robineau helped her to set up a kiln at home and to fire her first batch of porcelains.

Quite possibly the existence of a lively Syracuse Arts and Crafts Movement may have been instrumental in determining the course of Adelaide's career at this time. Gustav Stickley's enterprising spirit was already bringing attention to all aspects of the movement in Syracuse. In 1902, Stickley purchased the Crouse stables, a building designed in flamboyant Neo-Romanesque style by Archimedes Russell on commission by the local eccentric D. Edgar Crouse, who had fitted out the luxurious four-story stable not only with walnut stalls and marble drinking troughs, but with some eighty Oriental vases and two huge Sèvres vases "among the largest productions of this famous factory."[19] Stickley turned the stables into a showroom for his United Crafts furniture, along with workshops, the publishing offices for *The Craftsman,* and an auditorium which was also used as exhibition space. The building was opened to the public on December 1, 1902, with a lecture in French by M. Germain Martin, *conférencier* of the Alliance Francaise. It seems hardly likely that the francophile Robineaus would have missed such an occasion.[20] In any case, they would certainly have been aware of the many public events in the hall which Stickley made available for public lectures, book reviews, and other cultural activities. In March 1903, an Arts and Crafts exhibition opened there which must have been widely influential. According to the catalog of the exhibition, the works on view were selected "according to the law set by that prototype of craftsman, William Morris." Included were works by many prominent European designers as well as those of American craftsmen (and even of native American Indian craftsmen). Among the European items were objects purchased by Stickley at Bing's famous *L'art nouveau* shop in Paris. Among the American exhibits was a group of seven vases by Adelaide Robineau. A review of the show, illustrating the Robineau pieces, was published in the June 1903 issue of *Keramic Studio.*[21]

Adelaide's early experiments in pottery-making yielded some of her most successful crystalline glazes, but the Robineaus soon found that firing to *grand feu* (the degree of heat necessary to produce fine porcelain) in "an ordinary rented house" was "not only difficult but dangerous." Samuel recalled that at their last firing in rented quarters, smoke poured through the floorboards of the living room, and Adelaide had to pour water continuously on the floor. In Samuel's words, "It was time to make a change!"[22]

The Robineaus built first a studio (in 1903–1904) and then next to it the following year a house, on a hillside overlooking Syracuse (Plate 13). Adelaide designed the house — appropriately named "Four Winds" — together with an architect friend, Catharine Budd.[23] The house exemplified the English cottage style typical of the Arts and Crafts Movement and repeatedly illustrated in *The Craftsman,* which just at that time had begin to reproduce Harvey Ellis' sensitive renderings of the style (Plate 14). The interior of the house was distinguished by its

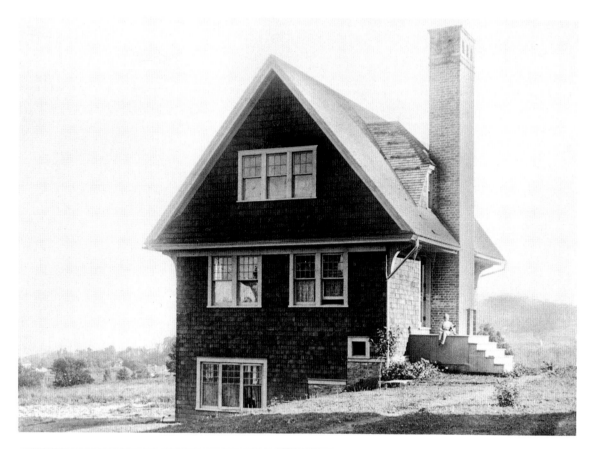

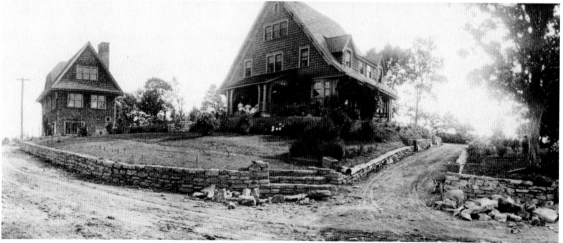

13. Robineau Pottery on Robineau Road, Syracuse New York, 1904–1918 (top).
14. Four Winds and Pottery on Robineau Road, Syracuse, New York, Spring 1911 (bottom).

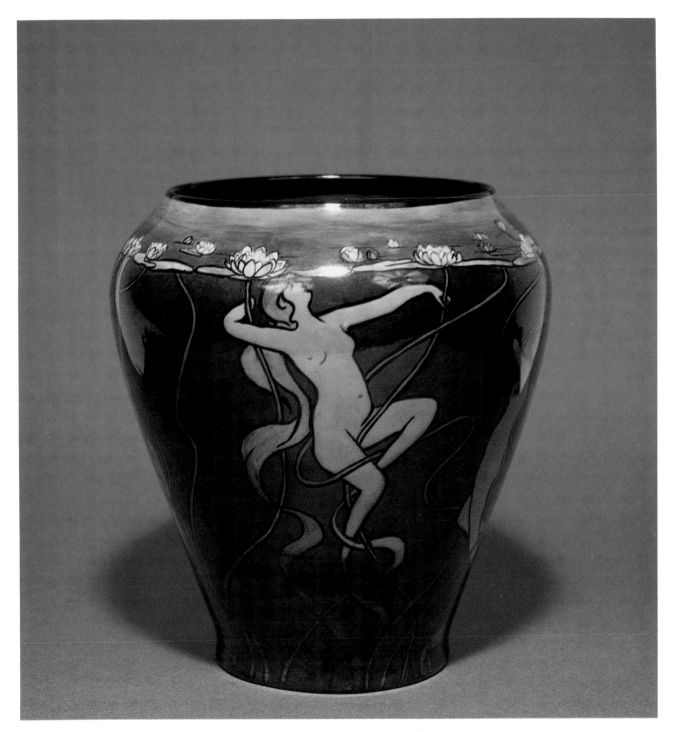

1. *Water Lily Vase,* ca. 1899. Private collection.

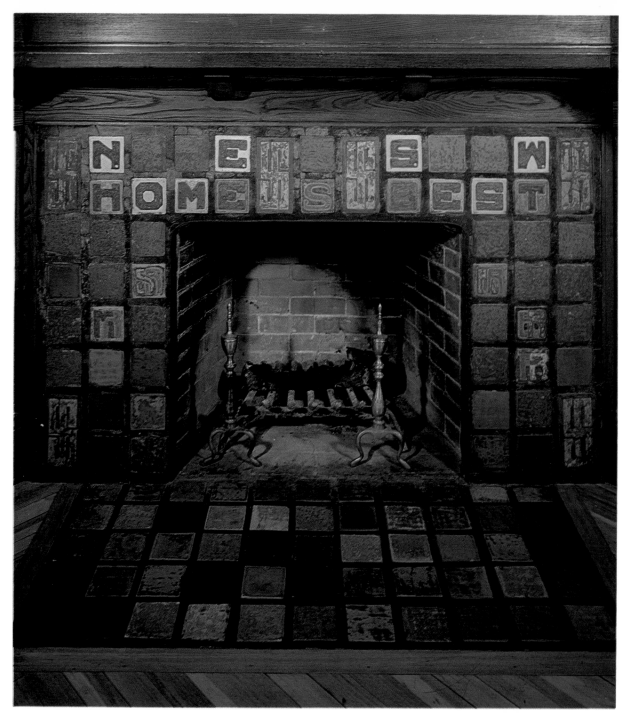

2. Dining room fireplace, Four Winds. Photograph by Jane Courtney Frisse.

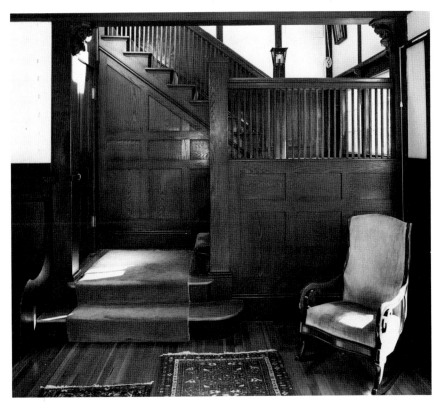

15. Main stairway, Four Winds. Photograph by Jane Courtney Frisse.

dark oak paneling (Plate 15), the geometric architectural detail reminiscent of Voysey and Mackintosh, ceramic fireplace tiles designed by Robineau herself (Color plate **2**) and the ubiquitous inglenook (Plates 16, 17). A raised platform at one end of the dining room provided the setting for a magnificient built-in desk and perhaps suggested the importance of its use as an office space, yet in fact, it formed an ideal stage for impromptu performances by the Robineau children, two of whom did later become professional performers (Plate 18).

Both Priscilla (1902–1978) and Elisabeth (born in 1906) were to pursue careers in modern dance. Priscilla, whose style was formed in the same era as that of Ruth St. Denis and Ted Shawn, eventually presided over her own thriving dance studio in Carnegie Hall until her career was cut short by a back injury. Elisabeth worked as a dancer in the professional entertainment world, appearing in theaters, night clubs, and casinos with her partner, Wes Adams, for fifteen years, travelling extensively in the Near East, Europe, and the United States. In recent years she has become a successful sculptor, exhibiting her works in New York and Martha's

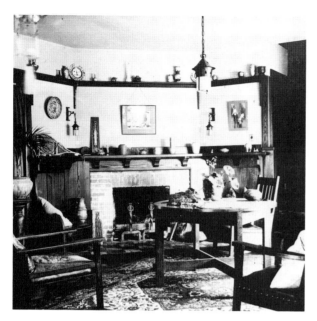

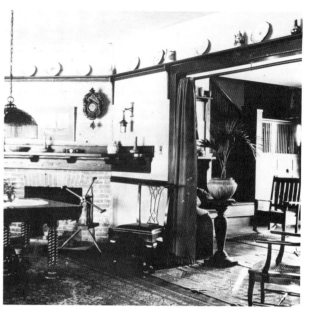

16. Southeast view of living room at Four Winds, ca. 1910, prior to installation of Robineau's fireplace tiles.

17. Southwest view of dining room (left) and living room at Four Winds, ca. 1910, prior to installation of Robineau's fireplace tiles.

Vineyard. Maurice transmuted his mother's tenacity and drive to the world of business (though he, too, had shown early signs of musical talent, playing the banjo, as Elisabeth has recalled), working his way up from ownership of a gas station to president of a major western oil refinery before his death in 1967.

The studio consisted of three stories, with the kiln area taking up the whole first floor and the pottery the second. The third floor was eventually used as a playroom for the three Robineau children—while mother worked—an innovation considered drastically "modern" when the Robineau homestead was reviewed in *American Homes and Gardens* in 1910.[24] Both buildings still stand on Robineau Road in Syracuse (Plates 19, 20).

Her plans for the large studio building had been grandiose. She even hired two fellow students from Alfred to help install and operate the ambitious equipment, which included three kilns (Plate 21). Hoping to recoup her initial investment through commercial sales, Robineau envisaged a large production of functional mold wares, such as doorknobs and drawer pulls, decorated with her special glazes (Plate 22). This idea, however, proved unfeasible due to both the lack of a

18. Raised end of dining room, Four Winds. Photograph by Jane Courtney Frisse.

market and to the expense involved. Furthermore, the reproduction of mold pieces proved to be totally incompatible with Adelaide's personality, and the effort was soon abandoned entirely. The assistants were dismissed within the year, and Adelaide returned to her throwing wheel and glaze experiments.[25]

Samuel Robineau continued to serve as his wife's able advisor and technician in the firing process. It was Adelaide herself, however, who, with remarkable skill, tenacity, and insight, experimented with different clay bodies, eventually developing the unusual range of glazes both fixed and flowing, crystalline and matte, for which she is known.[26] She finally discovered a special variety of Texas kaolin that lent itself to her special requirements of translucency and strength.[27] But then it was necessary to experiment endlessly in order to adjust the formulae suggested by Doat to this specifically American material.

Charles Binns later recalled that at the time Robineau started working, her sources of information "were few" and mainly from France where, after generations of development, "porcelain pastes and glazes could be obtained ready for use." In America no such easy solutions were available. "The raw materials had to be assembled and tested and the body paste composed and prepared. ... To this complex task Mrs. Robineau brought no special technical equipment: her re-

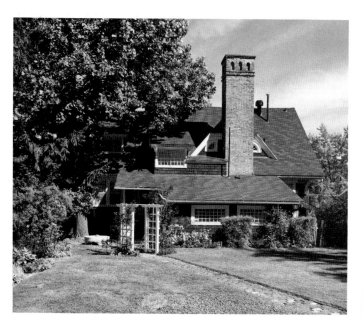

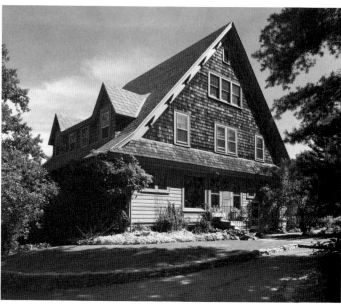

19. Robineau Pottery building, Four Winds. Photograph by Jane Courtney Frisse.

20. Main entrance, Four Winds. Photograph by Jane Courtney Frisse.

sources were a high ideal, an extremely delicate touch, indomitable perseverance, and unlimited patience." And Binns went on to point out that no matter what degree of skill and care is employed, "there remains in the progress of the fire an element of chance which cannot be eluded."[28]

Despite repeated failures and frustrations, Adelaide Robineau persevered in her attempts to create the most difficult types of porcelain, ranging in her brilliant experiments from the oxblood *flammé* of Chinese tradition to utterly new crystalline glazes in blue, white, and maize, from crackles to inlaid slip designs. The most difficult challenge she undertook was the creation of an eggshell coupe with excised design, thought by most of her contemporaries impossible to achieve. Only the Chinese had excelled in this technical *tour-de-force,* a shallow porcelain bowl with a literally eggshell-thin body. Because of the brittleness of the paper-thin porcelain clay, which can only be worked in the dry state, carving upon it requires extraordinary patience and delicacy. Of the dozen or so eggshell pieces she attempted, only three survived. Two of these are still in existence, one at the Metropolitan Museum in New York (Inventory *264*) and one now at Cranbrook (Plate 23). The third, which, according to Samuel's account was decorated with a

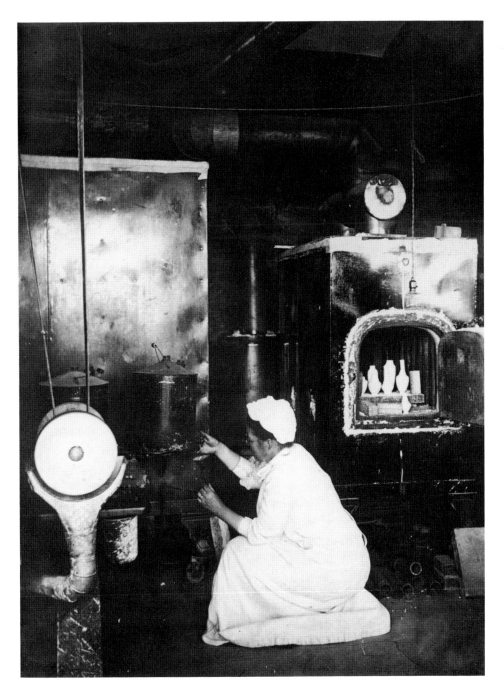

21. Adelaide Alsop Robineau at the kilns, 1911.

22. Doorknob with excised monogram *AR* (see Plates 114, 115, Inventory *337*), n.d. Ohio State University, CA-64. Photograph by Roger Phillips.

23. Eggshell coupe, n.d. Cranbrook Academy of Art/Museum, 1944.154 (see Inventory *155*). Photograph by Tom Wedell.

"beautiful excised design of swans," was broken in Detroit on its way to an exhibition (Plate 24). That, wrote Samuel, "was too much even for Mrs. Robineau's stout heart," and she never tried another.[29]

In a memoir written in 1935, Carlton Atherton, who studied with Robineau at Syracuse University and who later became her assistant and disciple, paid tribute to that "stout heart":

> There was in her make-up a strange combination of forces—an intense sensibility and an all-absorbing intellectuality. She had a passion for reducing sensation, by a process of analysis, elimination, and synthesis, to abstract statement, yet preserving the sensation upon which her sensibility was nourished. By analysis and classification, she proceeded to work out separately and in turn, the effective qualities of line, form, and color. The process of organization then became the logical deduction from the already classified data of sensation, a deduction stated by perfectly ascertained and preconceived methods. This was

24. Eggshell shards, n.d. Ohio State University, CA-71 (see Inventory *344*). Photograph by Roger Phillips.

more than a deliberate process and not a momentary recording of that divine inspiration with which artists are often credited; and yet inspiration is the only word which can be used before such beautiful conceptions. There were many things which were paradoxical in her personality, the combination of such elements as caution and recklessness, logic and intuition, patience and intolerance, prudence and indiscretion. These apparent discrepancies brought to fruition much that might never have materialized. Her inexhaustible patience and superhuman courage made possible many things which are lost to less pioneering potters. For her, nothing was too simple that its experience was not helpful, nothing too complex to try or to master. She was unmoved by catastrophe and never satisfied with apparent success. Nothing stimulated her as much as conquering some seeming insurmountable obstacle. No project, once started, was ever abandoned through failure of achievement, but by careful observation and deduction was brought to final completion through unyielding perseverance.[30]

The speed of Adelaide's progress in mastering her craft had been nothing short of spectacular. After her brief session at Alfred, she began to exhibit and

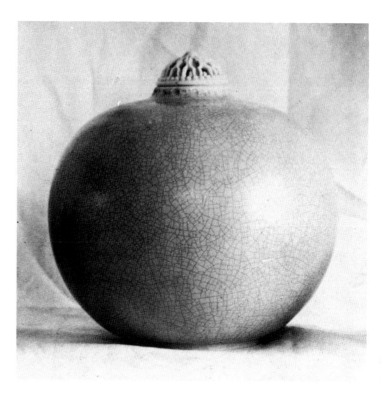

25. Porcelain vase with carved lid, n.d. According to Robineau's personal records, this piece was sold at Macbeth's Gallery, New York.

market her pottery widely, and in 1904 introduced herself to an international audience at the St. Louis Exposition. By 1905, Tiffany & Company of New York had become an agent for the Robineau porcelains, which were also later sold in New York through Macbeth's Gallery (Plate 25).[31]

By 1910, Adelaide's reputation was such that the Robineaus were invited by Edward G. Lewis, founder of the American Women's League, to join the University City Pottery at St. Louis, Missouri (Plate 26). She was to collaborate there with the master Taxile Doat, who had been imported from France to head the School of Ceramic Art, and with the English-born ceramist, Frederick Hurten Rhead. The Robineaus were also to edit yet another magazine, *Palette and Bench* (which they had founded in 1908) under Lewis' sponsorship (Plate 27).[32] It was there in 1910 that Adelaide created the magnificent *Scarab Vase* (Plates 28, 112, Color plate 3), a feat requiring some thousand hours of infinitely patient labor and two firings. Also called *The Apotheosis of the Toiler,* the vase is decorated with an excised design of scarabs, an ancient symbolic reference to rebirth and creative

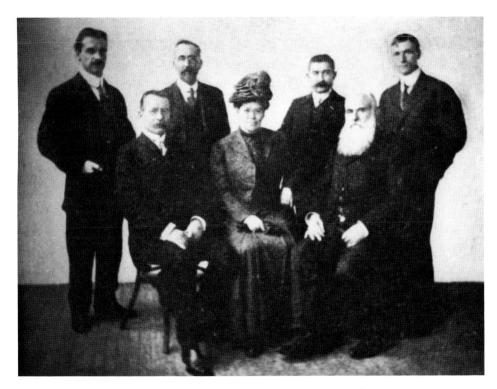

26. Formal portrait of the faculty of the school of ceramics of the Academy of Fine Arts, University City, left to right: Frederick Hurten Rhead, Émile Diffloth, Samuel Robineau, Adelaide Robineau, Eugene Labarrière, Taxile Doat, and Edward Lewis.

powers, but also symbolic of the patience and skill demanded of the craftsman. It is of translucent porcelain with the relief design glazed in a semiopaque white glaze, the background unglazed. Accents in pale blue green were achieved with a thin fixed semiopaque copper glaze.[33]

According to Samuel's memoir, the first firing of the *Scarab Vase* resulted in some bad cracks at the base of the otherwise incredibly beautiful vase. Taxile Doat expressed the opinion that it would be impossible to repair and that the cracks should be merely filled with paste and enameled to match the glaze. Adelaide, wrote Samuel, "laughed at that suggestion and said she would either repair the vase at high fire or throw it in the ash can." He recorded that she then spent hours filling the cracks with ground porcelain which she then glazed with the same glaze she had used for the body of the vase. From the second firing, the vase emerged miraculously perfect to the degree that the original cracks could no longer be detected at all (Plate 28).

25

28. *Scarab Vase* after second firing at University City, ca. 1910. From *Hard Porcelains and Gres Flammés Made at University City, Mo.*, undated catalog, University City, Mo. (after 1915), Collection of University City Public Library, St. Louis, Mo.

27. Cover, *Palette and Bench, For the Art Student and Crafts-Worker* (November 1908).

When the University City experiment failed the following year, the Robineaus returned gratefully to their hilltop home in Syracuse. Fortunately, and only due to the financial reverses suffered by the League, the *Scarab* was eventually returned to the Robineaus and was later purchased by the Syracuse museum.[34]

Although the *Scarab Vase,* a grand prize winner at the 1910 Turin International Exposition, offers a phenomenal demonstration of virtuoso technique, it was in other "lesser" works that Robineau achieved the true expression of her personal style, characterized, as the New York critic Royal Cortissoz was to note, by an unerring sense of taste and beauty. The so-called *Poppy Vase* of 1910 (Frontispiece, Inventory *187*) is a prime example of that sensibility. Only six and one-quarter inches high, it is decorated with an exquisite poppy and leaf design which was first excised and then inlaid with colored slips. In the firing the glazes remained perfectly set within the inlay, coloring and hardening to produce the effect of a transparent enamel over the whole. Together, form and design display that satisfy-

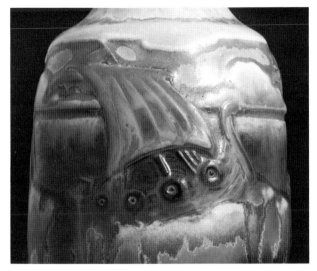
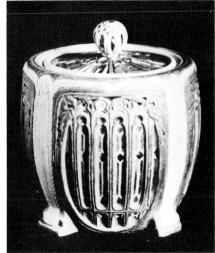

29. *Viking Ship Vase*, detail.　　　　　30. *The Chapel*, n.d. Private collection.

ing unity characteristic of the truly successful work of art. Small as it is, the vase has a monumental quality typical of Robineau's best work.

Another *chef d'œuvre* is the *Viking Ship Vase* of circa 1905 (Plate 29, Color plate **4**), a paradigm of Art Nouveau design. The modest form is decorated with a typical Art Nouveau Viking ship motif, wave-tossed around its rim, in rich matte and semimatte glazes of blue, green, brown, and cream. Again, the motif chosen, a symbol of human transcendence over the vicissitudes of life, was a particularly appropriate one for Robineau. And, in a remarkable *tour-de-force,* the Viking ship motif is transformed from relief to sculpture in the delicately pierced independent stand which supports the vase.

Indeed, vase after vase was to display some new and exquisite invention, from the delicate tracery and translucent "windows" of *The Chapel* (Plate 30), to the incredibly subtle striations of the 1919 *Snake Bowl* (Color plate **5**), with its delicate reptilian head replete with fangs. Stylistically her work ranged from a restrained and elegant adaptation of Arts and Crafts Movement taste (as in the 1905 *Monogram Vase,* Color plate **6**), to the Orientalizing manner of the eggshell coupes, to Art Deco urns and beyond; a stoneware *Threshold Plaque* in the Everson collection might have been done today, so modern is it in feeling (Plate 31).

Adelaide Robineau was also modern in terms of her attitude toward women. As Robineau's letter to Syracuse museum director Fernando Carter makes abundantly clear, she was fully conscious of her role as a *woman* in achieving status in a male-dominated society. Indeed, there are other indications that she upheld a

31. *Threshold Plaque,* 1923. Everson Museum of Art, 30.4.48 (see Inventory *220*). Photograph by Jane Courtney Frisse.

feminist viewpoint at a time when that was hardly fashionable. She insisted that her daughters be given educational opportunities equal to those of young men, and she encouraged them in every way toward developing independent careers. On a larger scale, she used *Keramic Studio* as a vehicle to encourage women everywhere toward a sense of self-worth. And in her associations with other professional women, she was invariably supportive, publishing their work in her magazine and often employing women to share with her the editorial responsibilities. When she opened a summer school at Four Winds, she thoughtfully provided children's classes and activities so that professional mothers could bring their children along and not have the burden of guilt otherwise associated with leaving them in the care of others.[35]

 Indeed, her whole association with University City and the American Women's League can be seen as an expression of her commitment to the cause of women's rights. She could not have known that the expressed idealistic intentions of the League were to be subverted by its eccentric founder.[36]

 She was fortunate in having an extremely supportive husband who, recognizing her genius—and perhaps this was his—was able to ally his own interests with hers entirely. But even so, she must sometimes have felt overwhelmed by her double allegiance to art and to family, as when in a 1913 editorial she exclaimed:

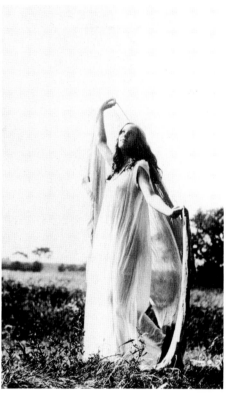

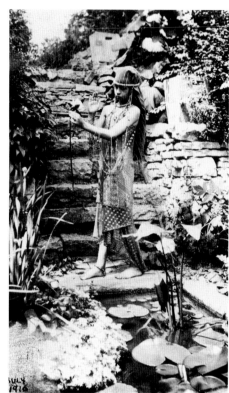

32. Elisabeth Robineau in the garden at Four Winds, July 1916.

33. "White Wings." Priscilla Robineau, 1914.

34. Elisabeth Robineau in Egyptian costume, Four Winds, July 1916.

"And now what are we going to do about the domestic problem? . . . It is because of the children and the home that we cannot and will not give up, that the woman can never hope to become as great in any line as man. Art is a jealous mistress and allows no consideration whatever to interfere with her supremacy."[37]

At that time, Adelaide's three children were ages thirteen, eleven, and seven, and she herself was forty-eight years old. She made most of her children's clothing (often batiked or tie-dyed and decorated with elaborate hand stitching and crochet), as well as elaborate costumes and wigs for her daughters' dancing performances. She did all of the family mending and tended an extensive and splendid garden. Elisabeth recalls that her mother "never wasted a moment of her life." Besides her other chores, she found time to compile five large (and eventually very valuable) stamp albums for her son, Maurice, and to trace the family geneal-

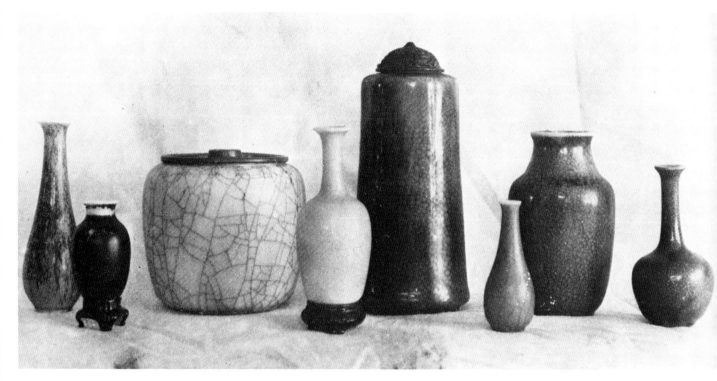

35. Robineau's "group of flammé vases including pinks of copper, craquele glazes and one example of oxblood," from *Robineau Porcelains 1915*, catalog for the Panama Pacific Exposition, San Francisco, 1915.

ogy (devising an eccentric system which traced the female as well as the male lines). She also kept the family photograph albums, photography being one of her favorite pursuits. Elisabeth has recalled hilarious but often tense family photo sessions in which the girls, dressed in Egyptian, Oriental, or other exotic costumes, were directed by their determined mother to strike dramatic poses in the garden, sometimes even in the middle of the lily pond (Plates 32, 33, 34).

In the spring of 1913, when Adelaide gave vent to the frustrations of "the domestic problem" in the pages of *Keramic Studio,* she was editing the monthly magazine with a national circulation of approximately 6,000 (for which she often wrote editorials and special articles), running a summer school for up to seventy students, already preparing her own porcelains for the 1915 Panama Pacific Exposition (Plate 35) and dreaming of "an Arts and Crafts village on top of 'Robineau Hill'"![38]

For three summers (1912–14), the Robineaus ran a full-scale six-week arts and crafts summer school at Four Winds. Courses offered included ceramics (both

36. Conventional designs from Four Winds Summer School, supplement to *Keramic Studio* (February 1914).

china painting and pottery production), design, landscape sketching, jewelry, metal and leatherwork, basketry, frame making, carving and gilding (Plate 36). Up to seventy students enrolled in the school, and noted teachers were hired as faculty (Kathryn Cherry for china painting, Henry Rankin Poore for landscape sketching) (Plates 37, 38).[39] Adelaide's hopes for continuing and expanding the school into an Art and Crafts colony were dashed by the onset of World War I.

After the war, the Four Winds studio had to be abandoned due to the new economic situation. Adelaide moved her studio into the main house and had a kiln shed built in the back yard. The former studio building was converted into apartments and eventually sold. She continued to work at home until, after her appointment to the faculty of Syracuse University in 1921, she moved her kiln to the university studio.

Though monetary rewards were not to have been expected from the production of the specialized and technically demanding work to which Robineau devoted her life, she was richly rewarded by professional recognition. While

37. Four Winds Summer School, 1913. Adelaide Robineau, top row, far left.

associated with University City, she had been awarded the Grand Prize in Ceramics at the Turin International Exposition of 1911 (fifteen of her works represented University City at the Exposition) (Plate 39), and was selected to exhibit at the Musée des Arts Décoratifs and at the Paris Salon in the same year. In 1915, a collection of her work was awarded the Grand Prize at the San Francisco Exposition. She also received special prizes and awards from the Art Institute of Chicago and from the Societies of Arts and Crafts in Detroit and Boston. In 1917, Syracuse University conferred upon her an honorary Doctor of Ceramic Science degree, and in 1920 she was asked to join the faculty. (Her students produced a low-fire ware known as "Threshold Pottery.") At her death the Metropolitan Museum mounted an unusual memorial exhibition of her work.[40] And in 1932, Anna Wetherill Olmsted, then director of the Syracuse Museum of Fine Arts, inaugurated in her memory a series of Ceramic National Exhibitions.[41]

Yet, according to Samuel Robineau's own accounting, only "about 600 pieces" were ever sold during Adelaide's lifetime — for a total income of about $10,000.[42]

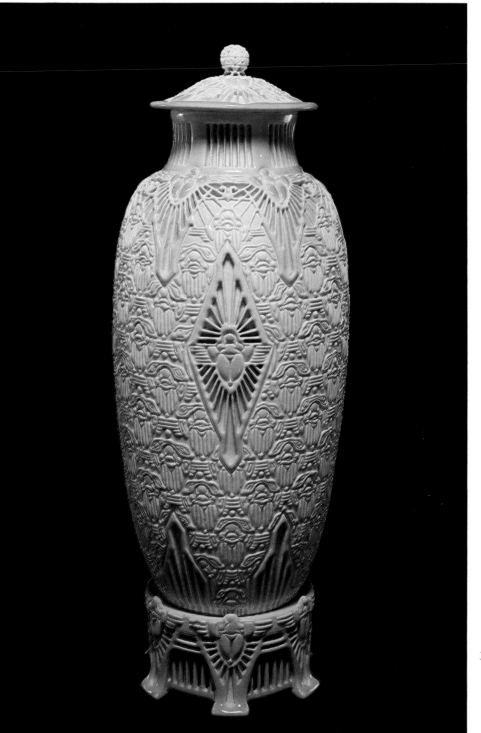

3. *Scarab Vase,* 1910. Everson
Museum of Art, 30.4.78 a-c
(see Inventory *248*).
Photograph by Jane
Courtney Frisse.

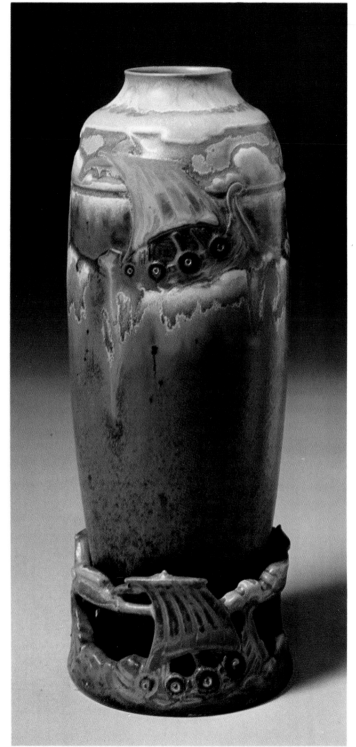

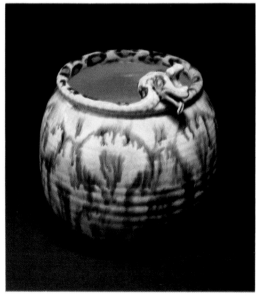

5. *Snake Bowl,* 1919. Everson Museum of Art, 30.4.81 (see Inventory *251*). Photograph by Jane Courtney Frisse.

4. *Viking Ship Vase,* 1905. Everson Museum of Art, 16.4.1 a-b (see Inventory *185*). Photograph by Robert Lorenz.

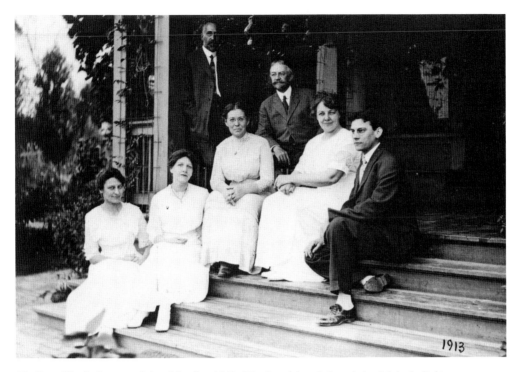

38. Four Winds Summer School faculty, 1913. Third and fourth from left, Adelaide Robineau,
Kathryn Cherry. Top row, standing, Samuel Robineau.

Money was always a worrisome concern to Adelaide, although her hus-
band, who actually managed their financial affairs with notable success, took a
more casual attitude. Elisabeth recalled that "Papa's" worth was listed in Dunn and
Bradstreet at what seemed to the children "a very high sum indeed." Yet Samuel
would chuckle over their amazement: "Silly bizness," he would say: "Wish I knew
how to get my hands on some of that." But "Addie" would despair about "going
over the hill to the poorhouse." While such expressions worried her older sister,
Elisabeth found it hard to take this attitude seriously: "I didn't know of any
'poorhouse over the hill,'" she recalled, "and besides, we always seemed to go to
France instead."

Adelaide was well aware of the true value of her work, and it must have
been a source of immense frustration to realize that she was not to be materially
rewarded in her lifetime. In her 1915 letter to Syracuse museum director Fernando
Carter, Robineau had already revealed an astonishing faith in herself and in the
value of her work, while at the same time expressing the eternal plaint of the artist

39. Porcelains by Adelaide Alsop Robineau exhibited by the American Woman's League at the 1911 International Exposition of Turin, Italy, *Keramic Studio* (August 1911), p. 83.

in the face of a society bent more on the monetary than the aesthetic rewards of civilization:

> In the days of the ancient Chinese potters, Emperors paid fabulous prices for examples of their work, and the nobility vied with each other to posess [*sic*] each piece which came perfect from the potter's hands. All through the ages Kings and wealth have been patrons and eager purchasers of art crafts, not only of former times but of contemporary artists. It remained for grand America, who has been too busy just growing, to neglect contemporary and native arts and crafts so that no country is so lacking in native craftsmen and crafts work.... Those who have acquired money... have failed to see that contemporary talent has to be encouraged by purchase of the best in native work (Plate 40).[43]

Robineau then went on to express pleasure in Carter's interest in adding her work to the museum's collection, and in order to encourage him and his board, she suggested the following:

FOUR WINDS COTTAGE
ROBINEAU ROAD
SYRACUSE, N. Y.

Nov 12 —
1915

My dear Mr. Carter,

[handwritten letter, largely illegible]

40. Letter from Adelaide Alsop Robineau to Fernando Carter, November 12, 1915. Photograph by Mainstreet Photography.

As a simple matter of "boosting" Syracuse such a collection might be a drawing card. When a city wishes to be called to sit up higher in the seats of honor, like a good businessman she [*sic*] should put her best foot forward, if she has anything above the average, she writes it in large letters, if she has anything unique, she blazons it abroad—Syracuse has *at least* two unique boasts to make— there is the salt which gives its savor. And there are the Robineau Porcelains!

Robineau proposed a logical purchase plan involving her own donation of some works as an incentive to the board, concluding with the remark that in future the Robineau porcelains would come to be known as Syracuse's "unique glory." Clearly Adelaide Alsop Robineau was not one to be easily dissuaded. Among her colleagues and peers she was admired for that very tenacity and forthright honesty, but also for a fundamental professional humility poignantly revealed in an article she contributed to *The Art World* in 1917. "This fascinating work," she wrote,

35

"unfortunately is not a paying proposition, but it has given me the satisfaction of doing original work, work which has not been done in this country before and may not be done again." Freely admitting her debt to Taxile Doat, she went on to enumerate and describe in detail the processes she had elaborated for herself, ending with the description of the most recent challenge not then as yet resolved, the invention of very thin fixed light color glazes for use on her intricately carved porcelains. "It is," she concluded, "a problem which I leave to my successors, if I have any, together with many other problems, for this field is unlimited in its possibilities. I often dream of all the things I would have done if I had begun earlier in life or if I had been financially independent so that I could have devoted myself entirely to my porcelains. The pieces I have produced are few in number, but they represent in design and shape the best that was in me and I hope that some of them may be an inspiration to some artist of the future, who perhaps will be able to do more and better work than I have done."[44]

During her tenure at Syracuse University, Robineau continued to produce brilliant and often radically experimental works: the *Threshold Plaque* of 1923 (Plate 31) bears the name of the stoneware pottery produced by her students; *The Sea* continued her tradition of fine carving (Plate 41); while a stoneware vase with a startling bronze black matte glaze and a restrained symmetrical incised pattern (Plate 42) declared her versatility and awareness of contemporary design. Although the example of her superb pottery undoubtedly exerted an enormous influence on her students, her technical prowess, aesthetic sensibility, infinite patience, and her strong personality etched equally indelible memories (Plates 43, 44, 45). Her last student assistant, Carlton Atherton, to whom she bequeathed her precious glaze formulae ("the only artist she considered capable of continuing her work," according to Samuel Robineau) has left a moving tribute in the conclusion to his 1935 memoir:

> Clay and glazes were the raw materials which kindled in her imagination the vision of form and color so related and integrated that their subtlety of relationship could capture and hold fast the sensations aroused in her dreams. These were the elements which lured her on to the inevitable struggle of capturing and imprisoning the essence of her emotion, that she might evoke it in others. Nothing held more interest for her than a challenge. She was challenged all her life by the medium and she did battle with it, though never by violence or force, but by the subtler method of learning its secrets and turning them to her advantage.
>
> In all her work there is persistent power. It has impact and a keen incisive vigor of expression. The early imaginative delineation developed into a glorious sense of ornament, forceful and vigorous, which rarely betrayed her. The elements were so incorporated that the resultant design is at all times an ordered embodi-

41. *The Sea*, 1927. Everson Museum of Art, 30.4.82 (see Inventory *252*). Photograph by Jane Courtney Frisse.

42. Vase, 1928. Everson Museum of Art, 30.4.62 (see Inventory *233*). Photograph by Jane Courtney Frisse.

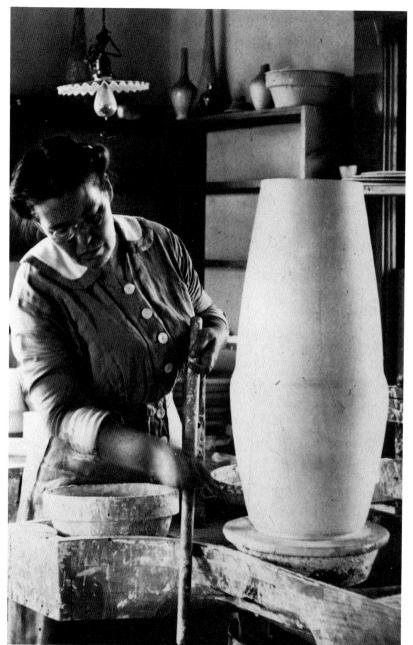

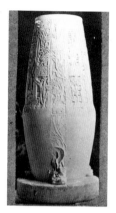

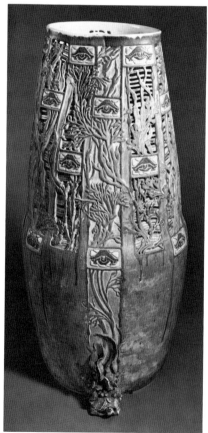

43, 44, 45. Robineau at work on the *Turtle Vase*, ca. 1913, a monumental carved piece nearly two feet high. The work collapsed on one side during firing and was never publicly exhibited, though it stood for many years in the ceramic studio at Syracuse University. It is now in the collection of the Everson Museum of Art, 74.24 (see Inventory 260). Plate 45 by Jane Courtney Frisse.

46. Adelaide Alsop Robineau in the garden at Four Winds, ca. 1927.

ment of essentials, with a transpiring and insistent beauty. There is always maintained a rapturous feeling of sustained immediacy.

Mrs. Robineau learned a complicated craft despite almost overpowering obstacles. There were sorrows and frustrations, but never a dearth of courage. The struggle was laborious, but it was carried on with a quiet though determined assurance. She accepted the challenge and won.[45]

Adelaide Alsop Robineu died of cancer on February 18, 1929. During the preceding October, seven of her porcelains had been included in an international exhibition of contemporary ceramics at the Metropolitan Museum of Art in New York. Writing in the New York *Herald-Tribune* at the time, the critic Royal Cortissoz had singled her out as the "leader" of the American contingent: "Here are taste and technique magnificently fused." She had continued to teach at Syracuse University up until the last two months of her illness, and indeed was

busily preparing an exhibition for London. At her death, the Metropolitan Museum took the unprecedented step of according her a memorial retrospective exhibition (from November 18, 1929, to January 19, 1930). Seventy-one Robineau pieces, included the *Scarab* (Color plate **3**), the *Pastoral* (Plate 47), and the monumental *Urn of Dreams* (Color plate **7**), were assembled in tribute, as Metropolitan curator Joseph Breck wrote, "to the memory of one who may with every reason be called a master craftsman."[46]

While a definitive biography of Adelaide Alsop Robineau remains to be written, her porcelains in their "unique glory" assure her immortality. Her memory is celebrated wherever her work is exhibited. More than half a century after her death, she is admired from coast to coast, indeed around the world, by artists who consider her work a monument to the craftsman's ideal: that peculiar blend of technique and aesthetic sensibility which transforms mere craft into fine art.

47. *Pastoral,* 1910, made for Priscilla Robineau. National Museum of History and Technology, Smithsonian Institution, 1979.0104.01 a,b (see Inventory 358).

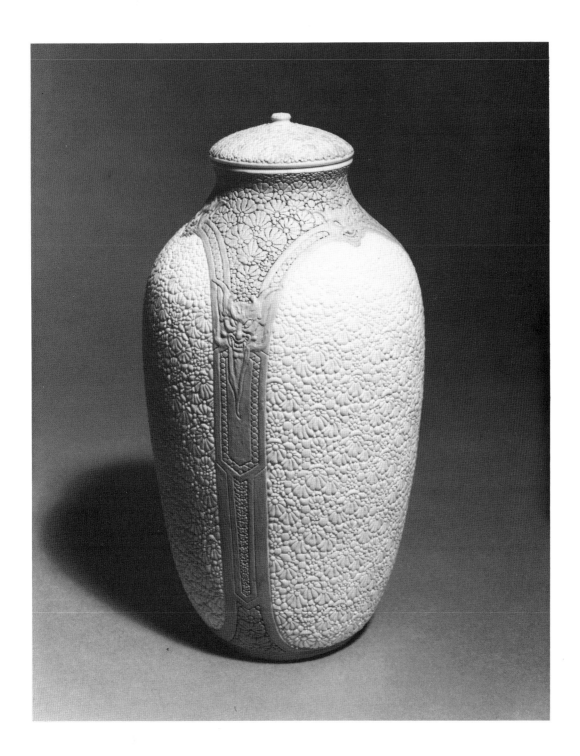

Although she had not learned this skill in school, she soon mastered it by reading various manuals. The only one which is specifically mentioned is Susan Frackleton's *Tried by Fire*, first published in 1886, but one can easily imagine that the young Adelaide Alsop also turned to other American texts, most notably Louise McLaughlin's *China Painting* (1877) and *Suggestions to China Painters* (1883). There were, as well, a large number of mostly French and English texts which would have offered her thorough instruction in this voguish craft.[3]

According to Sargent, "At the beginning, as is often the case, necessity was the spur to action. The feminine art which Miss Alsop began to practice as an accomplishment, quickly provided for her a means of livelihood with which to meet severe reverses of fortune."[4] In these all too brief words are encapsulated many of the basic ideological tenets and economic realities of the Arts and Crafts Movement. The problems of the female artist were many. Whereas it was difficult and even unseemly for a young woman to be a professional painter, it was socially acceptable for her to enter the decorative arts.[5] Not only did the applied arts open an avenue of commerce deemed appropriate to women, but also repercussions of the British Arts and Crafts Movement could already be felt in this country.

China decoration fulfilled a number of important criteria. It could be executed in a small studio or at home, and it was delicate work which did not require heavy, physical labor. Other aspects of pottery such as the grinding of clays and glazes, the throwing or casting of bodies, and the firing of kilns were duties which, according to that era's way of thinking, had to be executed by strong boys or men. Instruction in china painting soon became a woman's domain, and frequently these women also sold the pigments and other necessary supplies. Moreover, the final product—be it a decorated vase or tea or dinner service—was much in demand by other women. Thus production and selling could be contained within a genteel, feminine world. Not least of all, both the artist and her client could have the satisfaction of fulfilling William Morris' injunction of having objects which were at once beautiful (or at least decorative) and ostensibly useful. Thus in the 1880s and 90s china decoration was a major pastime for American women and a serious business for those who chose it as their profession. The National League of Mineral Painters, organized in 1891–92 by Susan Frackleton, had chapters active in all major cities of this country.

Although Samuel Robineau glosses over this early period, saying that his wife "soon became a prominent decorator," Sargent's account explains more clearly that "the proceeds of her sales of decorated china affording her only a precarious income, she turned to teaching as offering a more stable means of support."[6] This established a pattern which she was obliged to maintain throughout her life: her work as a china decorator and then later as a ceramist was always supported by her income as a teacher and as a publisher of an educational magazine.

It is easy to presume that many of Robineau's earliest decorated porcelains were adorned with naturalistically rendered flowers. The one early example I have seen—a piece signed "Adelaide Alsop" and thus antedating her 1899 marriage—had an all-over decoration of purple chrysanthemums.[7] Save for its signature, it was not distinguishable from china decorated by other professionals in this country. The inspiration of nature, one of the major tenets of nineteenth-century design theory, remained a constant factor in her work over the next decade. One can imagine that certain doctrines she later reiterated in the pages of *Keramic Studio* were part of her practice early on. For example, she stressed the importance of sketching directly from nature and studying the separate parts of the plant—the leaf, the blossom, the bud—to understand better the plant's anatomy. This was a standard practice in Reform theory which can be traced to Christopher Dresser's portion of Owen Jones's *The Grammar of Ornament* (1856), a book which she frequently used at this time, and it could be found in other English manuals, as well as in Continental ones. However, not much can be said of her early floral designs since by the time she began editing *Keramic Studio,* she had already begun turning from naturalistic renderings to ones more stylized or, to use the parlance of that day, "conventionalized." Even the vases decorated with lilies and iris which she submitted to the 1900 World's Fair (Plate 49, right) show the effects of this later tendency to "conventionalize" the composition and to emphasize contour lines (Color plate **1**).

Like most contemporary designers, Robineau was also strongly swayed by the nineteenth-century veneration of past styles that we term "Historicism." Predictably, the design lessons she published in *Keramic Studio* commenced in 1899 with a series on historic ornament. It began with Egyptian designs, then Assyrian in the next issue, then Greek, Chinese, and so forth, until the series was completed in the second volume with examples of Louis XV, Louis XVI, and Empire decoration. This series follows a specific tradition of Historicism whose origin can be traced to, most notably, Owen Jones 's *The Grammar of Ornament.* There were yet other such pictorial treatises which provided designers with the standard repertoire of historical styles, including Racinet's *Polychromatic Ornament* (1873) and Dolmetsch's *Ornamental Treasures.* Robineau recommended all three of these specific publications to her subscribers and she also derived her examples of historic ornament from them.[8] For example, in her lesson on Egyptian art (Plates 50–54) her diagrams of the lotus and papyrus plants, and of a hand holding the same species, are taken from Plate Four of Owen Jones's book, while the head of the sacred bull Apis is excerpted from a textile design found on Jones's tenth plate. Likewise, her image of winged cobras flanking a sun disk is taken from Plate 2 in Racinet's *Polychromatic Ornament* (Plate 55). Much of her text and instructions on color are taken from these manuals as well.

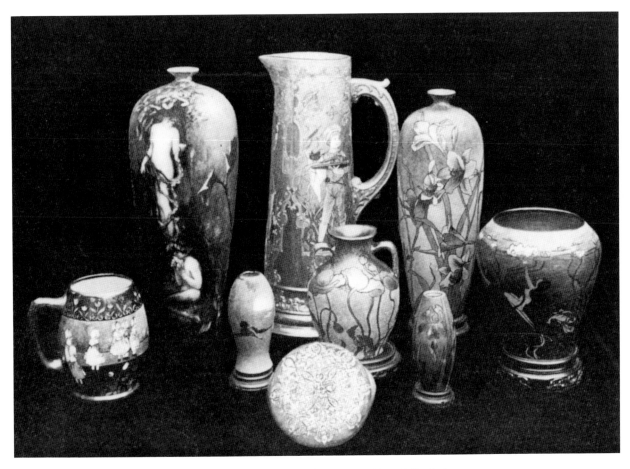

49. Adelaide Alsop Robineau, painted porcelains in the Paris Exposition, *Keramic Studio* 1, no. 11 (March 1900):230.

In addition to giving straightforward illustrations of historic styles, Robineau always provided an example or two of their "application to modern design." Thus her Egyptian lesson concluded with a design in the Egyptian mode for a stein—a popular shape for china decorating (Plate 56). The stein incorporates many of the elements given in the lesson, and adds still others. The upper frieze of alternating flowers and buds is undoubtedly based on one of the many similar patterns in Jones's book, but the lower frieze of alternating sacred bull heads and lotus flowers is Robineau's own variation. Although there is a certain authenticity to each separate motif, their combination and the form of the vessel are clearly Western and, according to the belief of that day, "modern." While not present in

50, 51, 52, 53, 54.
Adelaide Alsop Robineau,
illustration of historic
Egyptian ornament,
Keramic Studio 1,
no. 1 (May 1899):14.

55. A. Racinet, Egyptian designs, *Polychromatic Ornament* (1873), Plate 2.

56. Adelaide Alsop Robineau, design for a stein with Egyptian motifs, *Keramic Studio* 1, no. 1 (May 1899):15.

this particular case, there is often an attempt to make the historic style coincide with the form or function of the vessel. A Persian design is suggested for a coffee pot, a Chinese design is applied to a tea caddy, a Greek design is proposed for a classical urn, and so on. Here too we find a typical nineteenth-century sense of decorum.

Robineau's concern with historic styles was not merely theoretical or reserved for the benefit of uneducated, provincial subscribers. As can be seen in some of the illustrations from the first volume of *Keramic Studio*, she herself succumbed to this practice. A vase and pitcher were decorated with rococo scrolls, a hock glass was perhaps more Renaissance in style, and a small vase sent to the 1900 World's Fair (Plate 49, left of center) was in the Japanese mode.[9] Soon hereafter she turned away from such historicizing designs, but we must be wary of dismissing this portion of her career as merely a preliminary or temporary phase. As we shall see, the effects of this historicism were long lasting and dominated some of her later, more celebrated works.

57. G. Sturm, decorative panels, *Dekorative Vorbilder* 4 (1893), Plate 3.

58. Adelaide Alsop Robineau, design of serving boys from G. Sturm, *Keramic Studio* 2, no. 9 (January 1900).

One of Robineau's particular specialities, both as a china decorator and as a miniaturist, was figural decoration. Just as she used historic ornament, so too she "adapted" figural designs from existing compositions by other, generally European, artists. Three of the pieces she sent to the Paris World's Fair demonstrate this quite clearly. A tall pitcher (Plate 49, middle) has designs of serving boys in Northern Renaissance costumes which she copied from ones by G. Sturm that appeared in the German periodical, *Dekorative Vorbilder,* in 1893 (Plates 57, 58).[10] Similarly, she borrowed images of quaint children and a border of stylized tulips from Boutet de Monvel's *Chansons de France* (Plate 59) for use on a mug (Plate 49, far left).[11] It should be noted that in both these instances there is a sense of decorum in having the decoration fit the intended purpose of the object: there are motifs of food on a pitcher meant to be used at the table, and motifs of children on a mug intended for a child's use. The third object in this group, a tall vase (Plate 49, second from left)

59. L. M. Boutet de Monvel, illustration to "Nous étions dix filles à marier," *Chansons de France* (ca. 1884) (left).

60. J. W. Waterhouse, *Hamadryad,* 1893, from *The Studio* 4 (January 1894):104 (right).

shows a mysterious, druidic nymph listening to a satyr playing panpipes; this composition was taken unchanged from a painting by the popular British artist John W. Waterhouse, which was illustrated in *The Studio* in 1894 (Plate 60).[12] Modern admirers of Robineau's work may be disappointed by such artistic plagiarism, but it was commonplace at the time and helps to explain the low esteem in which china decoration was held.

Even before the century ended, Robineau had begun working in the Art Nouveau style. Given the cosmopolitan nature of New York City, the frequency with which artists, books, and magazines traversed the Atlantic and, not least of all, her marriage to a Frenchman, her adoption of the Art Nouveau style is not surprising. Although her lessons in its vocabulary and use did not formally begin in *Keramic Studio* until 1900 (symbolically terminating her series on historic styles),[13]

61. Adelaide Alsop Robineau, sketch of poppies after M. P. Verneuil, *Keramic Studio* 3, no. 6 (October 1901):149 (left).

62. M. P. Verneuil, study of a poppy plant, from E. Grasset, *La plante et ses applications ornamentales* (1897), Plate 4 (right).

she herself had begun to work in this mode before the turn of the century—at the same time that she was still practicing her exercises in Historicism. This overlapping of styles is registered in the selection of vases she sent to the Paris Exposition of 1900. Alongside her examples in older styles were two in the latest Art Nouveau manner. One was decorated with conventionalized poppies, and the other had a pattern of stylized, rhythmically leaping maidens holding waterlilies aloft (Plate 49, center and far right, see also Plate 10, Color Plate **1**).[14]

Robineau's knowledge of the recent innovations of Art Nouveau can be traced, once again, to specific European publications. Apropos of her vase decorated with poppies, it is noteworthy that in 1899 she illustrated her copy after a study of this plant by Verneuil which appeared in Eugene Grasset's *La plante et ses*

63. M. P. Verneuil, decorative designs using a poppy motif, from E. Grasset, *La plante et ses applications ornamentales* (1897), Plate 5.

applications ornamentales (Plates 61, 62), thus proving that even before the turn of the century she knew one of the most advanced pictorial treatises of the French Art Nouveau style. Grasset's book consists of six dozen full-color plates of flowering plants whose forms are analyzed and then composed into brilliant, modern patterns by Verneuil and the other pupils who followed the "Cours Grasset" in Paris (Plate 63). The parallel between these design lessons and those offered by Robineau over the next decade are striking (Plate 64); on the other hand, specific correspondences are more difficult to establish since this modern educative system was in general use.

Another French pictorial treatise which she knew and frequently utilized before 1900 was Jules Habert-Dys's *Fantaisies décoratifs*. Although many of Habert-Dys's designs show a conservative, Japoniste style, a substantial number are in a modern Art Nouveau vein. Not surprisingly, Robineau copied both types with

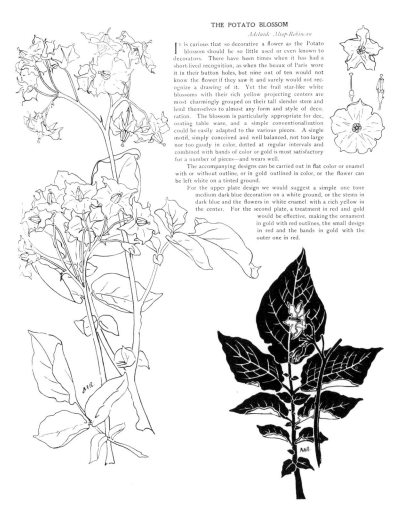

THE POTATO BLOSSOM

Adelaide Alsop-Robineau

It is curious that so decorative a flower as the Potato blossom should be so little used or even known to decorators. There have been times when it has had a short-lived recognition, as when the beaux of Paris wore it in their button holes, but nine out of ten would not know the flower if they saw it and surely would not recognize a drawing of it. Yet the frail star-like white blossoms with their rich yellow projecting centers are most charmingly grouped on their tall slender stem and lend themselves to almost any form and style of decoration. The blossom is particularly appropriate for decorating table ware, and a simple conventionalization could be easily adapted to the various pieces. A single motif, simply conceived and well balanced, not too large nor too gaudy in color, dotted at regular intervals and combined with bands of color or gold is most satisfactory for a number of pieces—and wears well.

The accompanying designs can be carried out in flat color or enamel with or without outline, or in gold outlined in color, or the flower can be left white on a tinted ground.

For the upper plate design we would suggest a simple one tone medium dark blue decoration on a white ground, or the stems in dark blue and the flowers in white enamel with a rich yellow in the center. For the second plate, a treatment in red and gold would be effective, making the ornament in gold with red outlines, the small design in red and the bands in gold with the outer one in red.

64. Adelaide Alsop Robineau, studies of the potato blossom plant, *Keramic Studio* 4, no. 6 (June 1902):191.

equanimity. For example, the pleasantly rhythmic border of mice eating cheese, which she proposed for a cheese plate (Plates 65, 66) was taken directly from one of the Parisian artist's designs (Plate 67), and its source was acknowledged. Likewise, her design for a fish plate was dependent on one by Habert-Dys for its lobster motif and its underlying geometrical schema (Plates 68, 69). In this instance she made substantial changes and, perhaps accordingly, made no mention of her French source.[15]

65. Adelaide Alsop Robineau, sketch of design for a cheese dish with decoration of mice, adapted from Habert-Dys, *Keramic Studio* 1, no. 10 (February 1900):213.

66. Small bowl with carved design of mice, 1908. Everson Museum of Art, 16.4.21 (see Inventory 200). Photograph by Jane Courtney Frisse.

67. J. Habert-Dys, frieze with mice, *Fantaisies décoratifs* (189?), Plate 6 (detail).

DESIGN FOR FISH PLATE

Adelaide Alsop-Robineau

GROUND, dark blue and grey blue; for the dark blue use Banding Blue 1½, Copenhagen 2½; for the light blue, Copenhagen thin. Lobsters and crabs, Pompadour Red; bands of Coral Red (LaCroix), black outlines.

Or, ground, dark and light green lustre; lobsters and crabs, rose lustre first, orange lustre in second fire; bands of orange lustre, outlines black or gold.

Or, ground in two shades of brown; lobsters, olive green; crabs, red; and bands, orange.

68. Adelaide Alsop Robineau, sketch of design for a fish plate, *Keramic Studio* 1, no. 11 (March 1900):225.

Of supreme importance to Robineau's work was her subscription to *Art et décoration*. This French magazine, which began publication in 1897, featured profusely illustrated articles on all of the major Art Nouveau designers and craftsmen, and reviews of the latest Paris salons. The works of Gallé, Guimard, Mucha, Lachenal, and all of the other innovators of the Art Nouveau movement were constantly being celebrated in the pages of this magazine. It is understandable that this publication, reporting as it did on stylistic developments well in advance of what was being done in this country, was so influential on francophilic Robineau.

69. J. Habert-Dys, designs for fish plates, *Fantaisies décoratifs* (189?), Plate 13 (detail).

70. M. Dufrène, A. de Riquer, A. Cossard, ornamented initial letters, *Art et décoration* 5 (1899):123.

This influence was registered on several different levels. She almost immediately appropriated ornamented initial letters from an 1899 issue of the French magazine to use in her own publication (Plate 70).[16] These letters were designed by some of the about-to-be famous exponents of the French style, including Paul Follot and Maurice Dufrène. In a like manner she also borrowed some floral vignettes from *Art et décoration* to use in *Keramic Studio*.[17] Robineau also repeated some of the French magazine's articles and illustrations of recent developments in European pottery.[18]

Not surprisingly, she also borrowed or adopted illustrations from this magazine for her own designs in the Art Nouveau style. Two "posteresque plac-ques" as she termed them, which she published in *Keramic Studio* in May 1900, and acknowledged to be after Privat Livemont, the Belgian imitator of Mucha, were based upon illustrations that had appeared just a few months earlier in *Art et*

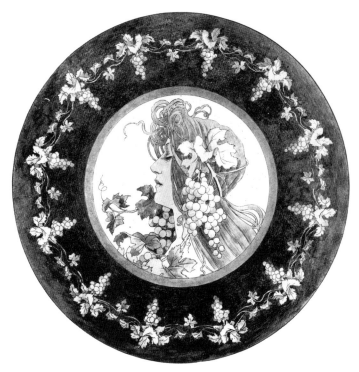

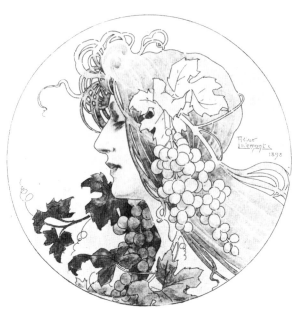

72. P. Livemont, *La Vigne*, decoration for the Provincial Governmental Headquarters in Hasselt, Belgium, *Art et décoration* 7 (1900):59.

71. Adelaide Alsop Robineau, design for a "posteresque placque," *Keramic Studio* 2, no. 1 (May 1900):9.

décoration (Plates 71, 72);[19] the trans-Atlantic repercussions were indeed immediate! And Robineau's design for the border of a salad plate (Plate 73) took its *femme fleur* from a prize-winning poster for chickory which had appeared in *Art et décoration* (Plate 74).

Robineau was also aware of certain important English publications. She evidently read British magazines such as *The Studio* and *The Artist*, both of which published news and illustrations of the most recent English and Continental developments in the so-called fine and applied arts.[20] In addition to recommending Walter Crane's *The Basis of Design*, she also was acquainted with Louis F. Day's many books.[21]

Moreover, as an avid reader and user of *Dekorative Vorbilder*, Robineau was exposed to the latest German and Austrian imitations of English and French Art Nouveau styles. Although this publication may not be deemed important today, it loomed very large in her work. At the same time that she was appropriating initial letters and decorative vignettes from *Art et décoration*, she also reprinted vignettes

73. Adelaide Alsop Robineau, sketch of a salad plate with chicory design *Keramic Studio* 1, no. 12 (April 1900):254 (top).

74. L. Ott, design for a poster for Nutley Chickory, *Art et décoration* 4 (1898):125 (left).

from *Dekorative Vorbilder.*[22] One of stylized violets by A. Erdmann (Plate 75) which she used to head a "Notes" column is typical of the modern style she began to introduce to the readers of *Keramic Studio* in mid-1899. Robineau was evidently so much in awe of this German publication that she even arranged to have several of their plates reprinted in Germany with English titles and used them as color supplements in her own magazine.[23]

75. A. Erdmann, vignette, *Dekorative Vorbilder* 10 (1899), Plate 52.

Most important of all, she continued her earlier practice of copying and adapting designs for her own work. For example, she borrowed a Mucha-like head by René Beauclair for one of her compositions.[24] Likewise, she adapted a design of poppies by the promising German designer, Patriz Huber, to use on a cup and saucer (Plates 76, 77).[25] Occasionally she selected a motif from one of the older volumes of this German publication and updated its style, as in the case of the magnificent peacock she borrowed for use on a stein (Plates 78, 79). Further examples of these correspondences could be cited, but I believe that the point is made: Robineau's work in the Art Nouveau style was heavily indebted to illustrations in European publications.

By 1900, Robineau, like so many of her peers, was won over to the modern style. In issue after issue of *Keramic Studio* for the next decade she waged a verbal battle in favor of what was termed "conventionalization." Although she continued to offer her more conservative subscribers naturalistic studies (supplied by other artists), she argued that naturalism was merely *painting* on china, whereas conventionalization of the motif enabled one to reach the proper goal of *decoration*.

As could be expected, her advice to the readers varied in its sensitivity. While expounding the virtues of modern style she could also be wary of the Art Nouveau mode: "the more conventionalized the design the longer it will 'wear' in favor, as long as it is not conventionalized in the extreme of some style, such as the 'Art Nouveau.'"[26] What extreme did she have in mind—the style of Guimard and Van de Velde? Robineau's own design of conventionalized potato blossoms is one we would classify as Art Nouveau in style (Plate 80, top) yet she considered it only "somewhat in that style."[27] On other occasions she suggested a combination of full flowers and buds to obtain "Variety in Unity," an inverted form of Christopher Dresser's motto,[28] but she warned that if two different species are to be combined, they must complement each other not only in line but in "sentiment": a garden flower cannot be combined with a wild flower, nor can a field plant be coupled with a water plant—advice which might seem a trifle old-fashioned, were it not that we know Robineau was in fact an experienced and enthusiastic gardener.

76. Adelaide Alsop Robineau, sketch of cup and saucer
 with decoration of poppies, *Keramic Studio* 1, no. 5
 (September 1899):107 (top).

77. P. Huber, designs for intarsia work, *Dekorative Vorbilder*
 11 (1900), Plate 4 (left).

78. Adelaide Alsop Robineau,
 sketch of tankard with
 decoration of peacocks,
 Keramic Studio 1, no. 6
 (October 1899):120–21.

79. G. Sturm, tondo design,
 Dekorative Vorbilder 9 (1898),
 Plate 47.

80. Adelaide Alsop Robineau, sketch of cup and plates with potato blossom, *Keramic Studio* 4, no. 6 (June 1902):192.

Today we tend to emphasize Robineau's eminence as a china decorator. Certainly she was a talented and very active participant in the movement. In addition to her own work, she taught others and sold supplies. Her studio was frequently the meeting place for the New York Society of Keramic Arts, and her editorship of *Keramic Studio* gave her national prominence. But it should be remembered that there were other china decorators, even in New York City, who had equal prominence or even seniority. One was Anna B. Leonard, who for a while co-edited *Keramic Studio* with Robineau. There was also Adelaide Osgood, Laura H. Worth-Osgood, Mrs. Monachesi, the Mason sisters, and Marshal Fry, one of the few male participants in the field of china decoration.

It comes, then, as a startling reminder for us today that Robineau's decorated china did not receive much attention in its own time, especially not in

regard to official prizes. At the Paris World's Fair of 1900, the American china decorators who were granted Honorable Mention (the highest award allowed an individual in this category) included Miss C. M. Dexter of New York, Ada White Morgan of Minneapolis, Laura H. Worth-Osgood of Brooklyn, and Henrietta Barclay Wright Paist of Minneapolis.[29] At the Buffalo Pan-American Exhibition of 1901 those recognized for Honorable Mention were Susan S. Frackelton of Milwaukee, Marshal Fry of New York, The Atlan Club of Chicago, Matilda Middleton and Eva Adams of Chicago, and Mrs. W. S. Day of Indianapolis.[30] Not only is Robineau's name conspicuously absent from both these lists, but also her work was not singled out in journals other than *Keramic Studio*. In fact, and this is a point which must be emphasized, Robineau's work resembled that of the other professional china decorators in New York City and elsewhere in the country. As best as can be judged from photographs, her work was as skilled and her sense of design as refined as that of her colleagues. Her conservative attitudes were no more conservative than those of many of her peers, nor were her modern ideas more modern than theirs. There was a shared community of ideas and motifs, and a variety of styles which bound them all together. Yet because of Robineau's later achievements and because of our general lack of interest in personalities like Mrs. Monachesi or Anna Leonard or Marshal Fry, Robineau's work has stood out disproportionately.

The most important turning point in Robineau's early career was her decision to give up china painting and to devote herself to creating porcelains "from clay to finish." Most of her biographers have tended to emphasize the uniqueness of her action and have explained it as the result of her having secured Taxile Doat's treatise on the manufacture of porcelain in 1903; neither assumption is accurate. Most modern historians, myself included, have been misled by the brief biographical account which Samuel Robineau prepared in 1929 after his wife's death:

> What brought about that radical change from a china decorator to a potter of unusual excellence? Although she had done some very good work in china decoration, Mrs. Robineau did not like it. It had been only for her a bread earning medium. She did not like to put her designs on commercial white china, the shapes of which did not satisfy her. She thought that an artist, using china or pottery as medium should make the shape as well as the decoration. She wanted to make pottery but the making of ordinary pottery did not appeal to her, she wanted to do something different. In 1903 I secured from Taxile Doat, a well-known artist of the Manufactory of Sevres, a series of articles for "Keramic Studio" . . .
>
> Mrs. Robineau's decision was immediate, she *would* make porcelain. After spending two or three weeks at the Pottery School at Alfred, N.Y., she bought a few materials, a potter's wheel and a kiln and started experimenting.[31]

The sequence of events in Samuel Robineau's narration is quite specific: his wife's general dissatisfaction with china decoration came to a head in 1903, the securing of Doat's treatise decided her on a course of manufacturing her own porcelains, she studied very briefly at Alfred, and then immediately began producing her own vases. However, it should be remembered that this account was written a quarter of a century after the event and, while there are certain truths imbedded within the data, there are also errors;[32] it is patently a simplified schema which makes his wife's actions disproportionately heroic and makes Doat's treatise a deus ex machina. As we will see, the events were not so precipitous; they did not occur in the stated chronological order, and Doat's treatise was not as great a causal factor. Robineau's evolution from china decorator to ceramist was actually a gradual one; it can be traced to a series of events around 1900, and it was part of a general trend in American ceramics of which the artist herself was well aware.

Looking back to the turn of the century we will find that Robineau's "conversion" was stimulated in large measure by her admiration of modern European and especially Danish porcelain. Quite naturally, she and her china-decorating colleagues in New York were very conscious of factory-decorated wares, particularly those from European establishments, since they set a standard of professional excellence. A very specific shift of taste in favor of Danish porcelains can be seen in the reviews which appeared in *Keramic Studio* in 1900 and shortly thereafter. Two chief contributors to the magazine who went to the Paris World's Fair of 1900, Marshal Fry and Anna Leonard, wrote reports critical of the Sèvres and Berlin factories but, on the other hand, they gave very favorable accounts about the exhibit of the gentle blue and gray porcelains of the Royal Copenhagen factory.[33] Praise of that factory can also be found in a letter from Dr. Clement Chaussegross, Counsel to the National League of Mineral Painters.[34] Although Robineau apparently did not go to the Paris fair (due to the impending birth of her first child), she was evidently of the same opinion since two laudatory articles on the Royal Copenhagen factory, both heavily illustrated, appeared in her journal (Plates 81, 82).[35]

Praise was soon followed by emulation. The subjects and coloration of the Royal Copenhagen factory are reflected in a number of Robineau's painted porcelains of 1900 (Plate 83).[36] For example, her vase entitled *Daybreak* (Plate 83, second from left) recalls the Danish porcelain both in terms of its silhouetted subject and its color scheme of grey blues. An even more striking correspondence can be established *vis-à-vis* the plate in the foreground of this group; its pattern of alternating paired and single geese flying among stylized clouds is copied from a Royal Copenhagen plate (Plate 84).[37] Not coincidentally, a number of the color schemes for her published designs suggested combinations of grey and blue in the Danish manner.[38] And, as always, the same admiration and emulation of Royal

81. Royal Copenhagen, porcelain vases, from *Art et décoration* 5 (1899):180, reprinted in *Keramic Studio* 2, no. 1 (May 1900):2.

Copenhagen porcelains could be seen in the work of her New York colleagues.[39]

Another Danish factory whose porcelains received strong commendation in *Keramic Studio* was that of Bing & Grondahl (Plate 85).[40] In addition to singling out their strong metallic glazes, Robineau praised their use of conventionalized motifs and contrasted this with what she saw as a dangerous tendency toward naturalism in the designs of the Royal Copenhagen factory. Above all, she praised Bing & Grondahl's preference for modeled and pierced decoration, and the use of powerful, sculpted forms. Her comparison of Bing & Grondahl with the Royal Copenhagen factory, to the detriment of the latter, is striking:

> The artists of the Royal Manufactory are painters, Bing & Grondahl are modelers and sculptors. Here the paste is everywhere incised, broken by open work decora-

82. Royal Copenhagen, porcelain teapot and vases, from *Art et décoration* 5 (1899), reprinted in *Keramic Studio* 2, no. 1 (May 1900):2.

tion, thrown in powerful and striking shapes, and the color is only used to complete the decoration, while in the Royal Manufactory works the color is the whole decoration. The latter's wares give the impression of charm and refinement, the Bing & Grondahl wares that of strength.[41]

What she wrote about Bing & Grondahl was prophetic of what in a few years she would be able to write about her own work. Indeed, I believe that directly or indirectly, Bing & Grondahl greatly inspired Robineau. Although she ultimately relied on Doat's treatise for matters of porcelain bodies, glazes, and techniques of firing, she never accepted his chief method of decoration — painting *pâte-sur-pâte* — but instead chose Bing & Grondahl's mode of modeling, incising, and piercing.

Inherent in the bias of Robineau's article, although unannounced, is her shift away from painting and toward modeling. It was precipitated not solely by her encounter with Bing & Grondahl's porcelains but, rather, was part of her general reassessment of china decorating. There were several causal factors. One major stimulus was the generally low esteem in which china decoration was held. For

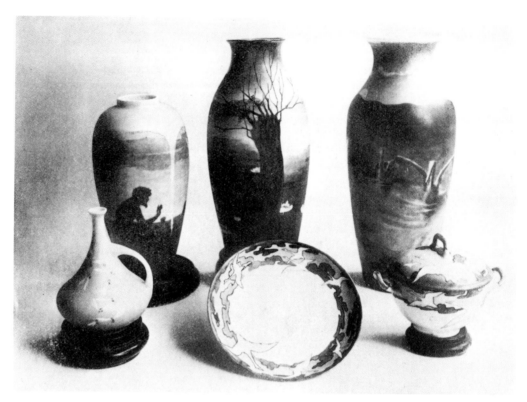

83. Adelaide Alsop Robineau, painted porcelains shown at the Annual Spring Exhibition of the New York Arts and Crafts Society, *Keramic Studio* 2, no. 9 (January 1901):184.

84. Royal Copenhagen, porcelain plate, *Art et décoration* 10 (1901):82.

example, at the Paris World's Fair, the exhibit of the National League of Mineral Painters ran into an abundance of problems: decoration which had been executed on European blanks was severely criticized, decorators were not granted individual status for the higher class of prizes, and the League was told that had it not been for the pottery which was included in the exhibit (submitted by the Dedham, Newcomb, and Roblin potteries and by Louise McLaughlin) the jury would have ignored the entire display. And at home the situation was not better, for most American ceramists voiced a similarly low opinion of china decoration.[42]

Another and more positive factor which caused Robineau's shift in direction was the growing possibility in New York City of making one's own pottery. There were a number of places where one could learn this skill, and the introduction of a new high-fire Revelation Kiln allowed the individual artist to fire his or her own ware.

When the article on Bing & Grondahl appeared in June 1901, Mrs. Robineau had already been trying her hand at modeling ceramics for more than a year! Her instructor in ceramics was the celebrated New York potter, Charles Volkmar. Robineau knew him from at least the late 1890s since he supplied her with an article on underglaze decoration for the very first issue of *Keramic Studio*. [43] We cannot determine exactly when she began working wth him, but it was certainly by the spring of 1900, since at that time he was beginning to teach underglaze painting and ceramic modeling in Robineau's own studio in Manhattan.[44] In January 1901, he began a second series of lessons in her studio and probably even taught throwing on the wheel.[45] Only a few students attended the first series of lessons, but Robineau was certainly one of them. Her participation is indicated not only by the strategic location of the course but also by the fact that along with the decorated china which she submitted to the 1901 Buffalo Pan-American Exposition, she included "two pieces modeled in Mr. Volkmar's clays."[46]

Some idea of her work is suggested by a small bowl with beetles modeled in relief which she executed in 1901, using Volkmar's clay and glazes (Plate 12).[47] This piece is particularly interesting in light of her praise of Danish porcelains. Its modeled insects recall one of the Royal Copenhagen vases she illustrated in *Keramic Studio* (Plate 82), while the pierced holes are more suggestive of Bing & Grondahl's work. Even Robineau's choice of blue and white glazes, while due perhaps to an easy and frequent combination of Volkmar's, also summons to mind the Scandinavian porcelains. Although crudely executed, it represents a first step toward much more major achievements.

Once again it must be emphasized that Robineau's interest in making ceramics was not unique; one could amost say that by 1901 it was a vogue among china decorators in New York City. The Brush Guild, under the direction of George deForest Brush, was making handbuilt pottery even before the end of the

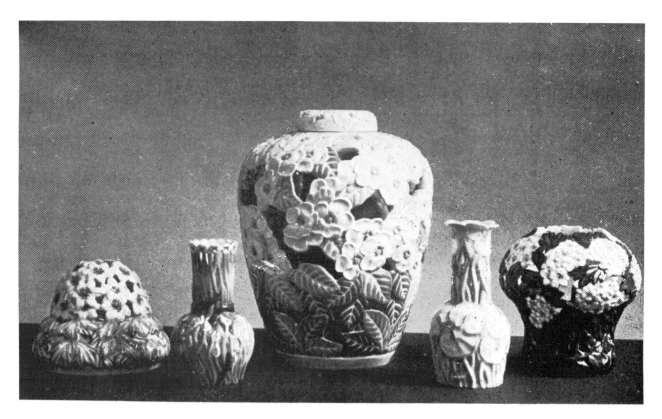

85. Bing & Grondahl vases, *Keramic Studio* 3, no. 3 (July 1901):61.

century.[48] By early 1901, Clara Poillon had established the New York School of Pottery in Manhattan, and she opened a pottery for her own work across the Hudson River in Jersey City Heights.[49] Among those experimenting at Poillon's school in 1901 were two prominent figures from Detroit, Mary Chase Perry and Horace Caulkins, the co-inventors of the Revelation Kiln.[50] Perry, a well-known china decorator who often supplied designs and articles to *Keramic Studio* in its early years, was now turning her attention to ceramics and soon would establish the Pewabic Pottery in her native Detroit. In response to the increasing demand for a brief course of instruction in ceramics, Charles Binns held the first summer program at Alfred University in 1901, and among the New Yorkers attending was Marshal Fry, the well-known china decorator, teacher and ally of Robineau.[51]

Similar impulses were registered elsewhere in the country. Louise McLaughlin, for the second time in her career, had given up china decorating for ceramics, and more will be said about her shortly. The other doyenne of china

painting, Susan Frackelton of Milwaukee, had been experimenting with salt glazed wares for some time, and her lecture in 1901 to the National League of Mineral Painters (which was printed in *Keramic Studio*) emphasized the point that women, not men, had been civilization's first potters; her call was to rekindle this tradition.[52] Also, attention focused on Linna Irelan of San Francisco, whose decorated pottery won an Honorable Mention at the Paris World's Fair.[53] Thus, as Robineau herself justifiably commented in an unsigned review of the pottery she and Poillon exhibited at Buffalo in 1901, there was a "spreading tendency to go into Keramic work from clay to finish."[54] Editorial comments in her journal continually encouraged this tendency.

When Robineau moved from New York City in 1901 she was already on the verge of her "conversion." On settling in Syracuse she still advertised her old specialities of painting miniatures on ivory and china decoration, but she may well have been setting up her own pottery studio at the very same time. Certainly the proper equipment would not have been a problem. As early as December 1901, *Keramic Studio* was selling potter's wheels to its subscribers,[55] and it could be reasonably argued that the magazine's involvement in this business reflected Robineau's already existing preoccupation with working in clay and her need for such equipment. In truth, we know very little about her work in this crucial period. While she continued to offer designs for her subscribers, it is uncertain whether she herself was still decorating china. The last examples of her decorated ware which she illustrated are the objects painted in 1900 (Plate 83). The next time she offers us a glimpse of her work, in the June 1903 issue (Plate 86), it will be of "experimental pottery and porcelain." It may be, then, that this interval represents a busy period of experimentation.

Because of Samuel Robineau's testimony, it has generally been presumed that our artist did not enroll in the summer program at nearby Alfred University until 1903, but the evidence suggests that this too actually occurred earlier in her career—a year earlier, to be exact. As we have seen, her interest in pottery was steadily rising in 1900 and 1901. An unsigned article in *Keramic Studio* about the 1902 summer session at Alfred which reveals first-hand knowledge of that year's summer program may well have been written by the editor herself.[56]

Evidence to support my belief that she studied at Alfred in the summer of 1902 can be found in the pottery and porcelain which she made in late 1902 or the very early part of 1903 (Plate 86) — that is, well before Alfred's 1903 summer session.[57] In technique and style these vases already bear the imprint of the Alfred course. They are for the greater part built from cast sections, thus recalling not only Binns's custom of joining sections but also the frequency with which casting was used at Alfred. One of these early vases (Plate 86, center) is an Oriental form which Binns admired and his pupils often used (Plate 87). The type of geometric

73

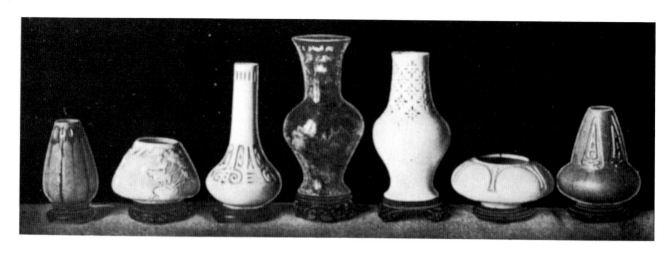

86. Adelaide Alsop Robineau, "experimental" porcelain and pottery vases, ca. 1902–1903, *Keramic Studio* 5, no. 2 (June 1903):38.

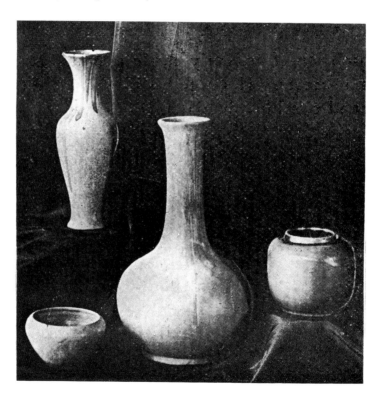

87. Alfred University Summer School, ceramic vases, ca. 1902, *Keramic Studio* 4, no. 6 (October 1902):119.

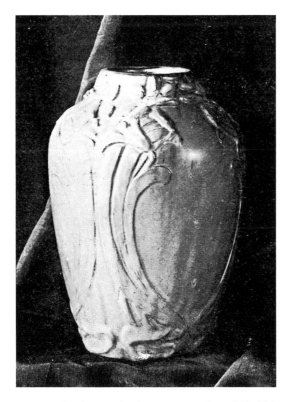

88. Olive Sherman, vase with *pâte-sur-pâte* decoration made at Alfred University, ca. 1902, *Keramic Studio* 4, no. 6 (October 1902):120.

decoration which Robineau incised on some of her vases (Plate 87, left of center and far right) suggests the type of design, inspired by American Indian pottery, which was then popular at Alfred. Even Robineau's use of *pâte-sur-pâte* for the floral decoration of one of her pieces (Plate 86, second from left) is analogous to work done at the 1902 Alfred summer session (Plate 88).[58]

Although Samuel Robineau's account would have us believe that his wife did not receive Taxile Doat's manuscript on porcelain manufacture until 1903, and that she decided to make her own after this, his account proves to be inaccurate on these points as well. As we have just seen, she must have embarked upon this program by the end of 1902. While it is true that the Robineaus did not acknowledge receipt of the Doat manuscript or their intention to publish it until May 1903,[59] this date provides only a terminus ante quem. In fact, Sargent's more exact account specifies: "It was also in the same year, 1902, that, through the influence of M. Robineau, a series of practical articles upon the making of hard porcelain was obtained from M. Taxile Doat."[60]

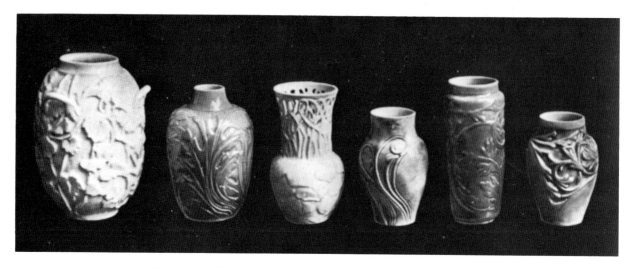

89. Louise McLaughlin, porcelain vases, ca. 1900–1901, *Keramic Studio* 3, no. 8 (December 1901):178.

Also, while it has been traditional to follow Samuel Robineau's account that Doat's manuscript was a deus ex machina prompting his wife to begin experimenting with porcelain bodies, there are certain flaws in that argument. It leaves unexplained why a china decorator or even a budding potter would have wanted such a treatise in the first place. An inversion of the sequence seems more logical, that is, only after Robineau was interested in trying to make porcelains did she seek out Doat's treatise. And there is a logical explanation as to why by 1902 she would have been stimulated to learn that art.

The die had already been cast in 1901. In one of the articles Robineau wrote in praise of the Royal Copenhagen factory, her thoughts took an important turn which may have initiated the process:

> Europeans have thus far the monopoly of artistic porcelain, but there is no reason why it should be so, as we have in this country large deposits of kaolin and all materials necessary for the manufacture of the best porcelains... there is among our decorators such a strong feeling that the time has come to give up the old styles of decoration and to turn to more serious and thorough work, that undoubtedly the next generation will see the birth of artistic porcelain manufactories on this side of the Atlantic.[61]

Obviously, it did not have to wait until the next generation.

Robineau's assertion that no artistic porcelain was being produced in this country was immediately countered by a note from Louise McLaughlin which was

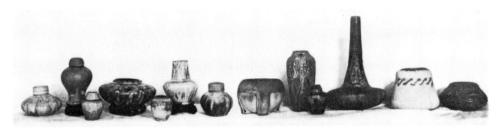

90. Adelaide Alsop Robineau, *grand feu* porcelains with matte glazes, ca. 1903–1904, shown at the Annual Spring Exhibition of the New York Arts and Crafts Society, *Keramic Studio* 6, no. 1 (May 1904):24.

dutifully printed in the July 1901 issue of *Keramic Studio*.[62] The Cincinnati artist pointed out that for some time she had been experimenting with porcelain bodies and that twenty-seven of her recent pieces were on view at the Pan-American Exhibition at Buffalo. Undoubtedly Robineau saw that display (which was awarded a Bronze Medal), and before the year was over she also published an article by McLaughlin which illustrated many of the carved pieces (Plate 89).[63] Thus we have a confluence of two important stimuli: the porcelains of the Royal Copenhagen and Bing & Grondahl factories provided an important artistic impetus, while McLaughlin's work proved that an American female studio potter could independently produce artistic porcelains in her own home.[64] One can well imagine that it was soon after this point that Robineau, still making her debut as a potter, sought Doat's professional expertise.

Robineau's first porcelains show a certain latitude of styles, but they rarely suggest the style for which she would soon be famous. Most of her early vases, bowls and covered jars, such as the ones she submitted to the 1904 Spring Exhibition of the New York Arts and Crafts Society and then to the St. Louis World's Fair (Plate 90), continue to reflect the Alfred traditions of squat, bulbous forms and incised geometric decoration. Some of her pieces, such as the central one, may reflect the Alfred practice of building with slabs; some have small, primitive-looking handles of a type found on ceramics by other Alfred students. All these early attempts were covered wth flowing matte glazes (termed "texture" glazes by Binns), but Robineau apparently left the technical and physical aspects of firing and glazing to her husband.

By the latter part of 1904, indications of her mature style were apparent. She created her first vase with a successful crystalline glaze (Plate 91),[65] thus inaugurating a new and major phase of her career. Although the immediate stimuli for choosing this type of glaze may have been the Sèvres crystalline glazes on view at the St. Louis World's Fair and the formulas provided by Doat, Robineau had also

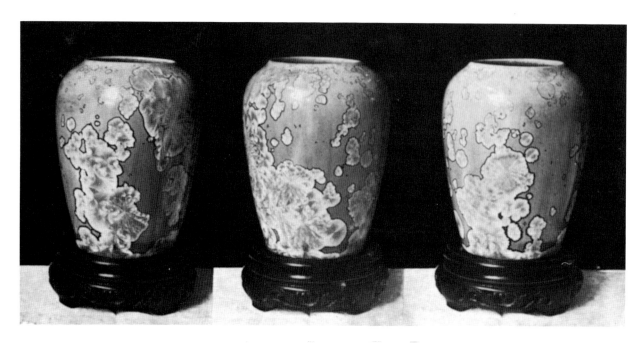

91. Adelaide Alsop Robineau, three views of her first successful porcelain vase with crystalline glaze, 1904, *Keramic Studio* 6 (September 1904):101.

admired Royal Copenhagen's crystalline glazes several years earlier.[66] Likewise, the suave, simple forms which she used, though ultimately inspired by Oriental ones, are of the same type as those used by her European colleagues. Once achieved, these beautiful glazes and forms were repeated in a short-lived attempt to produce molded ware on a semi-industrial basis (Plate 92).[67] The project proved unsuccessful for several reasons and was abandoned, but her handthrown vases continued the very same aesthetic of form and color throughout the next decade.

By 1905 the artist's mature style was more fully apparent. The naive, "craftsy" look of many of her first vessels was replaced by a refined, elegant sense of design. Reflections of the Alfred program can still be detected, but they are very much transformed. For example, she produced a series of what she called "Indianesque" vases (Plate 93) which only in theme continue that school's interest in native American pottery; the forms of the vessels are more in keeping with sophisticated Western versions of Oriental porcelain, as are the delicate, matte glazes. Likewise, another of her 1905 vases, one which is divided into panels and uses her circular monogram as a decorative medallion (Color plate **6**), is a type of design exercise which was frequently practiced at Alfred—albeit on more primitive, handbuilt forms and with more ordinary clay bodies and glazes (Plate 94). Her

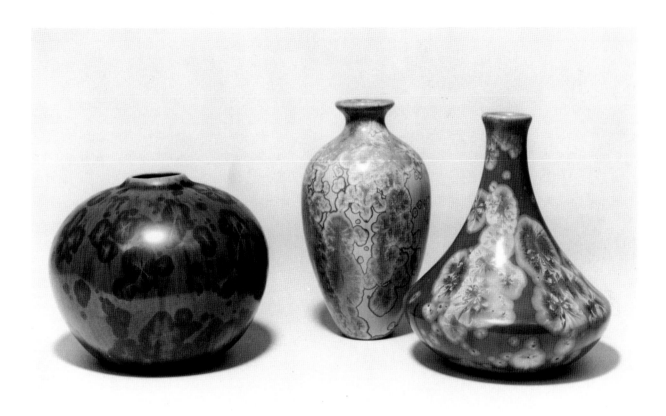

92. Adelaide Alsop Robineau, molded porcelain vases with crystalline glazes, 1905. Martin
 Eidelberg collection. Photograph by T. Rose.

tall, elegant forms are much more in line with those used by Doat, and, not by
chance, she, like Doat, frequently carved porcelain bases or flanges at the bottom
of her vases to help balance them (Color plate **8**).[68]

Most important of all, in 1905 Robineau began to carve into her porcelains
designs of conventionalized flora and fauna of the type which until now she had
used only in conjunction with china decoration. For example, the motif of a mouse
which she used around a bowl in 1908 recalls the border design she copied from
Habert-Dys in 1900 (Plates 65, 67). The border design of lilies which she used on
another of her porcelain vases recalls her first design lesson on "modern" ornament
which she offered in 1900 (Plates 95, 96). Likewise, the disposition and motif itself
of her famous *Poppy Vase* (Frontispiece) recall designs that she proposed first in
1899 and then in 1907 (Plates 76, 97). As before, she continued to emphasize
designs of conventionalized motifs, and we can presume (and hope) that for the

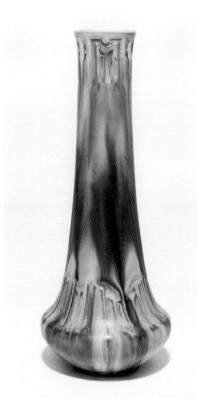

93. Adelaide Alsop Robineau, carved
porcelain vase with "Indianesque"
decoration, 1905. Martin Eidelberg
collection. Photograph by T. Rose.

94. A. E. Baggs, ceramic lidded jar, 1903. Private collection.

greater part they were derived from studies after nature. Yet she also continued as before to rely on published designs by other artists. For example, her celebrated *Viking Vase* is based on a design by H. Edgar Simpson which appeared in *Dekorative Vorbilder* (Color plate **4**, Plates 29, 98).[69]

Although Robineau now threw her own forms instead of relying on commercial blanks, and she carved instead of painting her designs, her work was still very much that of a decorator. Indeed, the continuity of her work in these years should be emphasized. It is not only a matter of style but also of the way in which she worked. Her method of carving slowly over a long period of time, and of firing and refiring the vessel until it was perfect, is a continuation of the way she had decorated china; just as she had once boasted of the sixty hours and many firings it took to complete her enameled hock glass,[70] so now she spoke of the three hundred

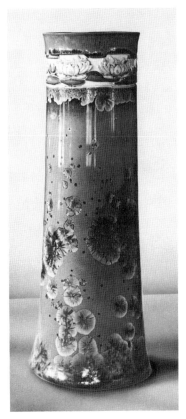

95. Adelaide Alsop Robineau, sketch of plate with border decoration of water lilies, *Keramic Studio* 2, no. 6 (October 1900):121.

96. Adelaide Alsop Robineau, vase, ca. 1905–1909 with incised design of water lilies, crystalline glaze (right).

hours it took to carve her *Lantern* (Plate 3) and the thousand hours it took to execute the *Scarab Vase* (Color plate **3**, Plates 28, 112).

Frequently one finds the style of these early Robineau porcelains designated by the all too inclusive term "Art Nouveau" but it is not an entirely accurate description. While her earlier designs for china decoration did rely heavily on rhythmically structured flowers woven into entrelac bands and symbolist female heads with coiling coiffures, these elements are conspicuously absent from her carved porcelains. Rather, Robineau's carved designs show a marked tendency toward vertical rigidity and to banded, nonrhythmical designs. Vibrant, rhythmical designs like those of the *Viking Vase* (Color plate **4**, Plate 29) are a rare exception.

Indeed, in looking at Robineau's carved designs from 1905 onward, one cannot help but be struck by the spartan and rigidified quality of many of her designs. It is instructive to compare her 1905 vases with dragonflies and moths (Plates 99, 101) with patterns from *Art et décoration* which she published as part of a

97. Adelaide Alsop Robineau, design for a vase with anemones, *Keramic Studio* 9, no. 8 (December 1907):176.

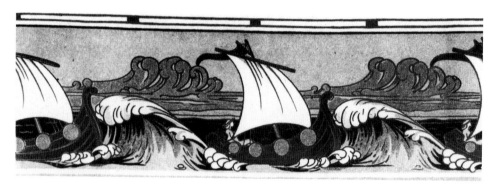

98. H. E. Simson, border design, *Dekorative Vorbilder* 12 (1901), Plate 55.

99. Adelaide Alsop Robineau, unfinished tile (unglazed bisqueware) with design of dragonfly and water lilies. Date and location unknown.

100. Drawings of the cicada, from *Art et décoration*, reprinted in *Keramic Studio* 6, no. 7 (November 1906):152.

101. Adelaide Alsop Robineau, porcelain vase with carved design of dragonflies, 1905. Martin Eidelberg collection. Photograph by T. Rose.

lesson on the stylization of insects in the November 1904 issue of *Keramic Studio* (Plate 100).[71] Whereas the French patterns show a rhythmical complexity and richness typical of Continental style, Robineau's isolation of the insect motif against a large expanse of unornamented ground, the stiffness of the insect itself, and her use of clearly defined vertical axes or paneled divisions create a sparse and sober effect. Likewise, a comparision of Robineau's earlier design of mice from 1900 with the carved bowl of 1908 using the same motif (Plates 65, 66) reveals a significant change: the earlier design is arranged so that the mice are rhythmically conjoined by a series of flowing curves; the later design has the motif pared down and compartmentalized, so that all movement is stilled.

While many of Robineau's drawings from this period still show a gentle softness recalling Japanese prints and her early studies with Arthur W. Dow in New York City,[72] her carved designs are quite different. In her celebrated *Wisteria Vase* of 1908 (Plate 102), for example, the carved blossoms fall with a marked stiffness, and the stem is transformed into a rigid axis.[73] The snails at the base of the vase further intensify this axis and the fixed, tripartite division. The same principles of vertical organization can be seen in many of her vases, such as the one with cicadas and the *Poppy Vase* (Plate 103, Frontispiece).

Moreover, the formality of her style with its closed, symmetrical shapes indicates how governed she was by the process of throwing on the wheel and by her earlier experience as a china decorator using commercial blanks. Although she had admired the powerful, sculpted forms of Bing & Grondahl, she never attempted that organic union of decor and shape which characterized the best of European Art Nouveau ceramics and which was only occasionally imitated in American pottery as, for example, in the works of Artus Van Briggle and Tiffany Studios.

All in all, one is hard pressed to justify using the term "Art Nouveau" in an unqualified sense for either Robineau's forms or her carved decoration. Perhaps this was inevitable. By the time she was carving porcelains in 1905, the popularity of high Art Nouveau style (never that well received in this country in the first place) had begun to wane. Robineau's work can be more easily aligned with the British-oriented Arts and Crafts style which became widespread here soon after 1900. The sobriety of her vessels and decoration could well be compared with the work of another Alfred graduate, Arthur E. Baggs, who became the director of the Marblehead Pottery (Plates 104, 105, 106).

He too favored simple, thrown forms and formalized patterns conceived with strong vertical axes or restrained within the confines of horizontal bands. Robineau's work might also be compared with the wares of the Rookwood Pottery, America's most famous "art pottery." After a brief flirtation at the turn of the century with the French Art Nouveau idiom, both in terms of painted and modeled decoration, the Rookwood decorators often chose to compress their designs within narrow, horizontal bands or on stiff, vertical axes.

102. *Wisteria Vase*, ca. 1907–1908. Ohio State University, CA-60 (see Inventory 333). Photograph by Roger Phillips.

103. Adelaide Alsop Robineau, porcelain vase with carved design of cicadas, ca. 1907–1908. Martin Eidelberg collection. Photograph T. Rose.

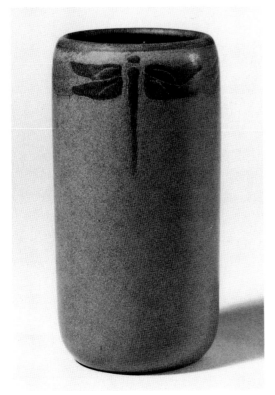

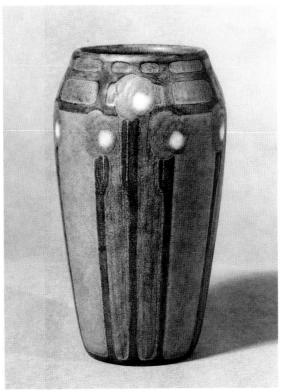

104. Marblehead pottery, ceramic vase with painted design of dragonflies, ca. 1908–1910. Private collection. Photograph by Taylor & Dull, Inc.

105. Marblehead pottery, ceramic vase with painted design of flowers, ca. 1908–1910. The Newark Museum. Photograph by Taylor & Dull, Inc.

Along with the gradual sobering of her design, Robineau's work took a shift in direction, and once again she began to emulate historic styles of the past. It was the time of artistic *détente* and retrenchment in both America and Europe. With the waning of Art Nouveau, there was a period of indecisiveness in which many a designer fell back upon the time-honored, "safer" modes—be they Oriental or Classical. Even before 1910, Robineau, like so many others, reverted to aspects of Historicism which we might otherwise have thought she had permanently renounced years earlier.

One of the major expressions of this resurgence of Historicism in Robineau's *œuvre* is her renewed emulation of Oriental porcelains. Her admiration of far eastern ceramics had long been apparent in her simple forms and *grand feu* glazes; these aspects of her work were increasingly stressed around 1910. In addition

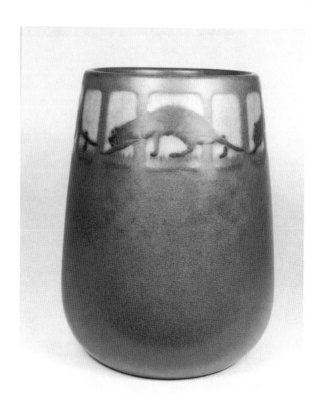

106. Marblehead pottery, ceramic vase with painted design of leopards, ca. 1908–1910. Private collection.

to the graceful Eastern forms which she had used in the past, she turned to sturdier, more cylindrical shapes that were undoubtedly inspired by Japanese tea caddies and ink pots. Also, she more consistently carved porcelain stands and covers for her vessels in imitation of Oriental ebony and ivory ones.

It was almost inevitable that Robineau tried her hand at "developing new glazes... similar to some of the old Chinese glazes."[74] She sought the elusive *sang de boeuf* or oxblood, as well as pink *flammés* of copper (Plate 35). She also initiated experiments to obtain *craquelé* effects, "either the fish-roe crackle or the larger mesh, both of which the Chinese have used extensively in their porcelain work of the best periods."[75] Even though, ironically, the basis of much of twentieth-century ceramics can be found in the so-called purity of forms and glazes seen here, Robineau was consciously working within a specifically Far Eastern context. In her writings she consistently emphasized the Oriental nature of her work and, save for

the Sèvres Manufactory, Eastern porcelains remained the standard of excellence by which she wanted critics to judge her work.

At the same time that Robineau was working on these unadorned porcelains, she was exploring other avenues that were also patently inspired by the Far East. In 1907, she began experimenting with thin, eggshell porcelains that were excised and incised with patterns. Although her ostensible concern was with the revival of these old processes, she imitated Chinese forms and decorative systems as well. Her first example was a covered tea bowl carved with prunus blossoms;[76] some idea of its Oriental decor is perhaps suggested by an eggshell coupe made in 1911 (Plates 23, 24, Inventory 264).[77] And, of course, she carved her famous *Lantern* in 1908 (Plate 3). Although William Grueby praised it as "the most wonderful ceramic piece ever produced in this county,"[78] its form and intricately pierced and painted decoration are a frank imitation of a Chinese "bride's basket" (Plate 107). Although these works are celebrated as *tours-de-force* because of their technical achievements, their designs can be viewed as strongly conservative and reactionary. They are all too suggestive of the lessons on historic ornament which the artist had offered a decade earlier.

Perhaps the clearest example of Robineau's new, conservative turn is offered by her most celebrated work, the famed *Scarab Vase* of 1910 (Color plate **3**). Despite the paeans of praise lavished on it because of the thousand hours it took to carve, it represents a significant turn away from "modern" design. The form of the vessel is an all too apparent restatement of the traditional Chinese form known as the ginger jar. Also, the pale green was, according to the artist: "a new departure in glazes, . . . a glaze of the semi-opaque texture which was so much in favor with the Chinese, a glaze of glove skin finish which retains its transluency without being too brilliant."[79] On the other hand, the decorative, lozenge-shaped pattern of a scarab holding the sun disc in its upper claws and dragging a dung ball behind it is strongly evocative of an Egyptian pattern of scarabs which the artist would have known from Racinet's *Polychromatic Ornament* (Plate 55, left), the textbook of Historicism on which she had relied so heavily a decade earlier.[80]

Although I have considered only the first decade of Robineau's documented career, still, certain conclusions can be drawn. Her career reads very much like a long Russian novel in which seemingly important protagonists at the beginning of the tale gradually fade from sight while characters who appear only sporadically in the opening chapters later emerge as chief protagonists. Likewise, Robineau's artistic development did not follow a simple, straightforward route but, rather, took a series of complex and often unexpected turns.

In many ways the seeds of her later career were there at the beginning, but it would have been difficult to foretell just what would happen. Her early preoccupation with floral and animal motifs, which one might have thought would remain

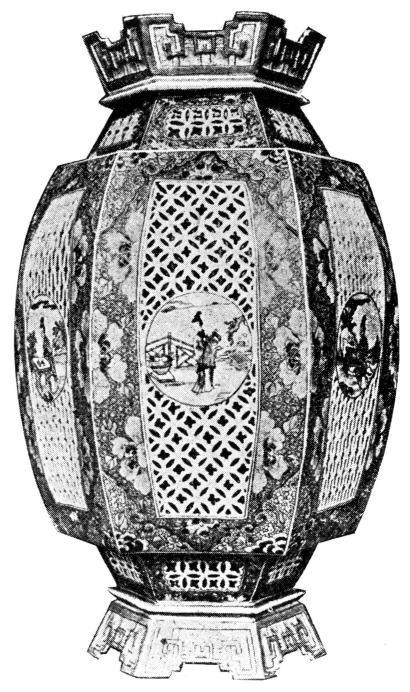

107. Chinese porcelain lantern, K'ang Hsi period (1662–1722), *Keramic Studio* 15, no. 4 (August 1913):78.

108. *Cinerary Urn*, ca. 1929. Everson Museum of Art, 30.4.79 (see Inventory *249*). Photograph by Jane Courtney Frisse.

the mainstay of her career, gradually diminished in importance; although she continued to carve floral designs, as on the vase with foxgloves at Detroit (Color plate **9**), the motif became progressively drier and more abstract. On the other hand, her fascination with figural compositions, present in her decorated china but suppressed in her early porcelains, reasserted itself in vases of the teens and twenties, as in *The Urn of Dreams, The Sea,* and the never executed program of the *Cinerary Urn* (Color plate **7**, Plates 41, 108). Her admiration of the Far East remained a constant factor in her late works, in terms of forms, decoration, and glazes. Indeed, if anything, her attachment to historicism reasserted itself strongly in her later works. In the mid-teens, for example, she began to imitate Mayan and Inca patterns, a variation, perhaps, of her earlier interest in North American Indian art. And despite her early injunctions against the mixing of historical styles, this became a frequent aspect of her later work, as she freely combined Chinese and Inca designs, or Chinese and Gothic.

Throughout her later career Robineau stayed as abreast of modern tendencies as ever. Her change away from flamboyant, Art Nouveau designs to more sedate, Orientalizing ones can be compared to the similar evolution visible in the works of one of France's leading ceramists, Emile Decoeur; her lidded bowls can be compared with the work of Henri Simmen. Her interest in Mayan and Inca designs can be likened to the ceramics of Seraphin Soudbinine or, closer to home, the architecture of Frank Lloyd Wright. One might even compare *The Urn of Dreams* and *The Chapel* (Color plate **7**, Plate 30) to those curious American styles of "Skyscraper Romanesque" and "Skyscraper Gothic." Yet, despite these parallels, Robineau's work was essentially conservative. She favored only the less daring of the modern styles. Although to some degree she acknowledged an awareness of the syncopated floral patterns of modern French style in the designs she still supplied in the teens and twenties for ever persistent American china decorators, she did not adopt them for her own carved work. More importantly, one seeks in vain the impact of Fauvism, Cubism, or Futurism on her work; the influence of the Wiener Werkstätte and the Bauhaus are nowhere to be discerned. These progressive, avant-garde styles awaited a younger, newer generation. Robineau, like her contemporary, Louis C. Tiffany, had an aesthetic and work ideal bound to an older generation that flourished at the turn of the century. These artists took the first steps into the twentieth century but did not walk around freely.

3

The University City Venture

FREDERICK HURTEN RHEAD[*]

Edited by PAUL EVANS

I AM FAIRLY WELL EQUIPPED to tell this story, because I knew the Robineaus intimately for over twenty-five years. I worked with them for over three years; I am well acquainted with Adelaide Alsop Robineau's method and process, and to correct my bad memory for dates and places, I have a hefty file of Robineau correspondence dealing with every phase of what is described below.[1]

Sometime during the summer of 1909 I received a letter from Samuel E. Robineau asking me to come to Syracuse to discuss a proposal to go to University City, St. Louis, to organize and take care of a pottery course which was to be one of the ceramic activities in connection with a ceramic school to be headed by Taxile Doat (Plate 109).[2]

Doat occupied a unique position in the ranks of potters due to the fact that prior to the establishment of his studio he had served what I choose to term a twenty-six-year postgraduate course at the National Manufactory of Sèvres and he was a potter of recognized ability before he entered this factory.[3]

One of the main attributes which at once distinguished the work of Doat from that of the average potter lies in the fact that he was, before everything else, an artist. If Doat had not decided to become a ceramist, he would without doubt have earned a reputation in any other of the graphic or applied arts. He was an accomplished draughtsman and possessed a knowledge of human and animal anatomy at least equal to that of a painter or sculptor of national reputation. He

[*]Born in England in 1880, Rhead came to the United States in 1902. He worked at a number of art potteries and was one of the leading figures and critics of the artware and ceramics industries until his death in 1942. From 1920 to 1925 he served as chairman of the art division of the American Ceramic Society, and in 1934 he was the recipient of the Charles Fergus Binns Medal, awarded for excellence in the ceramic art. Adelaide Alsop Robineau, like a great many others of the period, was influenced to a considerable degree by the overall expertise of Rhead, especially his technical ceramic knowledge and his artistic ability. For more extensive biographical information, see Paul Evans, *Art Pottery of the United States: An Encyclopedia of Producers and Their Marks* (New York: Scribners, 1974). Material for this chapter, unless otherwise noted, is drawn from an ongoing weekly column by Rhead, "Chats on Pottery," in *The Potters Herald* (East Liverpool, Ohio) during 1934 and 1935.

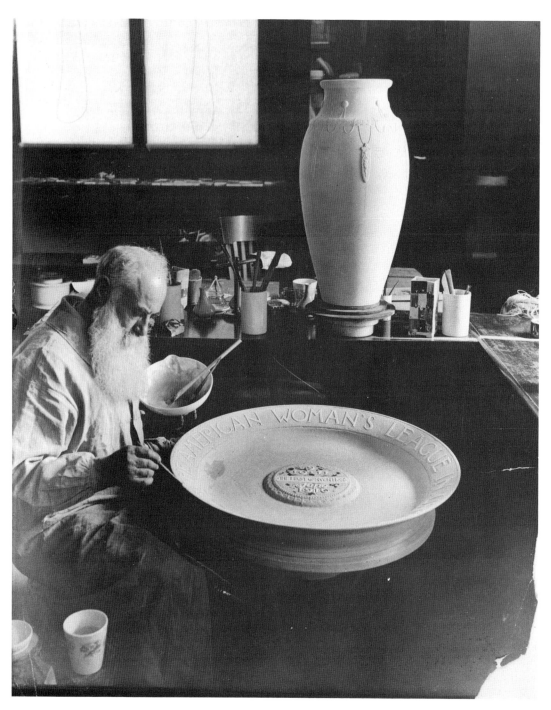

109. Taxile Doat working at University City, ca. 1910.

was intimately familiar with vegetable life, and his interest in structural detail is exemplified by his beautifully executed preliminary drawings. During my visits to his house at Sèvres, I saw many evidences of his versatility in the fictile and other arts. Mounted in a large cabinet were lovely Limoges enamels on copper which he had produced years ago. Other works of art such as sculpture and etchings were to be seen here and there. Some of these were done, he stated, with the purpose of developing his technique or power of execution; others were studies of portraiture, animals, or plant life made in order to acquire knowledge and mastery of structure and detail.[4]

Further claims to distinction are connected with his ability as a teacher and his enthusiastic willingness to impart without reservation any knowledge he possessed. His book *Grand Feu Ceramics* is but one example of his desire to spread information with regard to ceramic art and to awaken an interest in individual work. This book, although not generally known to the layman, exerted considerable influence in many directions, particularly in this country. Originally written in serial form for *Keramic Studio*, it was published in book form by the Robineaus in 1905. The work of Mrs. Robineau is a direct result of Doat's writing,[5] and her knowledge of mediums and process technique increased considerably during the period she was associated with him when he was in this country at University City.[6]

The Robineaus had been approached regarding the University City venture by Edward Gardner Lewis, founder of the American Woman's League and president of the University City activities.[7] I had become tired of the commercial art pottery in Zanesville[8] and decided to spend a few months away from pottery centers to do a little writing, a little planning, and maybe make a few pots without the official censorship and direction of the so-called progressive business mind. I rented a little place in Oyster Bay,[9] and it was during these very happy months that I received the Robineaus' invitation.

Arriving in Syracuse, I was met by Mr. Robineau, who in due time unfolded a story which would have intrigued anyone who was primed for a change from the commercial activities of the period. It appeared that Lewis, then owner of the St. Louis *Star*, had organized the American Woman's League, an organization composed of women mostly from agricultural and rural communities who were interested in those cultural contacts not easily made in outlying districts. He had discovered that a large group of publishers were willing to pay 50 percent commission for magazine subscriptions. It naturally followed that if tens of thousands of women got to work and solicited subscriptions in their respective communities, 50 percent of the total would be a sizable amount. If the inducement were one which offered free education and instruction in the arts and sciences with resident scholarship possibilities in a well-equipped university, many women in farming and rural districts would chase around and get subscriptions for all the magazines a family could absorb.

Early in 1909, the results were such that a square mile or so of property adjacent to Forest Park was purchased and developed into a commercial, residential, and university district. Lewis named the place University City. In addition to a sizable residential area, which was separated from the university section by a large and elaborate gateway with sculptures by George Julian Zolnay, there were already erected half a dozen immense buildings which suggested, by reason of their ornate and diversified architecture, the beginning of an old-time international exposition. There was a tall, domed, octagonal building of several stories used for administration purposes. Adjoining this was the subscription building, housing some three hundred girls engaged in opening and filing subscriptions. Other completed buildings included a large marble structure in the Egyptian style which contained the largest printing press in the world (this was the press of the *Woman's National Daily* built by Goss at a cost of $100,000); the art academy in Italian architecture,[10] equipped for sculpture, painting, ceramics, and other arts; a city hall, and two or three other buildings—one a private school for girls. Plans had been made for academies of music and science, and, according to Robineau, everything was being done on a magnificient and colossal scale.

Lewis had somehow become much interested in pottery making and had determined that this would become an important part of the art school work. The ceramic school was to be "the finest in the world," and the most famous potters were to be assembled for this purpose. He had heard of Doat, who had earned a reputation at Sèvres, and later on his own after exhibiting at the Paris Exposition of 1900 and completing *Grand Feu Ceramics* for the Robineaus. Lewis must have Doat at any price. "If the members of the League wanted to make pottery, they would learn from the most famous potter in the world!"

Doat was brought over for a preliminary conference, expenses paid, and finally engaged at a salary of $10,000 a year plus living expenses and fare to and from France, but not before Doat stipulated that he must have assistance and equipment selected by him and of course financed by the American Woman's League or by Lewis. The assistance turned out to be composed of Émile Diffloth, late of La Louvière, Belgium, a porcelain craftsman but not a chemist, and Eugene Labarrière, a very clever thrower from Sèvres. Diffloth was paid $5,000 and Labarrière $3,500, twice as much as either earned before or later. With regard to the equipment, the Frenchmen must have had a hazy idea of the resources of the United States, because their carload of tools and materials included shovels, barrows, and any amount of hardware which could have been purchased here at a much lower cost. But I am ahead of my story.

Not being satisfied with the French contingent, Lewis decided that he should also have what he considered the outstanding American representatives of the pottery craft. This, of course, included the Robineaus. The salary here was

another $10,000 and, in addition, Lewis was to purchase or take over an art magazine, *Palette and Bench,* which was then published by the Robineaus. Mr. Robineau had sent for me because he had figured that the existing organization needed an instructor in pottery and also someone who was familiar with American equipment and practices.

Following the interview with Mr. Robineau, I decided to join the organization provided I was acceptable to Lewis. An appointment was arranged, and I proceeded to University City and found that Lewis had accepted Robineau's evident approval forthwith and consequently talked of nothing but the coming marvelous accomplishments of the new pottery group. I found that while the Frenchmen were not coming until three months later, my salary was to commence at once, and during the waiting period I could be working on a pottery textbook[11] to be used by the League students.[12]

The University City ceramic group, which functioned in the large art building, originally consisted of Doat, the head of the department; his French assistants, Diffloth and Labarrière; Mr. and Mrs. Robineau; and myself (Plate 110).

At the time I was engaged, during the early summer of 1909, the art building as not quite completed, so it was arranged that I would go back to Oyster Bay to commence the craft pottery textbook and plan a studio pottery correspondence course. I had worked on these for six weeks when the Robineaus wrote me to go to St. Louis. The building was ready, and I was to supervise the installation of the equipment. While I am sure that Lewis possessed no detailed information with regard to pottery or porcelain making other than that given in Doat's book, he had seen that there was ample, well-arranged space for individual studios, wheel rooms, kiln rooms, labs, and storage rooms. Doat, Mrs. Robineau, and I had adjoining rooms with connecting doors; Diffloth's lab and mill rooms were adjoining the kiln room, while Labarrière, for the time being, occupied the various rooms used for throwing and casting.

The problem of installation was complicated by the fact that there were to be three more or less independent sets of equipment: Doat's and Mrs. Robineau's both for porcelain, and the equipment for faience and the low-temperature work. As the Frenchmen had not arrived at this time, and because they insisted that their equipment be brought over on the same boat on which they sailed, I could do nothing about this except to reserve ample and appropriate space. Mrs. Robineau had outlined what she would bring from Syracuse and had specified additional requirements. The Frenchmen were about due with their carload of materials and equipment; as they had forwarded no advance information other than that they were bringing a complete porcelain setup, I decided to delay any installation until they arrived. I had prepared ground plans showing suggested locations for each requirement and thought it best to go over these with Doat before Mrs. Robineau's

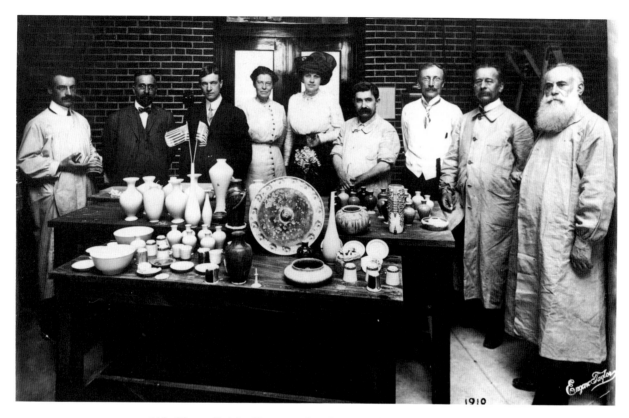

110. The staff of the University City Pottery and Art Institute, April 1910, with results of the first kiln. From left to right: Frederick Rhead, Samuel Robineau, Edward Lewis, Adelaide Robineau, M. G. Lewis, Eugene Labarrière, G. J. Zolnay, Émile Diffloth, and Taxile Doat.

or my own equipment was permanently put in place. Such obvious equipment as files, desks, and other furniture was acquired and ready to put in place at short notice (Plate 111).

 This work completed, and with another two weeks before the long-heralded arrival, I grabbed a desk in the administration building and continued work on the textbook. Finally, one bright afternoon, the folding doors of this very large office flew open to admit a most impressive group: Doat with his Moses beard; Diffloth with pop-eyes and bristling moustache; Labarrière, who looked like a chubby French cook; the Robineaus, Lewis, half a dozen other officials, and a couple of photographers. Following very solemn introductions we were herded together and photographed hither and yon. Then followed loud and rapid-fire French conversations between Doat, Diffloth, and Robineau. It appeared that

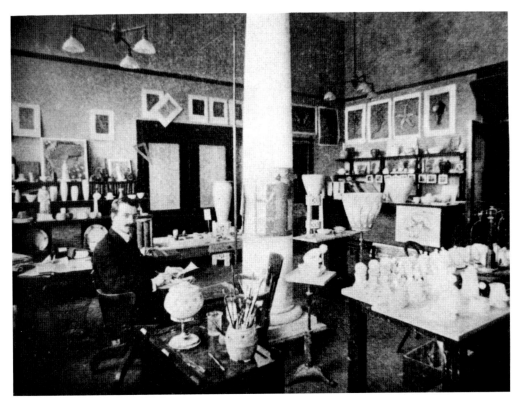

111. F. H. Rhead in his studio at University City, ca. 1910.

Diffloth had not been informed that the Robineaus and myself were to be included in the organization. He had assumed that this ceramic group was to be composed wholly of French potters, and in addition he had a number of relatives whom he had planned to bring over in the near future.

Lewis finally settled the argument by pleasantly informing Diffloth that if the arrangements were not satisfactory, he could be released from his contract and could have his return fare forthwith. Diffloth haughtily declined this propositon, so we adjourned to the art building to discuss equipment installation.

Within a short time after the arrival of the Frenchmen, the carload of equipment was released at the Custom House in New York and brought to St. Louis. There was some delay because the shipment included a very fine collection of Doat's porcelains. These porcelains were to form the nucleus of a collection which Lewis planned to assemble in the museum room in the art building. Doat, a very shrewd businessman, had also included in his contract the sale (at his own

figure) of this large group of pots which he had not succeeded in selling in Paris. However, in justice to Doat, the sum specified—about $7,000—was insignificant in comparison to the real value of the collection. This collection was later housed in the St. Louis Art Museum, and without exception is one of the finest groups of the work of one potter in existence.[13]

For the time being, the interest in unloading the equipment was secondary to the ceremony of the unpacking of Doat's pots. Lewis was present during the entire procedure; as some important plaque or vase was unpacked, it was carried about University City by Lewis and exhibited as an example of his vision in selecting Doat as the man for the ceramic department.

The pots were finally arranged in the museum cases, and the next job concerned the installation of the equipment. This turned out to be simple enough. As it happened, we could have done anything we wanted with regard to arrangement, compatible with practical results. Doat was interested only in favorable working conditions, and he was impatient to get started. He had accepted the Robineaus' recommendation of the large Caulkins high-temperature kilns which were already installed. The French shipment of supplies and equipment consisted of large batches of prepared porcelain bodies, raw materials, chemicals, body and glaze stains, oxides, Doat's personal tools and tests, kick wheels, mixing vats and troughs, and a lot of hardware and other paraphernalia.

While all this was being put in working order and the various departments organized for action, various situations arose which in one way or another influenced premeditated plans and hoped-for results. During the preliminary conferences between Lewis, the Robineaus, and myself, everyone had naturally assumed that Doat was bringing over assistants who were, to say the least, prepared to support him both in connection with the production of porcelain and also with regard to teaching. But it soon became too obvious that Diffloth was intensely jealous of Doat's reputation, and in addition he was from the first aggressively antagonistic to the Robineaus. The situation was made more harmonious by the fact that no one of the three Frenchmen could speak English at the time and were compelled to use Mr. Robineau as interpreter. Doat had planned to concentrate on purely decorative work and when occasion arose to coach advanced students. It was Labarrière's job to make the pots and also give instruction in throwing and other porcelain-making processes. Doat had turned over his body and glaze mixtures to Diffloth, and it was expected that the latter would prepare necessary compositions, supervise the practical processes, and assume his share with regard to teaching.

Mrs. Robineau, who had followed Doat's work so closely, was naturally enthusiastic at the prospect of this association with the Frenchmen. She had been given to understand that there would be free discussion of processes and compositions and that she could make use of anything in Doat's palette. She had carefully

examined every piece in Doat's collection and had made notes of glazes and effects in which she was interested. But when Doat requested that Diffloth furnish information to Mrs. Robineau, he was at first evasive, and when pressed finally refused to cooperate further than what was involved in supplying glazes and bodies already mixed. He refused to discuss formulas or processes. Diffloth was not a chemist; he was a good practical potter and had acquired a considerable number of porcelain compositions. His contract specified that he fulfill Doat's requirements with regard to the latter's personal work and nothing further; consequently he could withhold information without violation of his agreement.

Mrs. Robineau could and did work without any assistance or encouragement from Diffloth, but the situation created by Diffloth's aggressive and jealous attitude eliminated at the commencement of operations any possibility of the formation of the cooperative and harmonious group we had hoped would exist.

Doat, of course, supplied any information at his disposal and on any occasion was always the most cheerful, patient, and interested teacher. During the first year, Doat's work proceeded pretty much along the lines of the everyday work at Sèvres. Mrs. Robineau paddled her own canoe with necessary assistance from her husband,[14] while the pottery department completed the textbook, organized correspondence and local courses, and produced groups of pots for exhibits in New York, Chicago, and New Orleans.[15]

In this meandering description of Mrs. Robineau's work during the University City period, I have arrived at the stage where the three groups of equipment (Doat's, the Robineaus', and that required for the lower-temperature wares) were installed and ready for action and where everyone concerned was raring to go. Doat had made several drawings of large and small vases for Labarrière to throw on the wheel. Diffloth was preparing bodies and glazes for these pieces (when he was not conniving against Doat with any visiting official who would listen). The Robineaus were adjusting themselves to the new conditions, while for the time being I was acting as aide, working with the Robineaus and Doat to smooth kinks in connection with equipment and organization routine.

Diffloth's jealousy of Doat for obvious reasons was not permitted to affect his job as practical assistant to Doat, but he could and did refuse to cooperate with the Robineaus or anyone else. While Mrs. Robineau was not dependent on either Doat or Diffloth for technical, practical, or decorative assistance, she had looked forward to a close association with the French group and had expected an opportunity to experiment with Doat's bodies and glazes. During the first few weeks there were many bitter discussions between Robineau, Doat, and Diffloth with regard to the latter's refusal to impart information on formulas and processes. Sometimes Lewis would be dragged into these discussions, but nothing could be done. Both Diffloth and Labarrière had two-year contracts with Doat; as these were drawn up

in France, Doat was personally liable for heavy damage in the French courts in the event that one or both contracts were broken for any causes other than those specified.

Diffloth finally agreed to furnish bodies and glazes already prepared but flatly refused to discuss compositions. Mrs. Robineau was not interested. There was little fun in making pots if one could not adjust and change the clay and glaze compositions according to the result desired.

So, within thirty days after the arrival of the French group we have a production picture about as follows: Diffloth with a couple of assistants is preparing bodies and glazes for Doat's first porcelain group. Labarrière is busy on the throwing wheel making vases anywhere from three inches to four feet high. Doat has commenced the *University City Vase* and a dozen other cabinet pieces. Mrs. Robineau has made her preliminary sketches for the *Scarab Vase* but is spending most of her time during this period working at the wheel to get perfect pieces, and Mr. Robineau is preparing for the first bisque kiln. At this stage he had decided to fire Mrs. Robineau's work, because he was not familiar with the firing procedure of the Frenchmen.

The working atmosphere during this period was pretty much what one would find at Sèvres or any one of the European national factories. Time was no object. The various craftsmen proceeded leisurely to work out their respective decorative programs and, with the inclusion of various cabinet and other tricky dainty bits, the main objective seemed to be one where large and imposing exhibition vases must be made in order to properly establish reputation and prestige.

However, at this stage other demands were being made by League members and officials. Applications for instruction were pouring in. Within sixty days after the commencement of operations, I had on file over two hundred from prospective students for decorative work in porcelain, pottery, and china painting. These applications came not only from individuals who had never made pottery, but from craftsmen and school and university instructors in various parts of the country.

The textbook which I had completed was published, and copies were mailed to those interested. Preparations were made to take care of a number of students who wanted instruction by correspondence. Studio outfits were designed, made up, and supplied to these students, and the work of a dozen or more of these enthusiasts was such that they were brought to University City to continue at the school.

As the porcelain group was concentrating on exhibition wares, some provision had to be made to take care of the correspondence and local teaching. We engaged a young Englishman, Tom Parker, who in my opinion was the most skillful pottery thrower I had seen: a clever modeler and moldmaker, a practical

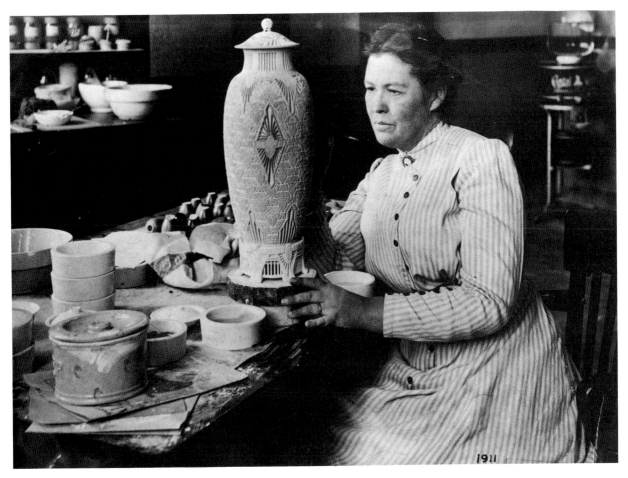

112. Adelaide Alsop Robineau working on the *Scarab Vase* at University City, 1911.

potter who could make either commercial or decorative shapes. With a minimum of clay he could make the neatest and thinnest wares on the wheel. In addition we added a china painting department headed by Kathryn E. Cherry, who at the time was well-known as a talented ceramic decorator and painter.[16]

 The two most monumental porcelain exhibition items[17] produced at this time were the *University City Vase* executed by Doat and the *Scarab Vase* (Color plate **3**, Plates 28, 112) by Mrs. Robineau.[18] Doat's *University City Vase* (Plate 113), thrown by Labarrière, was the first large piece made at University City. Doat was not familiar with the American portable studio kilns, and thus he was somewhat apprehensive and a little cautious. He had followed Mrs. Robineau's successful

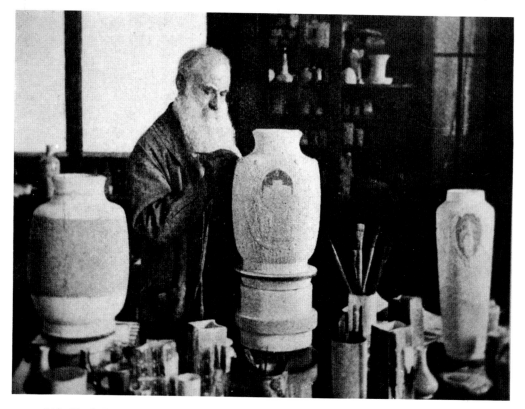

113. Taxile Doat working on the *University City Vase* at University City, ca. 1910.

practice with these kilns and was convinced that they could be used for his work, but he was taking no chances. While in the mind of a foreign studio potter an introductory *pièce de resistance* should be at least four or five feet high, he was compelled to work within the practical limits of the portable kiln. After studying its behavior during two or three preliminary firings for smaller pieces, he decided to do an elaborate piece about two feet high.

When the vase and base were thrown and placed in position for decorating, Doat walked into my studio, giving me a note written in English with the request that I correct faulty spelling and phrasing. As the note conveyed exactly what Doat wanted to say, I typed it for his signature as he had written it. Here it is:

Hon. E. G. Lewis
Mayor, University City
St. Louis, Mo.
Dear Mr. Lewis:
 I beg to announce you a big child is born in ceramic. Him father,
Taxile Doat, him mother, Labarrière. All is well.
 [signed] Taxile Doat

The note was delivered, and about one hour later a messenger came over with a birth certificate signed by the mayor of University City and otherwise duly covering the situation. Doat was delighted by Lewis' response, and everyone in the school was amused except Labarrière, who was highly indignant.

When the piece was not being shown to someone it was protected from direct contact with the air by a large waxed paper box. This was used until the vase was perfectly dry. While the piece was examined from time to time during the drying process, the real inspection commenced when the vase was dry. A light bulb was lowered into the inside and every inch inside and out was examined for strains, cracks, and any imperfection, particularly where the two pieces were joined together. Then, one of the remaining two pieces was fired to a vitreous state in order to test the placing props and to check against other possible faults.

I am not far wrong when I state that the making of this vase, the conferences involved, the various inspections, and the production of glaze trials and color tests occupied as much time and effort as that expended on the decoration. When it was finally decided that the piece was sound in wind and limb and dry enough to be decorated, quite complicated and almost imposing arrangements were made with this end in view.[19] Designed to commemorate the building of University City, the decoration consisted of a wide frieze in which were incorporated *pâte-sur-pâte* medallions of the most important buildings, supplemented by carved figures and ornaments symbolical of the various arts and sciences. Here was another formidable undertaking, particularly when there were included half a dozen incidental but elaborately carved borders, a delicately pierced and carved cover, and a carved base.[20]

No other work was done while the kiln with the *University City Vase* was under fire. About everyone except the chief of police and the President of the United States was invited to peep through the spyholes while it was under fire. Photographers were dragged in and everyone and everything was photographed every ten minutes in all manner of positions. The opening of the kiln was a breath-taking affair. So many people were in the kiln room that it was hardly possible to open the kiln door. Doat in a cutaway coat was there in all his glory; Diffloth, the first assistant, on one side; Labarrière, chief potter, on the other, with photographers snapping hither and yon. It was most impressive.

The door was eventually opened and the nearest vases taken out. The firing was successful. The *University City Vase* was withdrawn, hastily examined, tenderly wrapped in cloths and later brought out to be admired at leisure.[21] From a technical and practical viewpoint the result was everything that could be desired. Decoratively speaking, and I am expressing my personal opinion, the vase was just another of those occasional elaborate ceremonial works where the artist has less to do with the motif and ultimate decorative effect than does a group of individuals who for one reason or another outline specifications which at once strip the artist of any creative initiative.

To me the *University City Vase* is neither a work of art nor should it be accepted as a typical example of the work of Doat. The shape is little more than that of an ordinary cylindrical jar, and the color scheme and general decorative effect are in no way outstanding. Doat would have been the first to admit this.[22] If he could have followed his own inclinations, his *University City Vase* would undoubtedly have been in the spirit of his magnificent *paté changeant Triumphal Vase* which I saw in his house in Sèvres. But the commercial American mind admires subtlety of the sledgehammer variety, and consequently everything had to be on the vase except the cat.[23]

Whatever its significance as a work of art, the vase is unique because of the conditions under which it was produced, because it was executed by one of the few great potters of our time, and because it is one of the very few ceramic examples of the present century where thousands of dollars were involved in the course of its production.[24]

At the end of the first year the expenditure in connection with the University City organization was such that certain officials were concerned—with the exception of Lewis, who seemed to have no regard for money.[25] As Lewis would state, the League was earning around $40,000 a day, hence there need be no alarm with regard to expenditures. Both in size and in scope of operations, this school during its three years of activity represented the largest educational ceramic undertaking ever assembled.

While Mrs. Robineau was not concerned with teaching activities, she was always interested in the work of the students. Her own work demanded so much effort and concentration that she took advantage of every opportunity to lock herself in her studio in order to avoid interruption both from students and curious visitors. As far as purely decorative work was concerned, she did not enjoy the advantages which Doat had been careful to obtain. Labarrière, Diffloth, and others made his pots and assembled his palette, while Mrs. Robineau, with the exception of the assistance furnished by her husband, had to work out her processes from start to finish.[26]

To understand the Robineaus' work at University City and later, one must

have some knowledge of what preceded it. When Mrs. Robineau joined the University City organization in 1909 she had been making porcelains for around six years, one year less than the usual apprenticeship period in the English factories.[27] She had earlier found that she required something more subtle and involved than china painting to satisfy her urge for creative work. Incidentally, her husband could not see a permanent success in a magazine dealing with china painting alone, particularly when there was developing a growing interest in craft pottery making. Looking around for contributions to *Keramic Studio* covering pottery activities, Mr. Robineau published a series of articles written by Louis Franchet, the French ceramist. I contributed a series dealing with decorative processes as far back as 1902 during my first year in this country. In 1903 he secured the series by Taxile Doat which was later published as *Grand Feu Ceramics.*[28]

The possessor of a remarkably placid and tranquil mind together with a patient and gentle obstinacy or determination which no influence could affect, Mrs. Robineau decided to switch from china painting to porcelains. And this switch, I may add, is about as rational and as possible as a vocational change in the early thirties from dentistry to cello playing. But a little thing like this would not disturb Mrs. Robineau. The difficulties and problems involved in connection with the acquisition of a working palette, of technique and execution were recognized and appreciated, but they were never permitted to disturb a mind already turned to action.[29]

The information in Doat's book, together with the examples seen at the Louisiana Purchase Exposition, St. Louis, in 1904 gave Mrs. Robineau the impetus she needed. She proceeded to contact everyone who knew or pretended to know anything about porcelain making and at a very early stage in the game produced very creditable pieces which for design and technique were far beyond anything which had been done by the craft potters of the period. I do not believe that she ever gave serious thought to the difficulties involved. She decided to make porcelains and that was that. Doat's articles written in French had to be translated. Her husband did that job. Further, as Doat furnished only French sources of supply, the American equivalent had to be found. The logical thing to do—Mrs. Robineau always did the logical thing—was to acquire the information she needed. She went to the one man who could supply this information. She went to Professor Charles F. Binns at Alfred, New York. There were, of course, complications. Professor Binns, naturally, wanted her to go through the preliminaries. An individual bent on making porcelain must surely be expected to acquire a little technical knowledge and to work out the five-finger exercises in connection with practical procedure. But Mrs. Robineau did not want this. She wanted to know the American equivalents for Fontainebleau sand, Bougival chalk, PN (porcelaine nouvelle) biscuit, clay of Provins, of Sezanne, of Dreux, of Retourneloup. She wanted to know how

to make a frit and where to find a kiln that would behave itself when functioning at cone nine. Give her the dope and she would take care of the remainder!

Once she confessed that she did not learn all she expected at Alfred. I told her that she went to Alfred to ask questions and that the answers to these questions contained all the knowledge she was entitled to. The average person planning a pottery career will go to school and during the three or four years' study of fundamentals will experiment in this and that decorative process and style, finally winding up with a diploma, a bag of tricks, and plans for the future. But Mrs. Robineau, before she knew anything of clays, glazes, firing, and decorative processes, had decided exactly what she was going to do. As a straight line is the shortest distance between two points, she set her compass, and setting sail, there could be no storm or adverse wind that could affect her course.[30]

When she had acquired what she considered the necessary and essential information pertaining to body and glaze mixtures, sources of supply, data on portable kilns and their manipulation, and wheel equipment, she purchased an electric wheel, a Caulkins kiln, and enough material to go ahead. After installing these in the rented house in which the Robineaus were then living, she immediately, comparatively speaking, commenced to produce beautiful porcelains. I do not know of another potter who has produced even presentable examples without a long period of apprenticeship in one form or another, and we all know the story of Palissy; yet Mrs. Robineau during her first year as a potter produced examples which are as fine as anything she made later. In fact, I have one of these small earlier bits, small enough to hide in a closed fist, which I would not swap for a number of her later and more ambitious pieces.

The life work of the average potter may be divided into three fairly equal periods: first, apprenticeship; second, experimentation; and third, mature production. Mrs. Robineau entirely discarded the first and combined the two latter. Her experience in china painting gave her a technique which could be readily adapted to her decorative work in porcelain. Her extensive use of the small portable china-painting kiln at least made her familiar with its operation at the lower temperatures. Her study of design and decoration, and she did make a serious study of decorative styles and types, crystallized her style. Thus with freedom of action and expression the job consisted of the acquisition of data and information covering immediate procedure.[31]

Adelaide Robineau was one of the most "unskillful" potters on the wheel I have known.[32] However, what she lacked in wheel technique was amply provided for by the possession of more essential gifts and qualities. She would listen all day to those who attempted to advise her—at her request—about this and that, and soak in everything that was said, but no one who knew her well was ever in doubt that she would go her own sweet way in spite of tradition, precedent, experience, or

anything else. This does not mean that she ignored what had been done or that she refused to follow the advice of those who were interested in her work. Quite the contrary. She was all the time making a close study of past performances, and the perspective she acquired as a result of these studies plus the information she gained by her pleasant and interesting third-degree seances were reflected in her work in one way or another. But no critic could say that she copied this or that type, or followed this or that school, because her particular blend of creative genius with her own combination of processes resulted in a decorative porcelain type which is entirely distinctive.[33]

When she commenced to work on the wheel, there was a definite shape in mind. Pencil sketches had been made and first efforts followed this shape type. Little convex forms, simple in contour — at first little more complex than rather clumsy convex cylinders with heavy walls. When these had dried enough, they could be carefully turned to the required thinness. If in process of centering the ball, the cylinder was forced too much out of true, the piece would be discarded, and there would be another attempt. There was no time limit. She was not in a hurry. What if she did take all day to make a three inch pot which another potter could throw in less than a minute? What if she was occupied during the following day in turning this beginner's attempt until it reflected the qualities in the original sketch, and two or three more days in carving the piece? This labored concentration in connection with a specific shape, and a specific decoration already carefully planned, resulted in the production of examples which were as finished as the best of the porcelains then being made in the Continental studios.[34]

Mrs. Robineau always knew what she was going to do next, and how. If for any reason she was in doubt, she stopped work and immediately proceeded to acquire the information she needed. This acquisition of information was no half-hearted stunt procured by timid approaches to this and that potter. She knew exactly where to go when she needed information or guidance in connection with any phase of the work. She also knew how to get this information without leaving the impression that she was intruding or attempting to appropriate ideas or developments of others. While working on an elaborate carved piece, she had within reach a folio notebook. Ideas would be jotted down and entries would be made covering data to be acquired at some future time. Mr. Robineau would be asked to write for this and that information; or, if she knew the potter or individual who could answer the questions, she would write a three- or four-page letter stating her "predicament," winding up with a page headed "Questionnaire" enumerating her immediate problems. I had many of these letters over a period of more than twenty years.

If the problem was one which could not easily be covered by correspondence, she would go visiting to places where she could ask questions and watch

processes. She would take along a few pots as examples. She never posed as an artist or potter, but simply as a "poor lady" who was trying to do this or that and just how would you go about it? The most secretive potter would not hesitate to answer her questions because it was so obvious that she was interested in developing her own ideas. Note, while she absorbed Doat's *Grand Feu Ceramics*, she in no instance followed his decorative style or technique.[35]

In his book, Doat supplied the basic information and ably described the problems involved. Mrs. Robineau's almost immediate response, in the form of her first group of porcelains, is to me one of the wonders in the history of pottery making. In due time there appeared these most attractive little bits, thrown on the wheel and afterwards carved at the top or base, sometimes with very attractive stands of bases forming a part of the decorative scheme. I recall examples from six to eight inches high, the motifs consisting of such subjects as ships, turtles, and crabs, the motif finished in matte glazes while the plain surface or background was planned for a crystalline effect. Many of these first examples were sold for a song— between twenty and forty dollars each — examples which will be worth many hundreds of dollars when even modest collectors realize that they are out in the cold unless they own at least one or two Robineau specimens.[36]

Judging from the Robineau correspondence and my knowledge of their activities, perhaps one piece in one hundred must have been successful or presentable. However this may be, the Chinese have no better record. I have seen examples of Robineau *flambés,* and I am the fortunate owner of two pieces of this type, which compare favorably with the finest K'ang Hsi oxbloods posing magnificently in any collection.[37]

Mrs. Robineau's use of Doat's book during her first two or three years' work in porcelain amounted to something more than careful note making and the copying of body and glaze composition. In her patient and consistent determination to absorb and digest every particle of knowledge, she wore out more than one copy of the book. In her quiet way, Mrs. Robineau possessed the type of mind which would never be content until the job at hand was mastered to the last degree. Yet she was not a fanatic, nor did she ever to my knowledge pose as a craftsman or assume or affect any airs or graces.

As a matter of fact, she was too interested in making pots to be thinking about anything else. I recall visits to Syracuse during these first years and remember the gracious attentions to assure the welcome of the guest. Then the short walk from the house to the pottery, with comments about the flowers in the garden. Arriving at the studio, she would review her work to date and then commence to discuss the work from the raw materials to the grinding of the pots after they came from the glost firing. The leaves of Doat's much-thumbed book would be turned over again and again. What did he mean by this? and that? Many tests of porcelain compositions would be shown and examined for whiteness and translucency,

accompanied with observations covering their workability and behavior in firing. There were scores of little convex pots which she used for her tests of crystalline glazes. Other test pieces consisted of carved or processed fragments made to test various effects planned for elaborate pieces. In back of her finished work is a tremendous amount of carefully planned and as carefully executed preliminary work which in itself would establish the reputation of any potter. I do not know what has happened to these studies, but I do know that they would be a priceless possession for any university interested in ceramics.

After we had made a complete survey of the various tests, she would bring out the pieces in process. Here was a tall bottle vase on the wheel waiting to be turned. She was concerned about the neck which had proved difficult to form. She stated that she was examining the vase every little while for signs of warping or cracking during the drying process. Slight faults in the clay state could be corrected either before or during the turning process, but if there was any doubt that the piece would not successfully withstand the firing, it would be scrapped and another piece would be made — and in those days the throwing of a tall piece was an all-day proposition. On a table nearby was a group of unfired glazed vases waiting to be placed on refractory stands for the glost firing. Every piece was a work of art even in the unfired condition. The glazes had been applied with brushes with gum tragacanth as a medium. Due allowance had been made for the flow during the firing process and the perfectly smooth but graduated surface could have been acquired only with great skill and painstaking care. Here and there were pieces in process of carving and one or two carved or incised pieces in the bisque and waiting to be glazed. One of the latter had some of the details applied. The respective test pieces were at hand for observation. I was particularly impressed with the range and assortment of her tools. Doat in his book gives rather scant attention to the modeling and the more delicate carving tools without which much of the decorative work cannot be done. Good modeling tools are exceedingly hard to acquire; actually they cannot be purchased.

However, Mrs. Robineau, resourceful as she was, acquired by one means or another a set of tools which any potter might wish to own. The original uses for which some of these were made were quite other than that of carving in porcelain: dental and surgical instruments, piano wire, tapestry needles, and engraving and wood carving tools. She must have ransacked the supply houses of the country, and what is most interesting, these tools were not misfits. They were the very thing for the job at hand. They had to be because much of the carved and incised work was so delicate that it could not have been done without the right instrument.

By the time Mrs. Robineau joined the University City organization, she had about graduated from Doat's book, although she had expected to acquire knowledge through a personal association. But she was striking out on her own.[38]

While I generally consider the University City period to be classified as the

second stage in the development of the Robineau porcelains, this is not exactly accurate because Mrs. Robineau had already departed from the plain shapes and monochrome types. The first lantern and a number of other more or less elaborately carved pieces were made before she went to University City, and in addition she planned a group of ambitious things for European exhibition.

In other words, before she went to St. Louis in 1909 she had exhausted the information given in *Grand Feu Ceramics* and was using a palette and process which were truly her own. While Doat was content to ring changes—and noble ones—with the Sèvres palette, Mrs. Robineau explored, investigated, and experimented with new materials, compositions, and textures until her later palette was entirely different than the original Sèvres setup.

Her work with the Texas kaolin is but one example of such departure from her first French palette.[39] Doat used the French PN composition because it supplied the essential qualities for this work, so there was no need to spend considerable time to develop bodies which could do no more than effect the same results. Mrs. Robineau was in no such position. She was working in this country, and it was too inconvenient and too expensive to import the French paste. She made exhaustive tests of English and American kaolins before she finally adopted the bodies she most commonly used. Her important body developments are as follows:[40]

Pâte Syracuse	
English kaolin No. 12	7
Florida kaolin	5
Eureka spar	9
Maryland quartz	3
Robineau White Paste	
Texas kaolin	3
Florida kaolin	3
Feldspar	9
Quartz or flint	9
University City Paste	
English kaolin No. 7	6
Florida kaolin	6
Eureka spar	9
Illinois flint	3

Adelaide Robineau went to University City full of enthusiasm and ambition, but above all the great adventure was to be the association with Doat. She could see him in action, ask questions, acquire that experience and knowledge

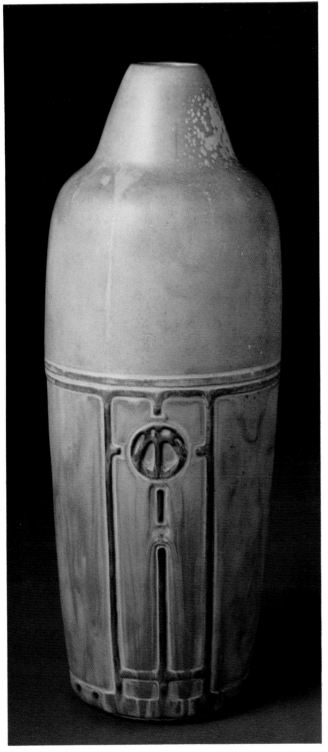

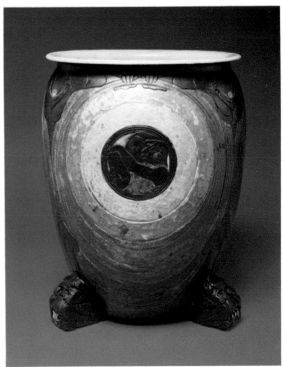

7. *Urn of Dreams*, 1920. Private collection.

6. *Monogram Vase*, 1905. Everson Museum of Art, 16.4.17 (see Inventory *198*). Photograph by Mainstreet Photography.

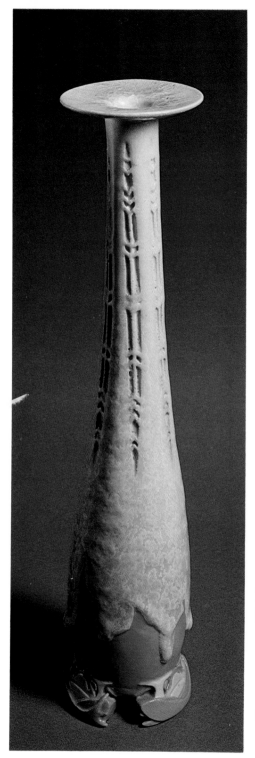

9. *Foxgloves Vase,* 1914. The Detroit Institute of Arts, 19.108 (see Inventory *175*).

8. Vase, 1910. Everson Museum of Art, 16.4.9 (see Inventory *192*). Photograph by Jane Courtney Frisse.

which come of close assocation with another craftsman. From my own observation, I do not think her expectations were realized. On the contrary, I am convinced that Doat—at this period—learned more from Mrs. Robineau than she did from him. I do know that Doat commenced to carve on the surface of the ware and also to attempt eggshell porcelains with the Texas clay.[41]

As far as the University City ceramic activity is concerned, this venture is unique in the history of American ceramics because it is the only one of which I have any knowledge where hundreds of thousands of dollars were lavishly expended for no other purpose than to create and produce beautiful pots. Kings, princes, and potentates in other countries have done this sort of thing and some governments are still doing it, but I know of no other instance where a group of potters were assembled together and permitted to run amuck regardless of cost and monetary returns.

Doat was in no way responsible for the final discontinuance of the activity. He was enough of an organization man, if he had been permitted to have his way, to have made the venture self-supporting after the third year of production. The various administrative forces, for one reason or other, were not interested in marketing the wares when they came from the kilns. Sizable collections were sent abroad and given high awards at Turin[42] and other international expositions; but at no time during the active period, which lasted well over three years, were examples offered for sale.

While Doat produced some interesting examples and two or three really fine bits while working in this country, the conditions surrounding this work were not conducive to distinctive creative efforts. Works of art may be purchasable, but they cannot be created by means of lavish expenditures if those involved in the creation and production — particularly the former — are not working under conditions which will permit the artists and craftsmen to think and plan. No serious activity can be successfully undertaken unless the planning and operating conditions are harmonious and without distracting influence. The conditions under which Doat worked were all wrong. His organization as a whole was not one of his own selection, and certain important and influential members were bitterly antagonistic. He was under observation and criticism from the time he came to this country. Compelled to work in the limelight of publicity, his studio was open to visitors at all times. Even conventions were invited bodily to come and stare at the "famous ceramists." On one occasion, the entire organization including Doat and the Robineaus were made to stand in line for nearly two hours to shake hands with a visiting aggregation of over seven thousand people. Creative artists cannot function to the best of their ability when they are working under conditions such as these.[43]

I have often thought that it would have been better for Mrs. Robineau's

work if she had never joined the University City organization. However, she did make a better showing than Doat, both productively and artistically. And while the University City development will one day be recognized as a unique activity in the history of American ceramics, and while high prices will be paid for typical examples, neither Mrs. Robineau nor Doat excelled themselves during this period. Of the group of Mrs. Robineau's porcelains which were sent by the University City organization to Turin in 1911, only some were made at University City,[44] and these in my opinion did not compare with the remainder. A number of her University City pieces were at best exhibitions of patience, skill, and technique. To me, the "one thousand hour" *Scarab Vase* is a monstrosity. I would not have it in my collection if I was paid for storing it. It is the sort of thing which a criminal condemned for life will whittle to pass the time. So are a dozen other "impossible" pieces. But the production of fifty or a hundred such pieces would not lessen her reputation or lessen the beauty of her other work. I classify these elaborately carved pieces as experiments in technique. No doubt there was a search for new decorative effects, but she wanted to know how far she could go, and, as Mr. Robineau often said, she would rather try for something tremendously difficult,[45] than work with a process which she had already mastered.[46]

Mrs. Robineau, as I have observed, did not realize her expectations in connection with her association with Doat during the University City period. As a matter of fact, while she had exhausted the possibilities of his palette before she came to St. Louis, she had worked enough with his *Grand Feu Ceramics* information to be reasonably sure of any results within the limits of her creative powers at the time.

She could, if she had desired it, have continued to produce lovely and desirable pots with the crystallines and *flambés* which she had mastered, as her work of the period adequately demonstrated. But unlike many potters—and, it may be added, too many of the so-called art pottery organizations—she was not satisfied with a mere repetition of process or formula no matter how satisfactory the decorative effect and perfect the result. She was continually experimenting with new mediums and new decorative effects. When once she had mastered either a decorative process or control over a particular type of glaze, she was looking around for something new.

In my present frame of mind, I do not pretend to judge whether she was right or not, and in any event that was her business and not ours. I am conscious of the fact that many promising developments in ceramics have passed into oblivion, artistically and commercially, for no other reason than that the powers that be have pounded away on the same old note until the limits of absorption were exceeded both fore and aft.

In my salad days, I recall the well-worthwhile efforts of Teco, Van Briggle,

Grueby, Newcomb, and even Rookwood to put the American art pottery business on the map, but they all fell by the wayside because of their monotonous repetition of decorative style and process. The commercial bric-a-brac potters of the Southeastern Ohio district flooded the market with their gaudy imitations of these products. Because the artists and designers of the art potteries mentioned did not possess enough creative ability to develop the full possibilities of their processes and decorative types, they repeated the leaf motifs and green mattes until the market was glutted.

A study of the pots of Adelaide Robineau is a most exciting adventure. One of the most exhilarating qualities of her work in its entirety is that of freshness. There was a new note in every piece she attempted. With this pot she was playing with clays. With another she was investigating a process. Her work might well be considered as a survey, within limits, of legitimate ceramic decorative processes in porcelain. If she could have lived another twenty years we would have seen some amazing things, because she had acquired a great amount of knowledge of processes and materials; her sense of design had become keener and more spontaneous; she had developed a technique which was peculiarly her own; and at the time of her death she had arrived at the full power of her creative ability.[47]

4

Technical Aspects of the
Work of Adelaide Alsop Robineau

RICHARD ZAKIN

THE TECHNICAL ASPECTS OF CERAMICS exert a telling influence upon the character of the final work. Technical and aesthetic choices are so deeply intertwined that it is difficult to talk of one without talking about the other. It is fitting, therefore, in any discussion of the work of Adelaide Alsop Robineau, to include a section dealing with technical matters. This chapter will introduce the reader to various technical terms, and provide an idea of the technical context in which Robineau worked. An attempt is also made here to reconstruct her particular methods of working in ceramics.[1]

Robineau was very conscious of the bond between aesthetic and technical matters in ceramics. She often expressed her technical concerns in the pages of *Keramic Studio:* You must carry your [clay] body and glazes to a point of perfection . . . decorate your ware with real artistic taste and skill, give the closest attention to your shapes: in a word work always for technical as well as artistic perfection.[2]

CLAY—A GENERAL INTRODUCTION

Clay is composed of aluminum-silicate (a combination of alumina and silica) crystals. These crystals are sheetlike and hexagonal in appearance; they are called platelets. There may be as many as 100,000 platelets in a cubic inch of clay. These platelets slide along each other's surfaces when water is added to the clay mixture, and this sliding motion gives clay its quality of plasticity or workability. Generally, the smaller the particles, the more workable the clay.

The research for this chapter was partially funded by a grant in aid from the State University of New York Research Foundation.

The Formation of Clay

Clay is formed from decomposed rock. This decomposition is caused either by erosion or by the action of hot gases. Many clays are heavily affected by erosion; in clays of this sort the platelets vary in size, but many are very small. These clays are therefore quite workable. Erosion also makes these clays impure; they pick up significant amounts of such minerals as iron, manganese, and calcium. Eroded clays, while easily worked, tend to be grey or dark in color when fired in the kiln.

Kaolin

Kaolin is a very special kind of clay and generally more difficult to find than other clay types. Often kaolin is formed by the action of hot gases rather than the more active action of erosion. Therefore kaolin is very pure, and when fired it is white. The platelets are comparatively large. Kaolin is therefore fairly nonplastic and difficult to work.

Clay Bodies

It has become rare for potters to use a single clay as a working material. Most potters use mixtures of a few clays plus other nonclay minerals (generally ground silica and ceramic melters).[3] The result is a mixture carefully engineered for workability and good firing characteristics. This mixture is called a clay body, or "paste." While the terms "paste" (in this context) and clay body are interchangeable, clay body is a more descriptive term and is more commonly used by ceramists today.

Clay Body Types

There are many sorts of clay bodies. Their ingredients vary with their intended purpose. They vary in both the types of clay they contain and in their ratio of clay to nonclay materials. This ratio is especially significant, for it exerts a very strong influence on the physical and visual character of the clay body. This influence is as strong as that of the clay types found in the body.

Porcelain is a special type of clay body; special in that it must contain only the purest clays; furthermore, it must have a high ratio of nonclay to clay materials in its formula. Its clay content must be all or nearly all kaolin, a very pure white clay. Its nonclay content is ground silica[4] and feldspar.[5] The combination of ground silica and feldspar contributes translucency and hardness.

Porcelain bodies are very white in color and are translucent (where worked in thin cross sections). When fired appropriately porcelains look like no other clay body, for they are pure and fine grained, as well as translucent.

Problems Associated with Porcelain

Porcelain clay bodies must contain high percentages of nonplastic, nonclay materials; furthermore, most of the clays they do contain are also comparatively nonplastic. Therefore, plasticity and workability are quite low; porcelain is a beautiful material but very difficult to work. It is especially difficult to form because of its low plasticity. Furthermore, porcelain is prone to problems during firing as well. Some of these problems stem from difficulties during the forming process. Others are the result of the lower strength of unfired porcelain bodies. Though these clay bodies are very strong once they are fired, while they are unfired they are quite weak. This is due to their low clay content and to their lack of variety in particle size (which encourages cracking). While all clay bodies undergo strains in the fire, this is especially true in the case of porcelain, and unfortunately, losses are sometimes high.

Charles Fergus Binns wrote feelingly of this in 1916: "Only those who have faced the difficulties of the Grand Feu[6] can have any conception of the patience and enthusiasm, and the indomitable perseverance and repeated and discouraging failures which lie beneath such work as this."[7]

However, a deft and patient potter can learn to master this material and the rewards in terms of beautiful and exciting results are great.

Robineau's Porcelain

In the Robineau material at Ohio State University is a formula for her clay body:[8]

Robineau Porcelain Cone 9

English kaolin	37.5
Florida clay	12.5
Eureka spar	37.5
Eureka flint	12.5

In terms of present-day availability, this formula would read as follows:

6 Tile kaolin or Grolleg	37.5
E. P. Kaolin	12.5
Kona F4 9	37.5
Flint	12.5

Though there is nothing magical about this formula, it is very well thought out and is a nicely balanced version of the classical porcelain formulation. Two different kaolins are used, one somewhat more fine particled than the other; this encourages particle size diversity and good working characteristics in the clay body.

While no porcelain body can have the workability characteristics of the impure stoneware bodies, this body would, compared to other porcelains, be quite workable and strong. Where suitably thin in cross section (one-eighth of an inch or less) this porcelain is translucent.

Clay Preparation

Robineau prepared porcelain clay bodies using the following method: The various materials in the formula were screened to remove lumps and impurities; they were then placed in a large container. Water was added, enough to give the mixture a soupy consistency. After thorough agitation the mixture was placed in plaster tubs, where its excess water was absorbed. The clay was removed from the tub when it attained a workable consistency. This method is called "blunging."

Though this method is comparatively slow, it is very thorough; it is the most effective way to coax as much plasticity as possible from a clay body, and careful workers still employ it, especially when they are making porcelain.

Ceramic Forming Methods

The two most popular methods for forming ceramic vessels, during the time when Robineau was actively working, were throwing on the potter's wheel and slip casting in plaster molds. While Robineau employed both methods, she far

preferred throwing on the potter's wheel, and after an abortive attempt to set up a porcelain manufactory for mold-formed pieces, the great bulk of her work was thrown on the potter's wheel.

Robineau's Use of the Potter's Wheel

Throwing on the potter's wheel is a skill similar to the skill required for music performance in that both require a blend of physical skill and aesthetic sensitivity. Adelaide Robineau learned to use the potter's wheel in 1903 when she was thirty-eight. And it is as rare for a potter to learn throwing at this comparatively late period in life, as it would be for someone to become a master at flute playing so late in life. Furthermore, she could be said to have been primarily self-taught on the wheel, for her formal training was extremely limited. She attended the summer program of the New York State School of Ceramics at Alfred for two weeks in the summer of 1902, working there with Charles Fergus Binns. Robineau in fact developed a fine throwing technique and attained mastery in this area very quickly; even her earliest surviving works are very well thrown.

Students of Robineau who saw her demonstrate throwing on the wheel testify that she threw exceptionally well and that her work needed little trimming and cleaning.[10] As was true for many potters of her time, she threw with the aid of a template, that is, a cut out metal shape that serves the potter as a guide so that strong, smooth, formal shapes may be attained.

The Influence of the Potter's Wheel on Robineau's Work

Robineau was very proud of her skill in throwing on the potter's wheel,[11] and did most of her work on the wheel. Work thrown on the potter's wheel is characterized by a strong symmetric character. Furthermore, the wheel encourages compact hollow shapes, shapes that fall under the category of vessels.

With the exception of some work on ceramic tiles, and her limited production of cast ceramic doorknobs, Robineau worked exclusively with wheel-thrown ceramic vessels, the walls of which became an area to be carved or glazed in a decorative manner.

Robineau's Use of Slip-Cast Moldwork

When Robineau first decided to produce her own forms, she had to choose between a number of different forming methods. At first it seems that she felt that

121

114. Mark used on Robineau porcelains, from Tiffany & Company, *Porcelains from the Robineau Pottery* (Lyman Press, Syracuse, N.Y.: ca. 1906).

slip-cast mold forming was very promising. She purchased a good deal of equipment for this purpose and hired two assistants.

Slip-cast moldwork is a very useful forming process, but it is indirect in nature. First a model must be made, usually in clay, wood or plaster; next a cast is made from the model. The cast is in the negative form — a mirror image of the model. At this point a wet clay mixture, especially formulated for cast moldwork, and known as "slip" is poured into the cavity of the mold through an opening at the top; it entirely fills the cavity. After waiting a few minutes, the mold is upended and the slip is poured out. However, by this time a coating of slip has adhered to the absorbent walls of the plaster mold. This coating is allowed to dry further and then the mold (which is made in two or more sections) is opened and the clay piece is withdrawn. The piece is then cleaned and prepared for firing.

This process is especially useful in producing multiple copies of an object. Great pains can be taken with the model in the knowledge that the investment of the time and energy will be spread out over a number of pieces rather than concentrated on just one piece. There is furthermore a great deal of freedom as to the sort of form and ornament that may be used in moldwork. Finally even very intractable and unworkable clay bodies can easily be used in the slip-casting process.

However, slip-cast moldwork is often felt to be mechanical in character, and the hand and personality of the potter is often quite obviously absent in pieces made in this way. Furthermore, while the mechanical repetitiveness of moldwork is sometimes an advantage, it is just as often seen as a drawback; there is a desire that each piece shall have a unique character and not be a replica of a thousand or more similar pieces.

Finally, in order to withdraw the finished piece, the mold must be made in two or more sections. In that place where the pieces come together a narrow raised seam is left on the surface of the piece. This seam is difficult to obliterate or disguise.

115. Robineau monograms, from Tiffany & Company, *Porcelains from the Robineau Pottery* (Lyman Press, Syracuse, N.Y.: ca. 1906).

Indeed, as Robineau's wheel throwing skills developed, she concentrated much more on that method and mostly abandoned mold work. She did continue to employ the process for a small percentage of her work. Tiles, such as those used to decorate the fireplace in her home (Color plate **2**), and two small vase types were mold made. These mold-made pieces were marked with the letters R.P. set in a rectangle (Plate 114), rather than with her monogram (Plate 115).

Robineau followed a long tradition in applying ornament to the surface of her pieces; the practice is almost as old as ceramics itself. The surface may be carved or modeled, or colored slips[12] or glazes may be applied.

The application of ornament has a great deal of historical precedence and even the earliest and most primitive work is often treated in this way. In *Keramic Studio,* Robineau often published illustrations of richly ornamented ceramic vessels from such places as Peru, Mexico, China, and Japan.

Carved Ornament —Incising, Excising

Often the surfaces of Robineau's pieces are ornamented by carving. The basics of the technique are very simple, but the method is flexible enough to allow some variation in carving method and in the character of the resultant imagery.

It is useful to distinguish three types of carved ornament: incising, excising, and reticulation (piercing). In incising, the prime or foreground imagery is carved, producing an image that is recessed into the surface of the piece (Color plate **10**). In excising, the background imagery is carved away leaving the foreground in relief. Here the background is recessed (Plate 116). In reticulation, the background is cut through so that the foreground imagery is contrasted with pierced openings in the wall of the piece. Incising and reticulation tend to be somewhat schematic and work well with imagery of a more abstract, decorative nature. Excising offers the potter a choice of decorative or naturalistic imagery (Plate 117).

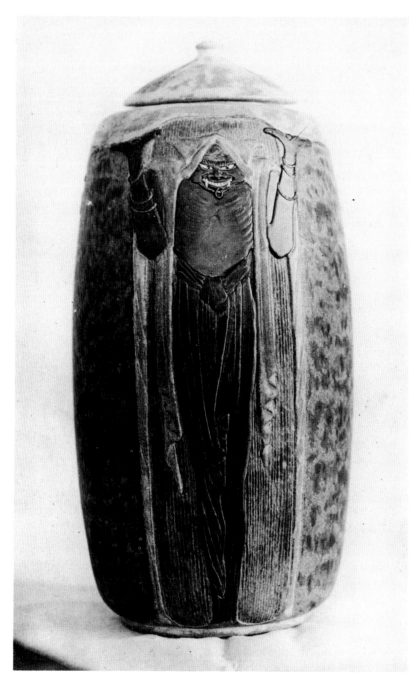

116. Vase with lid, n.d., with excised decoration of a genie. Made for Dr. Maurice Robineau of Paris (Samuel Robineau's brother).

While most potters carve into the clay surface while it is still moist, Robineau carved into dry porcelain. Carleton Atherton described the process in the following way:

> Excising may be accomplished in a comparatively short time on plastic stoneware bodies which may be worked in the damp state. But porcelain bodies are not worked satisfactorily in that state. The decoration of the paste must be done when the work is dry. Mrs. Robineau used one tool, a very sharp point.[13] In this case excising became extremely slow work, a work of tremendous patience and technical skill.[14]

Robineau's work is generally excised; only rarely, as in the *Poppy Vase* (Frontispiece) did she employ incised imagery. In Robineau's early carved work, the imagery was naturalistic but stylized. Often the carving was carefully finished with beveling and contouring in order to enhance the illusionistic quality of the imagery. The *Viking Vase* (Color plate **4**, Plate 29) is a good example of this tendency. Occasionally in her early work Robineau refrained from smoothing the carved imagery and the effect of the piece was comparatively direct. An example of this is the *Crab Vase* (Plate 2).

In the period from 1912 to her death Robineau tended to restrict the carved imagery to a banded area of the piece or to its lid. The imagery moved in the direction of ornament. It tended to be geometric and few attempts were made to imitate reality. This had a strong effect on Robineau's carving style which became more calculated and more decorative. While carving and smoothing were still employed, they defined not naturalistic form but a more abstract, decorative form. Space was no longer a stylized version of three dimensional reality but rather completely abstract. It was layered and dense and no longer attempted the illusion of any great depth.

AN INTRODUCTION TO GLAZES

The technical aspects of the crafts have great importance. This is true in ceramics and is especially true in the work of Robineau, for whom the technical aspects of ceramics exerted a commanding fascination.

It is therefore important for the student of Robineau's work to understand the technical principles of ceramic glazes. Here is a case of aesthetics being influenced by technique. This influence is important, and it can with great profit be explored and understood.

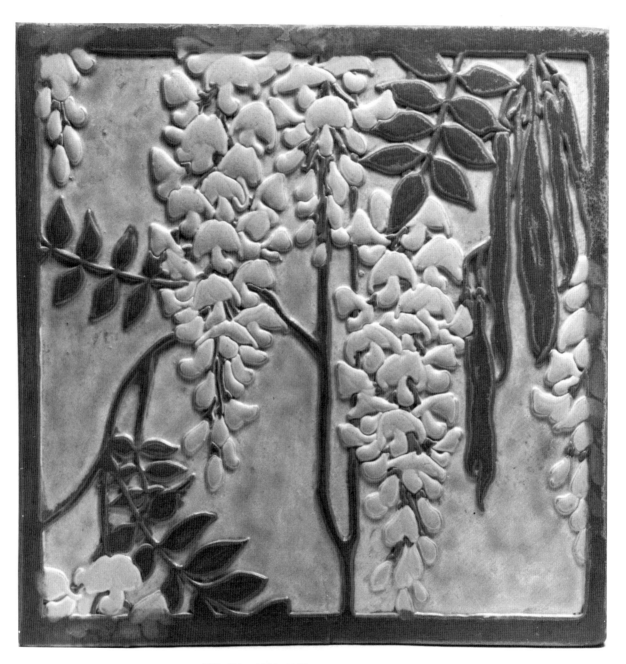

117. Tile, 1904–1905. Private collection.

A glaze may be simply defined as a type of glass, a type formulated to fit the "frame" of a ceramic piece. Ideally the clay and the glaze are compatible in terms of maturation temperature[15] and their reaction to the stress of firing.

The vitreous (glassy) character of glazes is derived from the combination of the elements alumina and silica. However, silica and alumina alone will melt only if they are subject to extremely high temperatures. Therefore all ceramic glazes in common use also contain a class of specially prepared ceramic compounds called fluxes or melters. When a melter is added to the alumina/silica mixture it will form a glaze at the temperatures that potters generally wish to use.

There is no one firing temperature that all potters use; there are low and medium firing temperatures (only in a comparative sense; 900° to 1200°C) and very high temperatures (1220° to 1300°C). The lower temperatures require greater use of strong melters in the glaze; this may have an effect on the usefulness or durability of the glaze, for strong melters may weaken the formula.

While it is easy to see the influence of firing temperature on the glaze, other factors have great importance as well. A very important consideration is the three-cornered ratio of the alumina, silica, and flux content of the glaze. Robineau, as we shall see, preferred a low alumina glaze. This preference exerted a profound influence upon the technical and aesthetic character of her work.

Glazes are also affected by the type of fluxes or melters used in the formula. In order to encourage glaze stability and richness, more than one flux is generally used in the glaze formula. The technically oriented ceramist has an extremely wide variety of combinations from which to choose, each contributing special characteristic qualities to the formula.

Low Alumina Glazes

As stated earlier, Robineau chose as her favorite type of glaze the low alumina formulae:[16] this choice is a bit unusual. Generally, for reasons of stability and durability, glazes contain alumina in amounts that vary from 7 percent to 20 percent in a percentage analysis. However it is possible to formulate glazes that contain only 2 percent to 6 pecent alumina. These low alumina formulations have a unique character and they produce rich and unusual results.

Alumina contributes viscosity to glazes; therefore glazes low in alumina have low viscosity, they flow and spread in the fire. Under certain firing conditions low alumina glazes also serve as a matrix in which richly patterned metallic crystals will grow.[17]

These very special glazes would be widely used except for the following problem: because these glazes flow so much, they flow off the sides of the piece in

an uncontrolled and unpredictable manner. It is therefore necessary to fire the glazed piece on a stand designed to catch any glazes that flow off the piece.

Glaze Application

There are many methods used by potters to apply glazes to their work. These glaze application methods are very carefully considered, for the application has as strong an impact on the character of the work as the glaze formulae.

Glaze application techniques never develop in a vacuum; they develop in response to the nature of the materials used by the potter, the clay body, glaze formulae, application tools, kiln, firing atmosphere, firing temperature, and the character of the desired imagery.

Taxile Doat, in his book *Grand Feu Ceramics,* recommended the following four methods of glaze application: immersion, spraying, sponging, and painting with the brush. Of all those methods, he preferred the brush as a glaze application tool: "I have kept for the last the glazing with a brush which sums up all the processes and although slower, may in almost all cases be advantageously substituted for them whether the pieces are raw (unfired), baked (the low temperature bisque fire), biscuit fired (the mature firing of an unglazed piece), or glazed."[18] Doat goes on to say: "The brush process is slower but it makes it possible to reserve certain parts of the piece, which is to have two or three different glazes, matte, glassy or metallic."[19]

Robineau's Glaze Application Methods

Unfortunately Robineau never wrote about her glaze application methods, and there is little written documentation of this important aspect of her work. However, according to former students who observed her at work, Robineau always applied her glazes with a brush.[20] Her brushes were large (about an inch wide at the widest point), round and full. They came to a point at the tip, affording her some control and flexibility. They were made from a very soft animal hair, and when fully charged with glaze they tended to droop.

Since Robineau glazed on bisquit fired clay which was mature and non-absorbent, it was necessary for her to suspend her glazes in a painting medium; otherwise she would not have been able to get them to adhere to the non absorbent piece. She used gum tragacanth as a binder.

Robineau is said to have often remarked during her glaze demonstrations that it was important to "float" the glaze onto the surface of the piece without

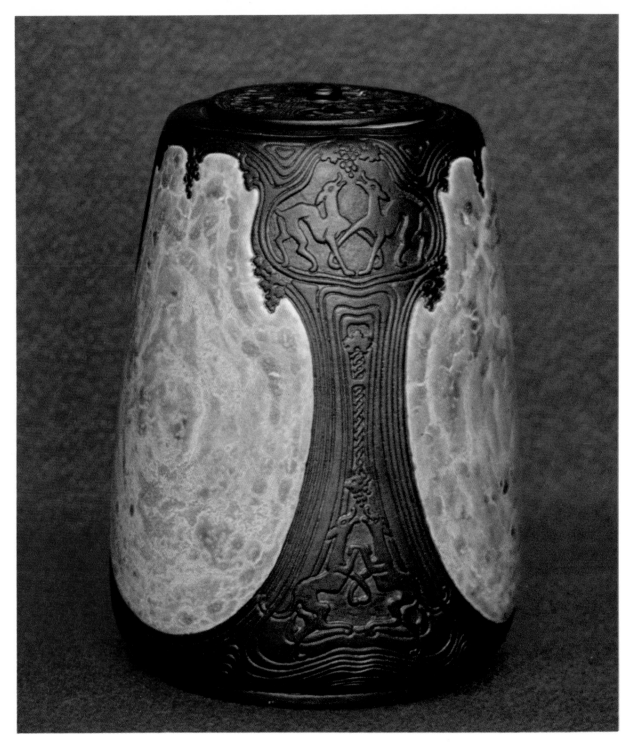

10. *Fox and Grapes*, 1922, with incised decoration of greyhounds, 7¼″. Private collection.

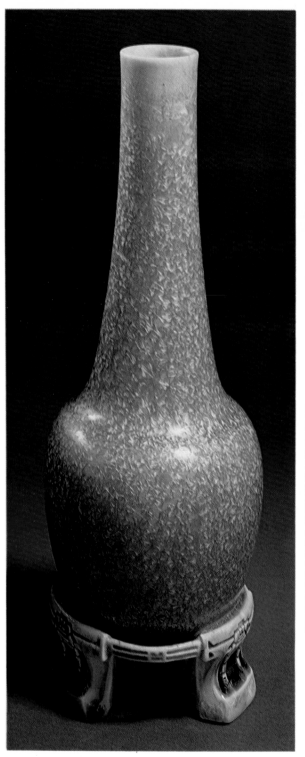

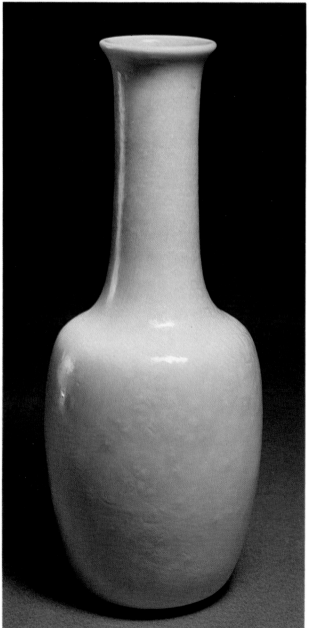

12. Vase, 1912. Everson Museum of Art, 16.4.31 (see Inventory *208*). Photograph by Jane Courtney Frisse.

11. Vase, 1905. Everson Museum of Art, 16.4.26 (see Inventory *205*). Photograph by Jane Courtney Frisse.

letting the bristles touch the surface. This would insure a smooth glaze application. The application was repeated three times to insure an even coating of glaze. In fact, brush application of glazes is especially useful when applying flow glazes which smooth and blur in the firing. In this way, any textures inadvertently left by the brush are smoothed in the fire.

ROBINEAU'S GLAZE TYPES

Flow Glazes

Flow glazes have a low alumina content and a low viscosity. They tend to flow and blur in the fire. These glazes also tend to be brilliant in color, for they are not as affected by the bleaching action of alumina as other glazes.

Robineau probably adapted this series of glazes from formulae furnished by Taxile Doat in his book *Grand Feu Ceramics,*[21] and continued to use these and other flow glaze formulae throughout her working career. While Doat recommended his flow glazes for use on "gres" (stoneware), the formulae also worked on porcelain and produced rich matte results.

Crystalline Glazes

Crystalline glazes are similar to flow glazes in that they are also low in alumina. In addition they usually have a zinc or titanium content and are fired in such a way as to encourage the growth of crystal patterns in the matrix of the glaze. Robineau adopted Taxile Doat's formulae for these glazes just as she did his flow glaze formulae and continued to use these formulae and others with similar characteristics until her death.[22]

Vitreous and Semivitreous Stains

A stain contains no alumina or silica, therefore stains are rarely vitreous (glassy) or even partially vitreous. However, there are certain stains that may be vitreous or semivitreous. This takes place in the following manner: certain stain formulae contain fluxes that are powerful and active melters.[23] The melt is so active that the fluxes combine with a thin layer of alumina and silica on the surface of the clay body. Thus a vitreous or semivitreous glazelike "skin" forms on the

surface of the piece. Because this skin is very thin, and because some of its components come from the clay body, these surfaces do not look applied to the surface, as do many glazes, but rather appear to be an integral part of the clay. Their gloss seems to come from within the clay, and if they have color this too seems to come from within.

The "Bronze" Semivitreous Stain

Sometime after 1910 Robineau began to use a semivitreous waxy black stain that she called "bronze." In his unpublished manuscript on Robineau, Atherton wrote: "another type of glaze was developed to be used over fine carving. This was called Bronze, and was in reality a simple metallic stain. It was used to preserve such carving as would be drowned by viscous glazes." The name is derived from its apparent similarity to patinaed bronze.

The formula for this stain is:

Burnt sienna	92.5
Cobalt oxide	7.5

According to the original instructions, the stain should be suspended in alcohol and ground in a ball mill[24] for some time (perhaps twenty-four hours). The stain is then dried and the powder is mixed with water as needed. It may be fired to cone 9, 10, or 11. While Robineau applied it to porcelain bisque, it may be applied to unfired clay as well.

This type of stain has its roots in China where it was used to imitate bronze. Whether the formula was obtained from Chinese sources or developed as a copy of the Chinese stain in Europe or America is at present unknown. It is possible that it was developed by Robineau herself or perhaps by her friend and advisor, F. H. Rhead.

The Firing of Ceramic Ware

Once the clay piece is finished it is allowed to dry. When dry it is subjected to high temperatures so that it will harden. This process is called firing. In this process all water is driven out of the clay and the particles shrink together to fill in the gaps left by the departed moisture. During this shrinking process, the particles of clay interlock, resulting in a durable, rocklike, material.

Glazes may be applied to the piece before the final firing. If the glaze and

the clay are compatible, the glaze will vitrify and the clay body harden at the same time. The potter usually aims for a unity of clay body and glaze, a point at which both are at their best in terms of richness and durability.

Ceramic Firing at the Turn of the Century

In the United States at the turn of the century, most ceramic work with any pretentions to artistic quality was fired at relatively low temperatures (1000°C and below). Kilns suitable for this sort of work were becoming fairly common. While earlier kilns were fired with wood or coal, many contemporary kilns were fired with a whole new category of fuels, methane, natural gas, oil, and kerosene. The availability of convenient fuels along with fairly reliable commercially built kilns led to a great expansion in the ceramic field. These new techniques encouraged both private potters and ceramic art manufacture; a new and larger audience was developed for the resulting readily available work.

Robineau's Firing Practice

When Robineau began her ceramic experiments, there were a number of small, fairly portable fuel-burning kilns on the market. These kilns, however, were designed for the low fire and could not withstand repeated high firings. After much effort, Robineau succeeded in persuading one of the manufacturers of studio kilns to make her a special kiln along similar lines but larger and with a lining of superior quality. Even this kiln often needed repair. Furthermore, this sort of kiln was difficult to fire with the required control. According to Binns: "Mrs. Robineau's kilns were of the updraft muffle type. In an updraft kiln the flame enters through ports in the bottom of the kiln and waste gases are expelled through an adjustable opening at the top of the kiln. Such a kiln is easy to construct but difficult to fire with any consistency of result."[25]

In a muffle kiln, heat is routed around the edges of the kiln's firing chamber by means of a series of ceramic tubes set in the kiln wall. This system was quite popular at the turn of the century, for it ensured that the potter could keep the open flame and spent gases away from the ware while heat radiated from the ceramic tubes.

In the ceramic studios at Syracuse University, Robineau fired in two oil-burning kilns, each of which is estimated to have had a volume of about twelve cubic feet. Robineau would start the kiln in the evening with a very low heat and fire this way overnight. The next day the burners would be turned up and the heat

would build up inside the firing chamber. By late evening, the ware would reach maturity, the burners would be turned off, and the kiln allowed to cool.

Oxidation Firing

A fuel-burning kiln of the sort used by Robineau is controlled in a number of ways. The amount of fuel and air available to the burners must be controlled. Also the exhaust of spent gases can be influenced by a damper (a baffle) in the exhaust chimney. If the dampers are opened too wide, heat escapes from the kiln; if they are not opened wide enough, spent gases remain in the firing chamber, leaving little room for air and burning gases which keep the fire alive.

The oxidation fire in the fuel-burning kiln is an efficient fire; the air and fuel are in correct balance for best combustion, and the damper is set in such a way that little heat is lost but the spent gases are exhausted. Robineau most often fired in oxidation. Her flow glazes and crystal glazes required this kind of atmosphere.[26]

The Reduction Fire

In the reduction fire, less air is allowed to reach the burners, the flame is smoky and high in carbon monoxide. The damper is partially closed and spent gases remain longer inside the firing chamber. Less oxygen can enter the chamber. Reduction influences the color of colorants such as iron and copper. This color influence is important in some of the glazes that Robineau used, as for example, her *flammé* glaze.

Reduction Glazes

Though Robineau worked with oxidation glazes most of the time, she did occasionally work with reduction glazes as well. Toward the end of her life she became more interested in reduction. Atherton mentions that she was planning an exhibition of reduction fired ware for London; her illness caused cancellation of this plan.[27]

Robineau's favorite reduction glaze type was the *flammé* glaze—a reduced copper glaze. In this glaze type, copper turns not green or blue as it would in oxidation, but rather a blood red. But Robineau's copper reds are streaked with oxidized green which is the result of an inconsistent kiln atmosphere.

Robineau's reduction work, in fact, never attained the level of technical

mastery of the oxidation fired work. Part of this must be ascribed to the limitations of her muffle kilns, which were engineered for oxidation firing. Robineau never seemed to achieve consistent and rich reduction effects.

Firing Atmosphere in the Muffle Kiln

In the muffle kiln great efforts are made by the designers of the kiln to separate the fire and the firing atmosphere from the ware. Such kilns are engineered to achieve a good oxidation firing, and they do so; however, they don't reduce very well.

Charles Binns, in his note on Robineau kilns, refers to "inconsistencies of result" with the muffle kiln. These inconsistencies seem to have plagued her attempts at reduction firing (the type of firing preferred by Binns).

Robineau's Firing Temperature

When illustrating her work in *Keramic Studio* magazine, Robineau gave few technical details. She did, however, occasionally mention that her pieces were fired to cone nine.[28] This statement could be somewhat confusing, however, to modern readers, as the cones she used, though manufactured in Ohio where the so-called Orton calibration method was developed, were calibrated according to the European (Seger) system. Thus the cone nine Robineau used would melt under normal firing conditions at 1310°C (2390°F) which is a little over cone ten, using the modern (Orton) cone calibrating system.

Postfire Cleaning

For Adelaide Robineau, the postfire cleaning process was exceptionally demanding and important. Because she used glazes with low alumina content, the glazes would, lacking viscosity, flow off the pieces. It was necessary, therefore, for her to fire her pieces on firing stands of soft, refractory (nonhardening) clay. When the glaze flowed over these stands, the stand and pot would stick together. With chisel and grinder, Robineau then had to separate them. Very often the foot of a Robineau piece shows evidence of this cleaning and grinding process. While she could have avoided this tedious process by using nonflowing glazes, she could not then have obtained the rich striking glaze effects for which she was noted.

In this piece (Frontispiece, Inventory *187*) Robineau employed an inlaid slip technique, a method she rarely used. However, she was not unfamiliar with the technique, for she had published an article about inlaid slips by F. H. Rhead in *Keramic Studio* in 1909.[29] Furthermore, during the following year, Robineau and Rhead were teaching at University City in St. Louis, Missouri, and it was during this period that the piece was made. It would seem that it reflects the strong technical influence of Rhead. While the technique may be indebted to him, the rich formal imagery is very much her own.

In the inlaid slip technique, the potter carves linear designs into the surface of the unfired clay. These designs are then filled with a colored clay slip. The surface of the clay is then carefully scraped and smoothed. The slip in the interstices cut into the clay remains after the slip on the surface of the piece is scraped away. If the scraping process is carefully carried out, the interstices are fully filled in with colored slip, and the slip imagery is flush with the surface of the piece. The imagery appears to be that of one color of clay inlaid into the surface of another. The piece may then be fired to biscuit at which point a transparent glaze is applied. It is then given a final firing. In the *Poppy Vase* Robineau used the inlay technique for the floral imagery. Other areas of the design were left as incised areas.

An interesting question for the student of Robineau's work is the nature of the pink color of the poppies. There are two likely possibilities, the first being a chrome/tin pink stain and the second being a stain derived from potassium bichromate. While chrome/tin pink stains are fairly common, potassium bichromate was more likely the colorant used here. This deduction can be made because the color of the poppies is not quite like that of chrome/tin pinks, but rather the color does have the roseate qualities of potassium bichromate stains. Robineau knew of the potassium bichromate pink stain because it is mentioned by Doat.[30] It is possible that many of the pink stains used by Robineau were derived from potassium bichromate. Robineau was fond of using pink as an accent color and used it on a number of her pieces.

The piece is covered with a colorless transparent glaze which is stained blue green at the shoulder and an ochre color toward the bottom. The cool green color at the shoulder is derived from the colorant copper which gives a cool green or a blue green in an alkaline formula when fired in the oxidation fire. A thick wash of copper or a copper-containing glaze was applied to the shoulder of the piece, probably before the final overall glazing with a clear glaze.

Robineau used a clear glaze that Doat mentioned in *Grand Feu Ceramics.*[31] The formula is quite simple:

Grog	24
Flint	43
Chalk	33

This is a high silica, high calcium, transparent formula.[32] In her notes Robineau suggests using ½ percent to 2 percent copper to obtain a green with this glaze formula.

The wash of yellow color toward the bottom of the *Poppy Vase* was derived from a rutile colorant. Rutile is a compound of titanium and iron. F. H. Rhead wrote of the inlaid slip technique, "There are few kinds of pottery work which display the individuality of the potter to the same extent as this inlaid process."[33] The *Poppy Vase* is ample corroboration for that statement.

THE *VIKING VASE*

This piece is an example of Robineau's early Art Nouveau carved style (Color plate **4**, Plate 29). The carving has been carefully beveled and smoothed in order to create an illusion of naturalistic space.

The vase is glazed with two different low alumina glazes. These are known as flow glazes. They are similar to crystal glazes and indeed a few small crystals are found on the shoulder of the piece. However, the piece was fired and cooled in a normal rather than a crystal firing. Therefore, we see as a result of the low alumina formula, a curious "blooming" phenomenon. This is caused by the unique behavior of low alumina formulae which spread and flow during the final phase of the firing. The result is a rich and dreamlike imagery. Glazes of this type are fine examples of the partnership possible in ceramics between aesthetics and technology.

While no notation of the glazes used in this piece has been left us by Robineau, the two following formulae were among the first listed in her notes, and were prefaced with the notation, "Glazes Proven Good."[34]

Flowing Matte Yellow Brown Glaze

Spar	53
Flint	14
Kaolin	8
Chalk	26
Rutile	10
Iron	5

This glaze is practically identical to Taxile Doat's matte reddish yellow glaze found in *Grand Feu Ceramics*, [35] the only difference being that Robineau lowered the kaolin content from Doat's 14 percent to 8 percent. This would lower the alumina content and encourage flowing. This sort of glaze would be much more compatible with porcelain in character.

Another glaze that may have been used on this piece is the following:

Flowing Matte Dark Green

Spar	31
Kaolin	26
Flint	36
Chalk	28
Rutile	18
Cobalt	9

This glaze, which was also in Robineau's formulary is practically identical to a Doat glaze, [36] his matte crystal in dark green. The only changes Robineau made in the formula were simple adjustments in order to round off the numbers.

Doat says of these formulae: "It is also with these matte glazes that I decorate most of my ceramics. They make a pleasing contrast with the bright glazes used on part of a vase and resemble more closely the matte effects of nature."[37]

The reader might be curious as to the feldspar used by Doat and Robineau. Doat recommends pegmatite which is Cornwall stone, a very fine high silica, high potassium feldspar. An almost identical version of Cornwall stone is still available.

Both the Flowing Matte, Yellow Brown, and the Flowing Matte, Dark Green are low in alumina and would run and blur in the fire. This is especially true of the Yellow Brown for it has a very low clay content. The Dark Green glaze does have a higher clay content, but its very high colorant content would act like a flux and encourage flowing.

THE *SCARAB VASE*

The *Scarab Vase* (Color plate **3**, Plates 28, 112) is important not because of any inventive or innovative qualities, but rather because it seems to have been a technical "summing up." Robineau employed a great many techniques in making this piece; it is larger than most of her work and employs a more complicated imagery.

Both surface carving and pierced imagery are employed very freely in the piece. The pierced imagery is especially interesting in that much of it is backed by a

slab of porcelain applied in such a way as to persuade the observer that the piece is double walled. The glazing, though not innovative, is applied with great deftness and care. Its technical orientation was noted by F. H. Rhead who classified this and other, "elaborately carved pieces as experiments in technique."[38]

This piece is special in that it is one of the few Robineau pieces for which we have a record of the formula used for the glazing. The white glaze and the turquoise glaze are the same, the turquoise color being derived from the addition of 1 percent copper to the glaze formula.

The Scarab *Glaze (white)* [39]

Spar	42
Kaolin	19
Flint	21
Chalk	18
Tin	10

THE METALLIC BLACK VASE

This piece was carved by Robineau in her last year of work (Plate 42) and is carved in her later style. There is little interest in naturalistic illusion, rather the piece is carved in a style suggesting a very shallow, decorative space. The imagery is abstract and tightly woven. After a mature biscuit firing the "bronze" stain was applied to the piece.[40]

CONCLUSION

The student of Robineau is struck by the fact that in her work aesthetics and technique are so closely intertwined and influence each other so profoundly that they must be studied together. Robineau was fascinated by the interplay of aesthetic and technical invention; she constantly experimented, in the most intense manner, in both areas.

This air of intense experiment gives the work a feeling of excitement and risk. One gets the feeling that Robineau needed every major piece to be both a technical and an aesthetic challenge. This would explain why she took on such a wide variety of difficult tasks requiring great skill and invention. This also might explain why she rarely repeated her successes; rather early on in her ceramic career

she was very successful, producing such work as the *Viking Vase* (Color plate **4**, Plate 29) and the *Crab Vase* (Plate 2). Yet, rather than continue with work in this vein, she chose to move on to new territory with new possibilities for success or failure. Because of this attitude her failure rate was quite high. This risk of failure was increased by her commitment to perfection in her work.

When one views Robineau's work as a whole one gets the impression of a restless, highly charged and inventive sensibility.[41] Her work communicates a sense of strong intellectual excitement, the excitement of the experimenter confronting in the studio the challenge of demanding technique and arcane method.

5

Robineau's Crystalline Glazes

PHYLLIS IHRMAN

ADELAIDE ROBINEAU'S WORK in crystalline glazes came at a time in history when there was considerable interest in them in America and Europe. Undoubtedly, the first major influence on her was that of the French ceramist, Taxile Doat, whose book *Grand Feu Ceramics* was translated and published by Samuel Robineau in 1905. It contained the formulae for the crystal and microcrystalline matte glazes in which she was interested. She also later worked in close association with Doat at University City in 1910 and 1911.

Robineau also met the British-born potter F. H. Rhead at University City. He later became a good friend and a technical advisor for her crystalline glazes. During the time he worked as director of research for the American Encaustic Tiling Company of Zanesville, Ohio, and later as art director of the Homer Laughton China Company, he answered many of her technical questions about glazes and glaze materials. He instructed her in the compositions of materials, how they behaved in the presence of each other, their function in a glaze, how to substitute one for another, where to purchase them, and how to raise the maturing temperatures of glaze formulae.[1]

Because the glaze formulae for high-fire porcelains used in the factories of Europe were usually kept secret, American potters were prompted to conduct their own experiments, and consequently some very good articles were published on crystal glazes in the magazine *American Ceramic Society*. These were written by prominent men in the ceramic field such as J. F. Krehbiel, R. C. Purdy, J. Koerner, W. Pukall, and F. H. Riddle. There is evidence that Robineau read them and was possibly influenced and helped by some of their information.[2]

Another example of her search for information is revealed in her correspondence. She was interested in a type of crystalline effect described as concentric rings. She wrote to Krehbiel asking him about the Japanese glazes that were reported to give this effect. She also asked about the "German mixes" for which she had formulae knowing that he had done some work with them at the University of

Illinois. They were high in manganese and were also supposed to give concentric rings. His reply with suggestions for working with these glazes was lengthy but rather vague.[3]

Robineau drew on the past for inspiration. Many of the shapes to which she applied her crystalline glazes were simple elegant forms reminiscent of old Oriental porcelains. In her notebooks she kept numerous descriptions of Oriental, Persian, Greek, and Egyptian pottery. She described what kind of glazes and slips were used and how they were applied. There are drawings of pots and her ideas of how to incorporate these designs in her own work.[4]

DEFINITION OF CRYSTALLINE GLAZES

Crystalline glazes essentially fall into two categories; macrocrystalline and micro-crystalline. Macrocrystals grow sunburst, flower, or snowflakelike forms floating in a sea of color. Often there are very tiny (1/10 cm. to 1/5 cm.) secondary crystals usually of a different formation and displaying a different color. Ghost crystals sometimes appear. They are like round blobs with no definite formation, floating on the very surface of the glaze. They are always very pale and sometimes can only be seen when the pot is tipped to catch the light. Often the color of the crystal differs from the background or matrix.[5] Microcrystal glazes have microscopic, needlelike crystals present in great quantities. When light strikes the surface of the glaze it is broken up by the crystals and reflected out in all directions. This often causes the surface to sparkle in the light and produces the satin matte surface that is pleasant to touch.

Both types of glazes have unique compositions. They must contain a sufficient amount of a crystallizing ingredient which, upon cooling will reach the saturation point and crystallize out of solution. Two of the most frequently used crystallizing agents are zinc oxide and titanium dioxide. Rutile is an impure form of titanium, having some iron in it. It is often substituted for pure titanium. Metal oxides provide the colors. If more than one is used, then usually one colors the matrix while the other colors the crystal. Glaze composition and firing schedules are varied to control the size, shape, and color of the crystals.

The firing schedule for crystalline glazes is different from all other types of firing. A peak temperature high enough to allow all the glaze components to dissolve must be reached. For the macrocrystals the temperature is usually dropped several hundred degrees after the peak has been reached, and the temperature held steady for several hours, allowing the crystals to separate out of solution and grow. For the microcrystals, a similar schedule with a holding temperature can be used or the temperature can just be allowed to drop very slowly.

GLAZE EXPERIMENTS

Techniques and Approaches

Adelaide Robineau had an avid curiosity which led to considerable glaze research, especially in the crystalline category, developing her own formulae and perfecting the recipes of others. Although she started out with some crystalline glazes provided by other potters, they were frequently European, and the formulae often called for materials not readily available in America. This required her to find substitute materials which in turn often necessitated a change in the glaze formula. The extent of her experiments is illustrated by the fact that one of her notebooks contains several examples of more than 100 variations for a single glaze. Despite her lack of technical training (as pointed out by Charles Binns in his essay "Refined by Fire"), she eventually achieved an uncommon degree of technical proficiency and was able to carry out experiments of a high technical caliber.

Her approach was usually one of "try it and see what happens," rather than an analytical and scientific one. But, she had a seeking and questioning mind which is seen in her correspondence with other potters in her field. This correspondence reveals that she often asked basic questions about glaze materials and how they were used.[6]

She seldom used the empirical formula in her glaze research, generally preferring to work directly with percentages of raw material. One of her methods was to vary the percentages of two ingredients in the formula, often raising the percentage of one while lowering the other. This could change the surface texture from rough to smooth, or could change it from shiny to matte, or the reverse. It could also change the size and shape of crystal growth.

At another time, she might begin with three base glazes[7] and combine them in different percentages to arrive at new recipes, then testing each one with combinations of metal oxides for a full range of colors. In one of her notebooks she lists one series of tests with 185 combinations of metal oxides in one base glaze.

Most of her glazes were in the cone 9 to 10 range (2280° to 2380°F), but it is probable that she did do some experimenting in cone 3 lead crystals and molybdenum crystals and cone 04 barium matte glazes. Formulae for these appear in her notebooks. There is a drawing of a pot with a cone 3 molybdenum glaze on it which she labeled "Failed" with a notation of another type of crystalline glaze to be tried over it. Usually she would raise the maturing temperature of those glazes to the cone 9 range.

It is the nature of most crystalline glazes to exhibit considerable flow during the firing. Because of this potential problem, which could cause the pot to become

fused to the kiln shelf, Robineau placed these pots on pedestals made of clay. These were coated with a mixture of equal parts of calcined alumina hydrate and kaolin. This was used as a parting agent so the pedestal could be knocked off the foot of each pot after the firing, without damaging the pot. Even then, she often had to grind excess glaze from the bottom of the pot.

RAW MATERIALS USED IN GLAZES

Robineau used a wide variety of glaze materials, sometimes testing some of the less frequently used ones. Her notes indicate she often considered trying two or three different forms of a chemical. For instance, when she wanted to use potash she might consider potassium carbonate, potassium nitrate, potassium chromate, or arsenate of potash. In a letter to her, Rhead cautioned her about arsenate of potash, saying the arsenate was poisonous and the potassium could be obtained in a safer form. Her desire to experiment is also revealed in her use of ground-up calcined plaster molds, chalk, or powdered marble for a source of calcium carbonate instead of the material whiting.

Experimental[8]

Lists of materials to try
Bismuth—Sulfates—Cryolite
Wolfram—Yttrim—Mica
Dolomic—Borate de No.—Carb. Bar.
Acetates—(illegible)—Molybdic
Vanadium—Tungstic de Sonde
Arsenate of potash—Chromate of zinc
Molybdenum
Cryolite is used to give milky
Mica—Moscovite [illegible]—Biotite

Phosphates
146 potassium nitrate = 100 carbonate potassium. Substitute chromate of zinc in glazes with tin oxide.—for oxide [of] zinc is likely to give pinkish color. If using borax or soda, chromate of zinc is liable to make yellows or greenish tones. Calcine zinc oxide for use below Cone 1.

A few of her glazes contained stains, singly or in combination with metal oxides to obtain certain colors. She used F. H. Rhead's recipes for stains, and those of H. A. Segers which were fritted[9] in a reducing atmosphere. Robineau had a small frit kiln and most likely made some of her own. Rhead suggested that she use a

pink stain in the clay body with a clear crystalline glaze over it.[10] During the firing the glaze would take up the stain from the body, producing a very soft delicate color. This may have been one of the methods she used for the very pale pink crystals. Many of her glazes were simple combinations of four to eight raw materials used in their raw state. Others were either partially or completely fritted before they were applied to the pot.

MULTIPLE GLAZES

It was common practice for Robineau to use multiple glazes on her porcelains. Some of her crystalline glazes were placed over a "ground glaze"[11] which was noncrystalline in structure, but of a carefully selected harmonious color. This was done to retard the excess flow which crystalline glazes have, and in some instances it was felt that better crystals were produced in this manner. The ground glaze was fired first, then the crystalline glaze was applied thicker at the top and stopping about an inch from the bottom to leave room for excess flow. During the second firing the crystalline glaze would spread and settle into the ground glaze. The Royal Factory in Copenhagen practiced this method in the late 1800s, and F. H. Rhead mentioned it to her in one of his letters.[12]

An interesting example is a carved vase in the collection of the Everson Museum of Art (Color plate **8**). It is dated 1910 U.C., which signifies that it was made at University City. The ground glaze is a pink orange which probably results from a chrome aluminum stain or from potassium bichromate with tin in the glaze.[13] It appears that the crystalline glaze is a zinc silicate without any color added to it. This has picked up the color from the ground glaze, turning it to a soft, shiny, transparent pink with lighter lavender pink crystals. The second glaze has not flowed quite to the bottom of the pot.

She also sometimes applied one crystalline glaze over another, the first sometimes being fired first and sometimes left raw or unfired. Unique and interesting colors were achieved this way. This may account for some of the crystals that are a very pale color on the shoulder of a pot, shading to much darker or different colors toward the bottom.

Plate 118, in the collection of the Cranbrook Academy of Art/Museum, is a very beautiful example of one crystalline glaze over another. The lip, neck, and shoulder of the pot are covered with well-formed golden peach crystal clusters shading into a pale blue green on the body. The golden peach crystals resulted from one glaze formula, while the pale blue green crystal resulted from another. The small amount of matrix visible has metallic golden luster. It appears to be a zinc

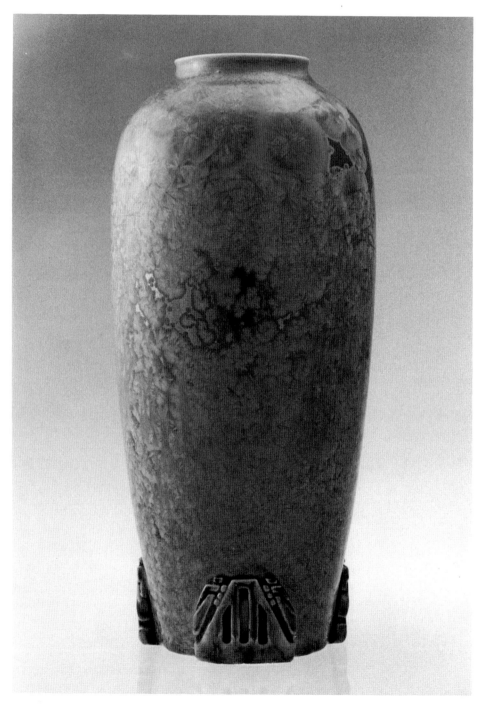

118. Vase, n.d. Cranbrook Academy of Art/Museum, 1944.135 (see Inventory 138).
Photograph by Jim Abbott.

silicate glaze with sodium, the colors resulting from the presence of titanium or rutile, copper, and possibly a little manganese, and the luster from tungsten. There are four carved areas at the foot of the pot which form an interesting base.

Occasionally, Robineau applied a crystalline glaze over a noncrystalline reduction glaze. A fine example of this is also to be found at Cranbrook (Plate 119). It is a small vase (8 cm.) with a copper red reduction glaze which was reduced, then reoxidized, possibly during the second firing, to a dark green except under the lip. It has a tiny crackle which is stained black. A crystalline glaze was placed over this and then fired in an oxidizing fire, producing a few blue crystals scattered on the surface of the glaze.

A nonperfect pot rarely left the studio. If Robineau didn't like the glaze, but felt the shape was redeemable, she would reglaze it. Sometimes with the same glaze, but often with one of another composition, and refire it. Some pieces are reported to have as many as six to seven glazes on them.[14] Undoubtedly, many of her unusual colors and interesting textures were achieved in this manner.

TYPES OF CRYSTALLINE GLAZES BY ROBINEAU

Robineau's crystalline glazes fall into several categories, zinc silicate, flowing matte, fixed matte, and molybdenum. The zinc silicate is probably the most popular and easiest to use. Many of these base glazes were combinations of feldspar whiting, kaolin, flint, and zinc. Zinc silicate is the crystallizing agent. Often rutile or titanium is included which also promotes the crystallization process and influences the colors which the metal oxides produce.

These glazes often produced large crystal clusters or "sunbursts" scattered across the surface. At other times, the crystals would overlap, completely covering the surface with no matrix visible at all. Sometimes the crystals have forms like ferns or flowers with feathery edges, at times they take on the form of thin rods. The surface usually has a shiny or satin matrix which can be translucent or opaque. Robineau occasionally added a small percentage of tungsten, and/or molybdenum, to her glazes which gave an iridescent luster to the matrix.

Color plate 11, a vase dated 1905 in the collection of the Everson Museum of Art, is a good example of crystals overlapping and completely covering the entire surface, with the exception of the lip of the pot. (Often the lip does not show crystal development because the glaze has run too thin for them to form). The crystals are in the shape of rods ($1/16$ to $1/4$ inch) overlapping and interlocking to form a pattern in a soft, pale, silvery blue green. The glaze probably gets its color from a small amount of cobalt and copper.

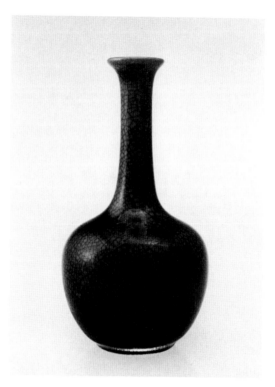

119. Vase, n.d. Cranbrook Academy of Art/Museum, 1944.140 (see Inventory *142*). Photograph by Jim Abbott.

A miniature vase (Plate 120), also at the Everson, bears a zinc silicate glaze with a matrix of mottled light green, grey, and green yellow, with a metallic luster. Very minute secondary crystals of different colors scattered across the surface account for the mottled look. A high percentage of metal oxides and tungsten account for the luster. The ⅜-inch crystal clusters are a metallic grey green and have formed feathery edges. The glaze colorants may be copper, nickel, uranium, and rutile.

One of the zinc silicate base glazes from Sèvres which she used was a combination of two frits, each containing potassium carbonate, zinc oxide, and flint.

Sèvres Frit[15]	#1	#2	Combination A	
dry carbonate of potash	138	69	Frit #1	85%
Zinc Oxide	162	202.5	Frit #2	15%
Silicate	360	350		

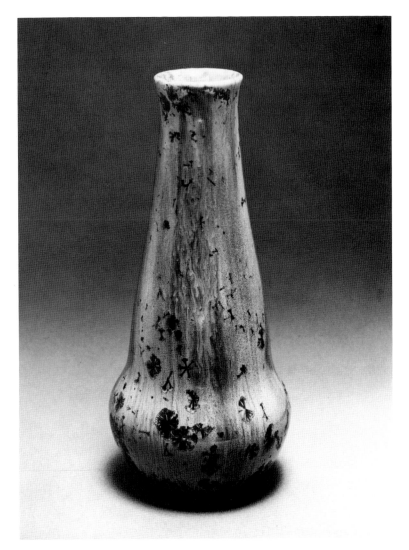

120. Vase, n.d. Everson Museum of Art, 30.4.80 (see Inventory *250*). Photograph by Jane Courtney Frisse.

Taking this glaze, she tested eighty-three combinations of metal oxides for color variations.

She also received a number of formulae for the zinc silicate crystal glaze from F. H. Rhead. These were often composed of feldspar, whiting, zinc oxide, flint, kaolin, and titanium or rutile and often a frit.

Rhead's Crystalline Glaze A-206[16]

Feldspar	400
Flint	300
Whiting	200
Kaolin	75
Zinc	400
Frit #2	50
Rutile	125
Tungsten	160
Cobalt	25
Manganese	10

Rhead used frits of his own composition, those of Hermann A. Seger, the European potter, and he also fritted some of Doat's crystalline base glazes to be used as a portion of another formula. Evidently, using Doat's glaze as a frit for a portion of her glaze was successful, because some of Robineau's recipes also contain Doat's frits. One of them was composed of pegmatite (cornish stone), flint, zinc oxide, barium carbonate, fused borax, and sodium carbonate. In a 1928 letter to Robineau, Rhead commented:

> In regard to the Doat type of crystals, I found that they would often come out with dry surfaces both from cone 8 to 11—unless the pieces were reglazed and refired. I overcame this by using the Doat type simply as a frit and loading the glaze with spar, clay, whiting, etc. with the addition of enough zinc [one of the crystallizing agents] to balance or insure crystals ... My work with the Doat type crystals convinced me that they were uncertain so far as crystallization was concerned and that there was not enough variety in color or texture (to say nothing of possible variations in crystalline formation). By adopting the Doat type simply as a frit and using a glaze of the general type 102 (and the others given) you have a result you can depend upon with a wide range of interesting effects not before obtained.[17]

FLOWING MATTE GLAZES

Robineau worked with microcrystalline glazes which she called flowing mattes. These consisted of feldspar, kaolin, flint, chalk, and rutile or titanium. Sometimes chalk was used in place of whiting, which is calcium carbonate.

Flowing Matte —Doat Sèvres[18]

Brown —A

Spar	53	
Flint	14	light greyish brown
Kaolin	10	sometimes crystallizes
Chalk	26	or has bluish streaks
Rutile	10	
Iron	3	

Unlike the zinc silicate glaze, these did not contain any zinc. The titanium or rutile was the crystallizing agent. They produced a soft satin matte surface that was very pleasant to the eye and the hand. Generally, the glaze would flow beyond the bottom of the pot.

One excellent example is found in the Everson collection. This is a carved monogram vase which is dated 1905 (Color plate **6**). The top half and the bottom are probably glazed with the same base glaze, but with different oxides in each half to produce color. The top half is a soft satin matte in grey ivory. There are a few half-inch crystals scattered on the surface. The bottom is a darker beige shading into reddish brown. It is a titanium silicate microcrystalline glaze colored with rutile and iron.

FIXED MATTE GLAZES

A third type of glaze she called fixed mattes. They were nonflowing as opposed to the flowing mattes. These were Golfe formulae and consisted of fluorspar, kaolin, feldspar, aluminum hydrate, and titanium. The titanium was the crystallizing agent.

Fixed Matte —Golfe[19]
"30" Mixture

Fluorspar	100	
Kaolin	100	
Feldspar	100	light red brown
Aluminum Hydrate	20	with darker crystals
Rutile	30	greyish darker outline
Iron	3%	
Manganese	2%	

There were two variations of this base glaze and forty different combinations of metal oxides for each one for color variations listed in Robineau's notes. These were also microcrystalline in structure, having a soft satin matte feel to them. Some of them produced a few larger crystals scattered across the surface.

MOLYBDENUM CRYSTALLINE GLAZES

Robineau was always attempting to achieve unique and interesting crystalline effects. This led to experiments with molybdenum. Rhead gave her some cone 3 molybdenum crystal glazes and suggestions on how to raise the maturing temperature to cone 9. This probably formed the basis of some of the experiments in the molybdenum glazes.

The molybdenum crystal is very elusive, less predictable, and more difficult to achieve than most other types of crystals. It differs from the zinc silicate and titanium crystal in that it is usually quite small and shaped like a rectangle, star, or diamond. In multitude they are double refracting, separating light into different colored rays. They seem to float on the surface of the glaze and display all the iridescent colors of the rainbow as light plays over them. The matrix is usually very lustrous and opaque. Often the crystals are very subtle only being seen when the pot is tipped to catch the light.

Robineau's base glaze for the molybdenum crystals usually contained some zinc and frequently some rutile and tungsten, the latter adding to the luster in the matrix. Metal oxides were sometimes added to give color to the matrix. A typical one is:

#PE[20]

Feldspar	20.0
Flint	7.5
Whiting	7.5
Kaolin	2.5
Rutile	5.0
Frit #1	25.0
Zinc	10.0
Tungsten	7.5
Molybdenum	5.0
Pink stain #1603D	

A good example is another vase in the Everson collection (Color plate **12**), dated 1912. The matrix is semimatte, white with a silvery iridescence. There

are small molybdenum crystals with four points scattered on one side of the pot. They are very iridescent, showing all the colors of the rainbow. The fact that they only grew on one side is because the growth of the molybdenum crystal is very sensitive to the proper temperature. It is not unusual for a pot to be hotter on one side than another during the firing.

Another example is a miniature vase (Plate 121) dated 1927, also at the Everson. This molybdenum glaze has a soft iridescent white metallic luster. There are scattered molybdenum crystals, looking almost like iridescent spots floating on the surface. Very small pale green secondary crystals are also scattered across the surface. The green could be the result of a small amount of copper.

UNUSUAL CRYSTALLINE GLAZES

Red and Pink Crystals

An interesting area of crystal research that Robineau explored was the development of red crystals for cone 9 porcelains. These have been reported by some authorities on crystalline glazes to be very difficult if not impossible to achieve. Very few have been found in other collections. The fact remains that Robineau did produce some very fine colors ranging from pale pinks and lavender to a deep dark red rose with very good crystalline formations.

The approach falls into two categories: the use of copper in a reducing atmosphere, and the use of stains in an oxidizing atmosphere. Both methods produce problems for the potter.

It has been generally assumed that only an oxidizing atmosphere can be used in firing crystalline glazes. Herbert H. Sanders comments: "Since a reducing atmosphere inhibits crystal formation, avoid using reduction when firing crystalline glazes."[21]

Taxile Doat makes this comment: "The presence of zinc oxide in this [crystal] glaze makes it necessary to have a strictly oxidizing atmosphere."[22]

In spite of these comments, which typify the attitude toward reduction red crystals, there is a Robineau porcelain in the Cranbrook collection which may well be a copper reduction. It is a miniature bottle (Plate 122). There are well-developed dark pink and red crystal clusters scattered on a mottled red and green matrix with a metallic luster. The matrix appears to be a copper red glaze fired in a reducing atmosphere and then partially reoxidized to green in some areas. It has the white lip which many copper red pots show. There is a picture of a vase by Taxile

121. Vase, 1927. Everson Museum of Art, 30.4.57 (see Inventory *228*). Photograph by Jane Courtney Frisse.

Doat in his book *Grand Feu Ceramics* with the following description: "Flamé copper vase, shading from black to white and having at base a band of rich crystals."[23]

This is interesting because this glaze does contain zinc, although the amount is small. Could Robineau have taken this glaze or a variation of it and achieved a copper red crystal in reduction?

Taxile Doat's Formula for the Red Copper Glaze[24]
The following should be thoroughly mixed and fused:
Pegmatite (feldspar)	180.0
Quartzy sand of Fontainebleu	126.0

Zinc oxide	15.5
Carbonate of barium	36.0
Fused borax	45.0
Dry carbonate of sodium	16.5
After fusion, the glass thus obtained is pulverized and colored as follows:	
Ground glass	10.0
Oxalate of copper	0.2
Calcined tin oxide	0.1

Robineau recorded a different approach: "The finest crystals come from titanic acid in a zinc ferrous glaze. When necessary to work with a reducing fire the zinc oxide is replaced by a corresponding quantity of magnesia."[25]

There are very few other comments found in her notebooks on obtaining crystals in reduction.

The other approach is to use stains in a base glaze for special colors, since no one metal oxide will impart a red color to crystals in a porcelain glaze. It is evident that she experimented with stains because references are found in her notes. These also produce obstacles for the potter. Many of the stains of that period were not as stable at high porcelain temperatures as they are today. There is the possibility that they could fade appreciably or completely burn out at porcelain temperatures. A crystalline glaze also has the tendency to separate the various metals used in stains, causing one color to go into the matrix while another colors the crystal. J. W. Melor comments: "Chrome tin pinks and reds can be damaged by the presence of zinc; also reducing conditions are lethal and the red can be completely destroyed."[26]

The presence of a high percentage of zinc is usually needed for the zinc silicate crystal. One of the Sèvres glazes in her notebook shows 10 percent of a chrome tin pink. Interestingly, that base glaze is high in zinc. Several of her glazes also contain pink oxide #1603D.

Cullen Parmelee has this to say about another type of pink stain containing manganese and alumina: "To get a clean color, a high alumina, zinc free glaze is required."[27] Generally, a high percentage of alumina in a glaze inhibits the formation of crystals.

In the face of many negative attitudes about the possibility of obtaining red crystals, Robineau achieved one of the most beautiful and exciting deep red rose crystals on a jar in the collection of Ohio State University (Plate 123). It has several carved ridges on the neck that are stained matte black. The matrix of the glaze is mottled grey green and covered very thickly with tiny secondary crystals in a rose pink so that the matrix appears mostly rose pink. The red rose crystals are of a good size and very well developed. There are both clusters and rods

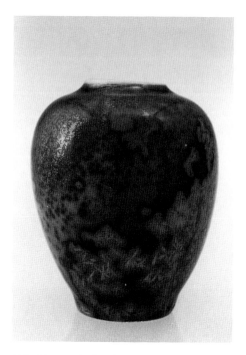

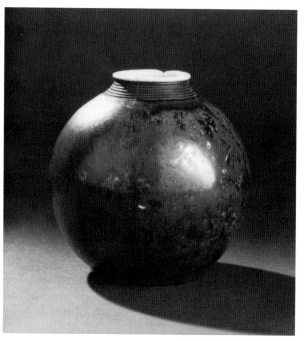

122. Vase, n.d. Cranbrook Academy of
Art/Museum, 1975.1 (see Inventory
163). Photograph by Jim Abbott.

123. Vase, 1919. Ohio State University, CA-62 (see
Inventory 335). Photograph by Roger Phillips.

having very feathery edges. The centers of the crystals and rods are colored a dark
grey. It is a very successful combination of crystal shape and colors. The coloring
agent for this pot remains questionable.

Ohio State also has in its collection a miniature vase (Plate 124) on which
the matrix is a satin matte, reddish maroon on one side, shading to almost black on
the other side. The crystals are round clusters shading from dark maroon to almost a
reddish black with darker edges.

The Everson collection includes a miniature vase (Plate 125) with a
crystalline glaze of a shiny dusty rose, with a one-quarter inch band of blue on the
rim. It is covered with very thin silvery rose pink needlelike crystals starting to form
into clusters. The vase probably received its color from the presence of stains of
manganese in the glaze. Another rather unique porcelain in the Everson collection
is a vase dated 1927 (Plate 126). This crystalline glaze has a shiny medium purple
matrix with tiny purple needlelike crystals going into clusters.

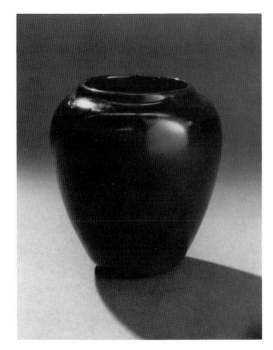

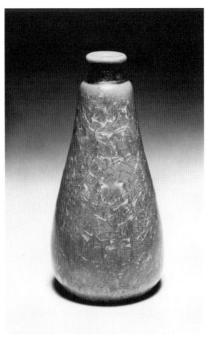

124. Vase, n.d. Ohio State University, CA-46 (see Inventory *319*). Photograph by Roger Phillips.

125. Miniature bottle, 1927. Everson Museum of Art, 30.4.70 (see Inventory *242*). Photograph by Jane Courtney Frisse.

Black Crystals

Another difficult effect that Robineau was successful in achieving was the development of a black crystal on a black matrix. To get a good black the glaze must have a high percentage of metal oxides or be colored with a black stain (which contains a combination of metal oxides). Again, similar obstacles face the potter. A very high percentage of metal oxides in a crystalline glaze can inhibit the formation of crystals. The other problem is that the stain can separate into different colors, some going into the matrix and the others into the crystals.

At Ohio State University there are three test vases with black crystals on a black matrix. Test vase No. CA-18 (Plate 127, second from left) has a shiny black opaque matrix with very tiny, perfectly formed dull matte black crystalline clusters. They are depressed like little craters into the glaze surface. This is unusual because crystals are usually on the surfaces or even slightly raised above the matrix. Test

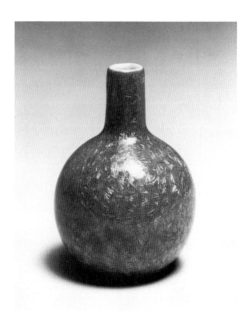

126. Vase, 1927. Everson Museum of Art, 30.4.66 (see Inventory *237*). Photograph by Jane Courtney Frisse.

vase No. CA-21 (Plate 128, left) and No. CA-22 (Plate 128, second from the left) are just the opposite. They have a satin matte black matrix with very tiny shiny crystals. All three are fine examples of coal black crystals on a black matrix.

Adelaide Robineau was a unique woman. During an era when most women were confined to domestic duties, she was able to pursue her own career with total support and constant encouragement from her husband. She obtained recognition for her superb pottery in the United States and abroad, winning many awards. Through her inquiring mind, indomitable perseverance, and unlimited patience, she developed a wide variety of some of the most interesting and beautiful glazes ever to be seen. We will benefit in many ways from her dedication for many generations to come.

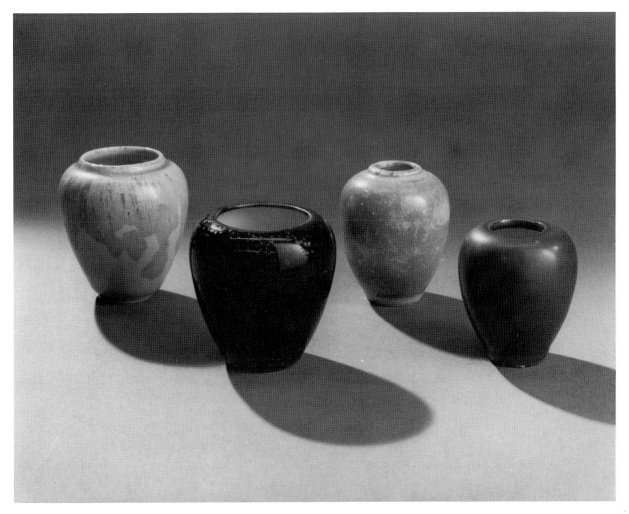

127. Vases, n.d. Ohio State University, from left, CA-17, CA-18, CA-19, CA-20 (see Inventory 292–295).
Photograph by Roger Phillips.

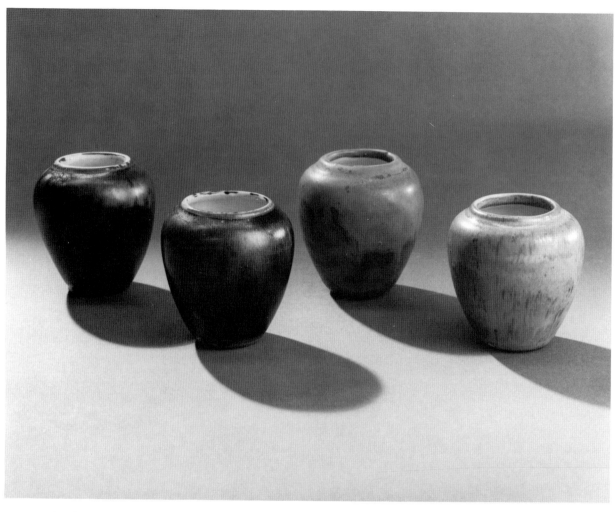

128. Vases, n.d. Ohio State University, from left, CA-21, CA-22, CA-23, CA-24 (see Inventory 296–299).
Photograph by Roger Phillips.

Inventory of Robineau's Works in Public Collections in the United States

LESLIE GORMAN

ATASCADERO HISTORICAL SOCIETY MUSEUM

Atascadero, California

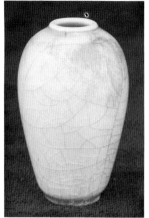

129. **Miniature Vase, ca. 1911**
Porcelain, with pale green and rose-colored glazes; white glaze on rim and interior
HEIGHT: 3¼"
INSCRIPTION: on underside, excised cypher of conjoined *AR*

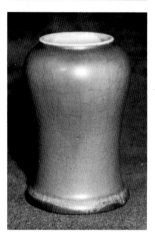

130. **Miniature Vase, ca. 1911**
Porcelain, with dark red and turquoise glazes
HEIGHT: 3½"
INSCRIPTION: on underside, excised cypher of conjoined *AR*

THE ART INSTITUTE OF CHICAGO

Chicago, Illinois

131. **Miniature Vase, n.d.**
Porcelain, with dark brown, buff, and blue glazes, buff colored crackle glaze on interior
HEIGHT: 1⅝"
INSCRIPTION: on underside, excised cypher of conjoined *AR* in a circle; incised *28*
Gift of Mr. and Mrs. William G. Swartchild, Jr. 1974.581

CRANBROOK ACADEMY OF ART/MUSEUM

Bloomfield Hills, Michigan

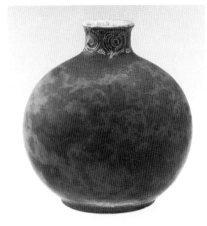

132. Vase, 1926
Porcelain, with incised decoration; blue glaze; mottled grey and green crystalline glaze
HEIGHT: 6⅜" (16.4 cm.)
INSCRIPTION: on underside, excised cypher of conjoined *AR* in a circle; incised *1926*
Gift of George G. Booth.
1929.124
Photograph by Jim Abbott.

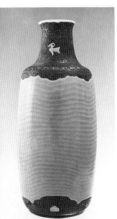

133. Cloudland Vase, 1914
Porcelain, with incised and excised decoration of clouds and birds; glossy grey glaze; mahogany brown semimatte glaze
HEIGHT: 12" (30.48 cm.)
INSCRIPTION: on underside, excised cypher of conjoined *AR* in a circle; incised *Cloud-land; E; 1914*
Gift of George G. Booth.
1944.131
Photograph by Jim Abbott.

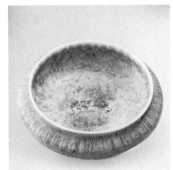

134. Bowl, 1915
Porcelain, with incised decoration; light green and grey matte glazes on exterior; yellow, green, and beige crystalline glazes on interior
DIAMETER: 5⅝" (14.3 cm.)
INSCRIPTION: on underside, excised cypher of conjoined *AR* in a circle; incised *1915*
Gift of George G. Booth.
1944.132
Photograph by Jim Abbott.

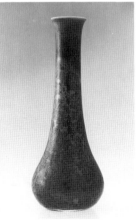

135. Vase, 1909
Porcelain, with brown and bright green crystalline glazes; emerald green crystals on metallic luster
HEIGHT: 8½" (21.3 cm.)
INSCRIPTION: on underside, excised cypher of conjoined *AR* in a circle; incised *674; 1909*
Gift of George G. Booth.
1944.133
Photograph by Jim Abbott.

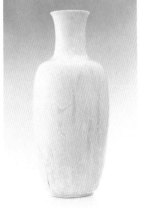

136. Vase, 1912
Porcelain, with pale grey green, pale mauve, and cream colored crystalline glazes
HEIGHT: 8¼" (21.0 cm.)
INSCRIPTION: on underside, excised cypher of conjoined *AR* in a circle; incised *1912*
Gift of George G. Booth.
1944.134
Photograph by Jim Abbott.

161

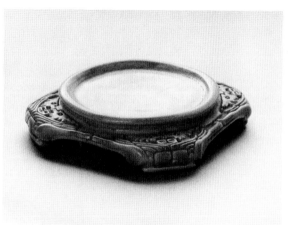

137. **Base, 1912** (base for 1944.134, plate 147)
Porcelain, with carved decoration; ivory matte glaze; four carved feet
DIAMETER: 3¼″ (8.3 cm.)
INSCRIPTION: on underside, excised cypher of conjoined *AR* in a circle; incised *1912; 9*
Gift of George G. Booth. 1975.9
Photograph by Jack Kausch.

138. **Vase, n.d.**
Porcelain, with incised decoration in basal motif; yellow ochre and silver grey crystalline glazes; three carved feet
HEIGHT: 8¼″ (21.0 cm.)
INSCRIPTION: on underside, excised cypher of conjoined *AR* in a circle; incised *667*
Gift of George G. Booth.
1944.135
(Plate 118)

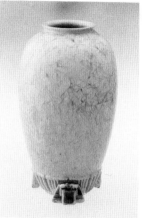

139. **Vase, 1909**
Porcelain, with excised decoration; grey white crystalline glaze; green and ochre glazes; three carved feet
HEIGHT: 6¼″ (15.9 cm.)
INSCRIPTION: on underside, excised cypher of conjoined *AR* in a circle; incised *1909; 669*
Gift of George G. Booth.
1944.136
Photograph by Jim Abbott.

140. **Jar with Lid, n.d.**
Porcelain, with light green crystalline glaze; buff colored matte, and deep rose glazes; lid with carved decoration
HEIGHT: (with lid): 2⅝″ (6.7 cm.)
INSCRIPTION: on underside, incised *I-X; V; I-X* in a circle; on lid, excised cypher of conjoined *AR* in a circle
Gift of George G. Booth.
1944.137
Photograph by Jim Abbott.

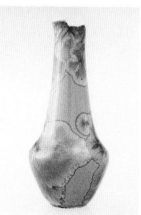

141. **Miniature Vase, n.d.**
Porcelain, with yellow ochre, green, and beige crystalline glazes
HEIGHT: 3″ (7.5 cm.)
INSCRIPTION: on underside, incised *R*
Gift of George G. Booth .
1944.139
Photograph by Jim Abbott.

142. **Miniature Vase, n.d.**
Porcelain, with dark green glaze and streaks of black; iridescent blue crystalline glaze; crackled
HEIGHT: 3⅛″ (8.0 cm.)
INSCRIPTION: on underside, excised cypher of conjoined *AR* in a circle
Gift of George G. Booth.
1944.140
(Plate 119)

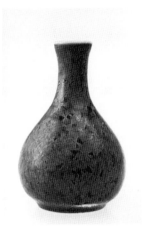

143. Miniature Vase, 1919
Porcelain, with blue black crystalline glaze
HEIGHT: 2¾″ (7.0 cm.)
INSCRIPTION: on underside, excised cypher of conjoined *AR* in a circle; incised *1919*
Gift of George G. Booth.
1944.141
Photograph by Jim Abbott.

144. Miniature Vase, n.d.
Porcelain, with white and light blue glazes
HEIGHT: 2¼″ (6.0 cm.)
INSCRIPTION: on underside, excised cypher of conjoined *AR* in a circle
Gift of George G. Booth.
1944.142
Photograph by Jim Abbott.

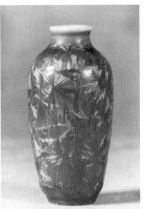

145. Miniature Vase, n.d.
Porcelain, with ultramarine blue crystalline glaze
HEIGHT: 2⅛″ (5.3 cm.)
INSCRIPTION: on underside, excised cypher of conjoined *AR* in a circle
Gift of George G. Booth.
1944.143
Photograph by Jim Abbott.

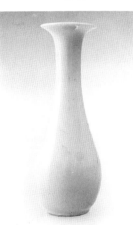

146. Miniature Vase, n.d.
Porcelain, with iridescent white crystalline glaze
HEIGHT: 3⅛″ (8.0 cm.)
INSCRIPTION: on underside, excised cypher of conjoined *AR* in a circle
Gift of George G. Booth.
1944.144
Photograph by Jim Abbott.

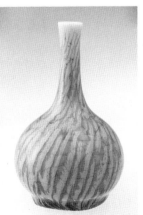

147. Small Vase, n.d.
Porcelain, with light green *craquelé* glaze; streaks of white overglaze
HEIGHT: 4½″ (11.5 cm.)
INSCRIPTION: on underside, excised cypher of conjoined *AR* in a circle
Gift of George G. Booth.
1944.145
Photograph by Jim Abbott.

148. Miniature Jar with Lid, 1913
Porcelain, with incised decoration; light green glaze with large crackle of purple red; lid with carved decoration in grape motif
HEIGHT: 3½″ (8.5 cm.)
INSCRIPTION: on underside, excised cypher of conjoined *AR* in a circle; incised *5; 1913*; on lid, excised cypher of conjoined *AR* in a circle
Gift of George G. Booth.
1944.146
Photograph by Jim Abbott.

149. **Miniature Vase, 1915**
Porcelain, with incised decoration; brown matte, pale blue, and pale green glazes
HEIGHT: 2½″ (6.3 cm.)
INSCRIPTION: on underside, excised cypher of conjoined *AR* in a circle; incised *1915*
Gift of George G. Booth.
1944.147
Photograph by Jim Abbott.

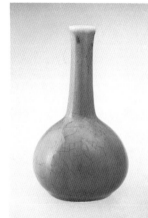

150. **Small Vase, 1915**
Porcelain, with light green blue crackle glaze
HEIGHT: 4⅝″ (11.75 cm.)
INSCRIPTION: on underside, excised cypher of conjoined *AR* in a circle; incised *1915*
Gift of George G. Booth.
1944.148
Photograph by Jim Abbott.

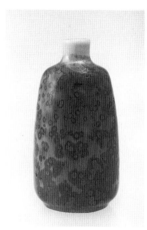

151. **Miniature Vase, 1915**
Porcelain, with mottled green blue glaze
HEIGHT: 2¼″ (5.5 cm.)
INSCRIPTION: on underside, excised cypher of conjoined *AR* in a circle; incised *1915*
Gift of George G. Booth.
1944.149

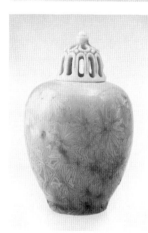

152. **Miniature Vase, with Lid, 1912**
Porcelain, with aqua and green crystalline glaze; caramel colored and white glazes; lid with carved decoration
HEIGHT: 2¾″ (6.8 cm.)
INSCRIPTION: on underside, incised cypher of conjoined *AR* in a circle; *MOL 10%/COP 2%*; on lid, incised *1912; 2*
Gift of George G. Booth.
1944.150
Photograph by Jim Abbott.

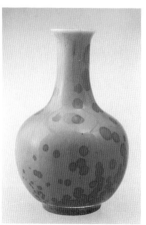

153. **Miniature Vase, n.d.**
Porcelain, with tan pink, and blue glazes
HEIGHT: 3¼″ (8.3 cm.)
INSCRIPTION: on underside, excised cypher of conjoined *AR* in a circle
Gift of George G. Booth.
1944.152
Photograph by Jim Abbott.

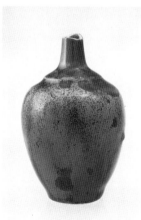

154. **Small Vase, n.d.**
Porcelain, with olive and light green crystalline glaze
HEIGHT: 4¾″ (12.0 cm.)
INSCRIPTION: on underside, incised cypher of conjoined *AR* in a circle
Gift of George G. Booth.
1944.153
Photograph by Jim Abbott.

155. Small Bowl (Eggshell Coupe), n.d.
Eggshell porcelain, with incised and perforated floral decoration; translucent white glaze
DIAMETER: 3¾″ (9.5 cm.)
INSCRIPTION: on underside, excised cypher of conjoined *AR* in a circle
Gift of George G. Booth.
1944.154

(Plate 23)

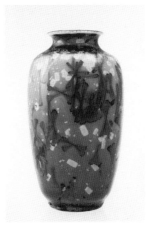

156. Miniature Vase, n.d.
Porcelain, with brown, blue, and yellow crystalline glazes; caramel colored glaze
HEIGHT: 3¾″ (9.5 cm.)
INSCRIPTION: on underside, excised cypher of conjoined *AR* in a circle; incised *312*
Gift of George G. Booth.
1944.155
Photograph by Jim Abbott.

157. Small Vase, 1920
Porcelain, with pale turquoise and pale grey crackle glazes
HEIGHT: 4¾″ (12.0 cm.)
INSCRIPTION: on underside, excised cypher of conjoined *AR* in a circle; incised *5; 1920*
Gift of George G. Booth.
1955.13
Photograph by Jim Abbott.

158. Small Vase, n.d.
Porcelain, with grey, white, and yellow crystalline glazes
HEIGHT: 4¼″ (10.8 cm.)
INSCRIPTION: on underside, excised cypher of conjoined *AR*
Gift of George G. Booth.
1955.13a
Photograph by Jim Abbott.

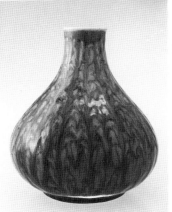

159. Small Vase, 1919
Porcelain, with flowing blue glaze
HEIGHT: 4¾″ (12.0 cm.)
INSCRIPTION: on underside, excised cypher of conjoined *AR*; incised *1919*
Gift of George G. Booth.
1955.13b
Photograph by Jim Abbott.

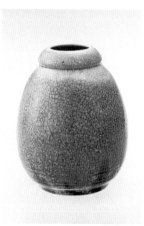

160. Small Vase, n.d.
Porcelain, with pale green matte glaze breaking to yellow glaze; crackled
HEIGHT: 4⅛″ (10.4 cm.)
INSCRIPTION: on underside, excised cypher of conjoined *AR* in a circle
Gift of George G. Booth.
1955.13c
Photograph by Jim Abbott.

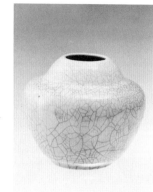

161. Miniature Vase, 1912
Porcelain, with white crackle glaze
HEIGHT: 3¼″ (8.3 cm.)
INSCRIPTION: on underside, excised cypher of conjoined *AR* in a circle; incised *1912*; on paper label (partially removed), inscribed *Art No. 18A*; *No. 137–99b*
Gift of George G. Booth.
1955.13d
Photograph by Jim Abbott.

162. Miniature Elephant Base, 1916
Porcelain; carved elephant with black semimatte glaze; originally the base for a small dish
HEIGHT: 1¾″ (4.5 cm.)
INSCRIPTION: on underside, incised cypher of conjoined *AR*; *1916* in a cloverleaf
Gift of George G. Booth.
1955.15
Photograph by Jim Abbott.

163. Miniature Vase, n.d.
Porcelain, with iridescent rose, aqua, green, blue, and gold crystalline glazes
HEIGHT: 2″ (5.0 cm.)
INSCRIPTION: on underside, incised cypher of conjoined *AR*; *Cop 7; Mang 1; Mol 2*
Gift of George G. Booth. 1975.1
(Plate 122)

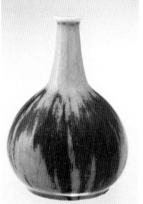

164. Miniature Vase, 1915
Porcelain, with grey green, and oxblood crackle glazes
HEIGHT: 3⅜″ (9.5 cm.)
INSCRIPTION: on underside, excised cypher of conjoined *AR* in a circle; incised *6; 1915*
Gift of George G. Booth. 1975.2
Photograph by Jim Abbott.

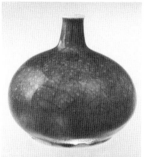

165. Miniature Vase, 1915
Porcelain, with smokey rose, and light green crackle glazes
HEIGHT: 2¾″ (7.0 cm.)
INSCRIPTION: on underside, excised cypher of conjoined *AR* in a circle; incised *1915*
Gift of George G. Booth. 1975.3
Photograph by Jim Abbott.

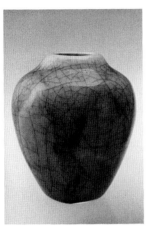

166. **Miniature Vase, 1915**
Porcelain, with flowing pale green glaze; pale tan, rose, and grey amber glazes; crackled
HEIGHT: 3¾″ (9.5 cm.)
INSCRIPTION: on underside, incised cypher of conjoined AR; 2; 1915
Gift of George G. Booth. 1975.4
Photograph by Jim Abbott.

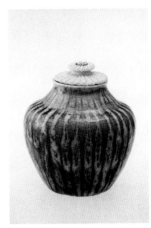

167. **Miniature Jar with Lid, 1912**
Porcelain, with incised floral decoration; apple green, and aqua glazes; lid with excised decoration in same motif
HEIGHT: 2⅞″ (7.3 cm.)
INSCRIPTION: on underside, excised cypher of conjoined AR in a circle; incised 1912; on lid, excised cypher of conjoined AR
Gift of George G. Booth. 1975.5
Photograph by Jim Abbott.

168. **Small Vase, 1912**
Porcelain, with white and rose lavender crackle glazes
HEIGHT: 4¼″ (10.8 cm.)
INSCRIPTION: on underside, excised cypher of conjoined AR in a circle; incised 1912
Gift of George G. Booth. 1975.6
Photograph by Jim Abbott.

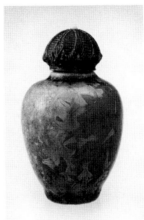

169. **Miniature Jar with Lid, possibly 1913**
Porcelain, with deep mauve crystalline glaze; lid with carved decoration, and brown matte glaze
HEIGHT: 2⅞″ (7.3 cm.)
INSCRIPTION: on underside, incised 13
Gift of George G. Booth. 1975.7
Photograph by Jim Abbott.

170. **Small Vase, 1917**
Porcelain, with grey blue crackle glaze
HEIGHT: 4¾″ (12.0 cm.)
INSCRIPTION: on underside, excised cypher of conjoined AR in a circle; incised 1917
Gift of George G. Booth. 1975.8
Photograph by Jim Abbott.

171. **Base, 1916**
Porcelain, with incised decoration; dark black matte glaze
DIAMETER: 2¾″ (7.0 cm.)
INSCRIPTION: on underside, excised cypher of conjoined AR; incised 1916
Gift of George G. Booth.
1975.10
Photograph by Jack Kausch.

167

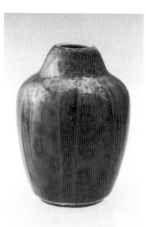

172. **Vase, 1912**
Porcelain, with blue crystalline glaze; streaks of lighter blue glaze; iridescent metallic spotting
HEIGHT: 5″ (12.7 cm.)
INSCRIPTION: on underside, excised cypher of conjoined *AR* in a circle; incised *1912*
Cranbrook Educational Community, Gift of George G. Booth.
CEC 254
Photograph by Jim Abbott.

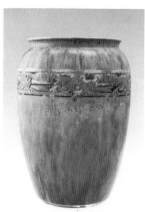

173. **Vase, 1906**
Porcelain, with incised frog decoration; brown and green glazes
HEIGHT: 9″ (22.8 cm.)
INSCRIPTION: on underside, excised cypher of conjoined *AR* in a circle; incised *1906; 553*
Cranbrook Educational Community, Gift of George G. Booth.
CEC 16
Photograph by Jim Abbott.

THE DETROIT INSTITUTE
OF ARTS

Detroit, Michigan

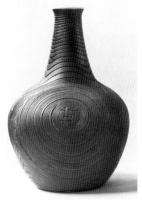

174. **Wind (Indian Vase), 1913**
Porcelain, with excised decoration; black bronze glaze
HEIGHT: 14½″ (36.9 cm.)
INSCRIPTION: on underside, excised cypher of conjoined *AR* in a circle; incised *1913; B*
Gift of George G. Booth. 19.101
Courtesy of The Detroit Institute of Arts.

175. **Foxgloves Vase, 1914**
Porcelain, with excised floral decoration; pale blue and yellow glazes
HEIGHT: 8¼″ (21.0 cm.)
INSCRIPTION: on underside, excised cypher of conjoined *AR* in a circle; incised *1914; F*
Gift of George G. Booth. 19.108
Courtesy of The Detroit Institute of Arts.
(Color plate **9**)

176. **Vase, 1912**
Porcelain, with olive green crackle glaze; originally with stopper with excised crysanthemum decoration
HEIGHT: 4″ (10.1 cm.)
INSCRIPTION: on underside, excised cypher of conjoined *AR* in a circle; incised *1912*
Gift of George G. Booth. 19.109

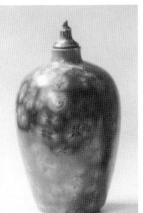

177. **Vase, 1914**
Porcelain, with brown crystalline glaze; stopper with carved decoration
HEIGHT: 6″ (15.2 cm.)
INSCRIPTION: on underside, excised cypher of conjoined *AR* in a circle; incised *1914*
Gift of George G. Booth. 19.110
Courtesy of The Detroit Institute of Arts.

178. **Vase, n.d.**
Porcelain, with dark blue crystalline glaze
HEIGHT: 4½″ (11.4 cm.)
INSCRIPTION: on underside, excised cypher of conjoined *AR* in a circle; incised *904* or *704; B ▽* or *B7*
Gift of George G. Booth. 19.113

169

179. **Vase, with Lid, n.d.**
Porcelain, with black matte glaze
HEIGHT: 2¼″ with lid (5.7 cm.)
INSCRIPTION: on underside, incised in black, cypher of conjoined AR in rectangle; (); on inside of lid, incised cypher of conjoined AR in circle
Gift of George G. Booth. 19.120

180. **Vase, with Lid, 1912**
Porcelain, with blue and green crackle glazes; black bronze lid with geometric decoration
HEIGHT: 5½″ with lid (14.0 cm.)
INSCRIPTION: on underside, excised cypher of conjoined AR in a circle; incised 1912; I; on inside of lid, incised cypher of conjoined AR
Gift of George G. Booth. 19.123

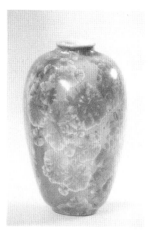

181. **Vase, 1912**
Porcelain, with green and blue crystalline glazes
HEIGHT: 4″ (10.1 cm.)
INSCRIPTION: on underside, excised cypher of conjoined AR in a circle; incised 1912
Gift of George G. Booth. 19.124
Courtesy of The Detroit Institute of Arts.

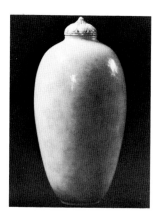

182. **Vase, with Cover, 1912**
Porcelain, with white crystalline glaze; lid with excised owl decoration; white, yellow, and light blue matte glazes
HEIGHT: 9¼″ with lid (23.0 cm.)
INSCRIPTION: on underside, excised cypher of conjoined AR in a circle; incised 29; 1912; on inside of lid, incised cypher
Gift of George G. Booth. 19.126
Courtesy of The Detroit Institute of Arts.

183. **Vase, n.d.**
Porcelain, with pale green glaze; streaks of red glaze
HEIGHT: 4½″ (11.5 cm.)
INSCRIPTION: on underside, excised cypher of conjoined AR
Gift of George G. Booth. 20.4

184. **Miniature Vase with Stand, 1912**
Porcelain, with oxblood and white glazes; black bronze stand
HEIGHT: 2½″ with stand (6.4 cm.)
INSCRIPTION: on underside, excised cypher of conjoined AR in circle; on top of stand, excised cypher of conjoined AR in a circle; incised 1912; 7
Gift of George G. Booth. 20.36

EVERSON MUSEUM OF ART

Syracuse, New York

185. **Viking Ship Vase, 1905**
Porcelain, with incised decoration of viking ships, and perforated porcelain ring base of the same motif; blue, green, and brown matte and semimatte glazes
HEIGHT: 7¼" (18.4 cm.)
INSCRIPTION: on underside, excised cypher of conjoined *AR* in a circle; incised *570*; on inside of ring base, incised cypher of conjoined *AR* in a rectangle
Museum Purchase. 16.4.1 a-b
(Color plate **4**, Plate 29)

186. **Crab Vase, 1908**
Porcelain, with incised decoration of crabs, and perforated porcelain ring base of the same motif; brown and tan flowing matte glazes; aqua, blue, and orange crystalline glazes
HEIGHT: 7⅜" (18.7 cm.)
INSCRIPTION: on underside, excised cypher of conjoined *AR* in a circle; incised *571*; on inside of ring base, incised cypher of conjoined *AR*
Museum Purchase. 16.4.2 a-b
(Plate 2)

187. **Poppy Vase, 1910**
Porcelain, with incised decoration of poppies; pale aqua, pink, and olive inlaid slip; white crystalline glaze
HEIGHT: 6¼" (15.9 cm.)
INSCRIPTION: on underside, excised cypher of conjoined *AR* in a circle; incised *o; u; c; 1910*
Museum Purchase. 16.4.3
(Frontispiece)

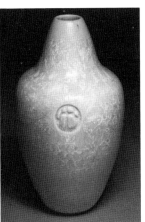

188. **Vase, 1910**
Porcelain, with excised decoration of conjoined *AR* in a circle; yellow matte, and pearly white crystalline glazes
HEIGHT: 4¾" (12.0 cm.)
INSCRIPTION: on underside, excised cypher of conjoined *AR* in a circle; incised *519*
Museum Purchase. 16.4.4
Photograph by Jane Courtney Frisse.

189. **Lantern, 1908**
Porcelain, with excised and perforated decoration; brown, turquoise, pale yellow, and white glazes
HEIGHT: 8½" (21.1 cm.)
INSCRIPTION: on inside, incised cypher of conjoined *AR; 1908; 668*
Museum Purchase. 16.4.5
(Plate 3)

171

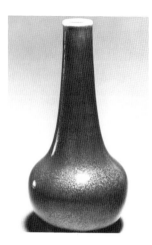

190. **Small Vase, 1908**
Porcelain, with dark red crystalline glaze; white glaze on rim
HEIGHT: 4⅛″ (10.5 cm.)
INSCRIPTION: on underside, excised cypher of conjoined *AR* in a circle; incised *1908; 659*
Museum Purchase. 16.4.6
Photograph by Jane Courtney Frisse.

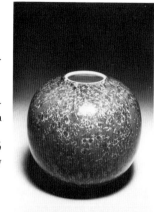

191. **Small Globular Vase, 1912**
Porcelain, with blue crystalline glaze
HEIGHT: 3¹/₁₆″ (7.8 cm.)
INSCRIPTION: on underside, excised cypher of conjoined *AR* in a circle; incised *1912; D*
Museum Purchase. 16.4.8
Photograph by Jane Courtney Frisse.

192. **Vase, 1910**
Porcelain, with incised decoration of waterlilies and geometric pattern; green, yellow and brown matte glazes; pink crystalline glaze
HEIGHT: 11½″ (29.2 cm.)
INSCRIPTION: on underside, excised cypher of conjoined *AR* in a circle; incised *1910; 11; U; C*
Museum Purchase. 16.4.9
(Color plate **8**)

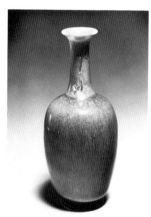

193. **Miniature Vase, 1912**
Porcelain, with blue green crystalline and streaked glaze
HEIGHT: 3⅜″ (8.5 cm.)
INSCRIPTION: on underside, excised cypher of conjoined *AR* in a circle; incised *20; 1912*
Museum Purchase. 16.4.10
Photograph by Jane Courtney Frisse.

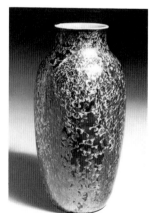

194. **Vase, 1909**
Porcelain, with dark green underglaze, and dark blue crystalline glaze; pale green crystalline glaze on rim and interior
HEIGHT: 7¹/₁₆″ (18.0 cm.)
INSCRIPTION: on underside, excised cypher of conjoined *AR* in a circle, within larger incised circle
Museum Purchase. 16.4.12
Photograph by Jane Courtney Frisse.

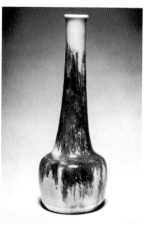

195. **Vase, 1910**
Porcelain, with pale blue, red, and dark blue glazes
HEIGHT: 5⅛″ (13.0 cm.)
INSCRIPTION: on underside, excised cypher of conjoined *AR* in a circle; incised *26; U; C; 1910*
Museum Purchase. 16.4.14
Photograph by Jane Courtney Frisse.

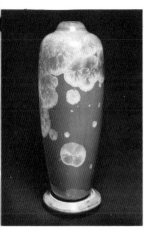

196. **Vase with Stand, 1910**
Porcelain, with golden brown crystalline glaze
HEIGHT: 7″ (17.8 cm.)
INSCRIPTION: on underside, excised cypher of conjoined *AR* in a circle; incised *1910;* additional marks indiscernible; on underside of stand, incised cypher of conjoined *AR*
Museum Purchase. 16.4.15 a-b
Photograph by Jane Courtney Frisse.

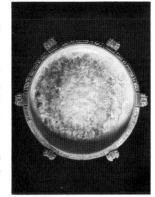

197. **Bowl, 1905**
Porcelain, with incised floral decoration; brown matte and grey knobs; tan matte glaze on exterior; aqua and pale green crystalline glazes on pink matte glaze on interior
DIAMETER: 9½″ (24.1 cm.)
INSCRIPTION: on underside, incised cypher of conjoined *AR* in a square; incised *'5; 282*
Museum Purchase. 16.4.16
Photograph by Jane Courtney Frisse.

198. **Monogram Vase, 1905**
Porcelain, with excised decoration; beige, tan, brown, and green matte glazes; originally with base
HEIGHT: 12⅜″ (31.4 cm.)
INSCRIPTION: on underside, excised cypher of conjoined *AR* in a circle; incised *141*
Museum Purchase. 16.4.17
(Color plate **6**)

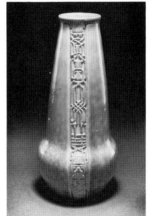

199. **Vase, 1914**
Porcelain, with excised decoration in vertical sections; pale blue, purple and green iridescent glazes; light tan matte glaze
HEIGHT: 6¹¹/₁₆″ (17.0 cm.)
INSCRIPTION: on underside, excised cypher of conjoined *AR* in a circle; incised *1914; B*
Museum Purchase. 16.4.18
Photograph by Jane Courtney Frisse.

200. **Small Bowl, 1908**
Porcelain, with excised decoration of mice; grey, brown, tan, and green matte glazes on exterior; turquoise, tan, and green crystalline glazes on interior
DIAMETER: 4½″ (11.4 cm.)
INSCRIPTION: on underside, excised cypher of conjoined *AR* in a circle
Museum Purchase. 16.4.21
(Plate 66)

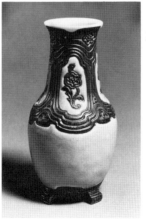

201. **Miniature Vase, 1914**
Porcelain, with incised floral decoration; brown matte and gray semimatte glazes; four carved feet
HEIGHT: 3³/₁₆″ (9.7 cm.)
INSCRIPTION: on underside, excised cypher of conjoined *AR* in a circle; incised *1914*
Museum Purchase. 16.4.22
Photograph by Jane Courtney Frisse.

173

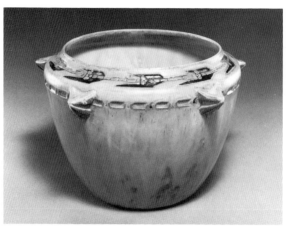

202. **Bowl, 1906**
Porcelain, with excised decora-
tion; six tetrahedral knobs; tan
and green flowing matte glazes;
dark blue glossy glaze
HEIGHT: 5¼″ (13.4 cm.)
INSCRIPTION: on underside, ex-
cised cypher of conjoined *AR* in a
circle; incised *1906; 558*
Museum Purchase. 16.4.23
Photograph by Jane Courtney
Frisse.

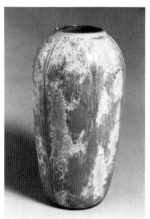

203. **Vase, 1905**
Porcelain, with incised vertical
stripes; light blue matte glaze; blue
and green crystalline glazes; tan
matte and brown crystalline glazes
on interior
HEIGHT: 6¹⁵/₁₆″ (17.6 cm.)
INSCRIPTION: on underside, in-
cised cypher of conjoined *AR* in a
circle; *230; '5*
Museum Purchase. 16.4.24
Photograph by Jane Courtney
Frisse.

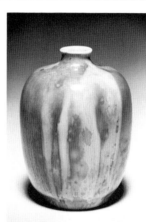

204. **Miniature Vase, 1912**
Porcelain, with iridescent blue
crystalline glaze
HEIGHT: 2½″ (6.4 cm.)
INSCRIPTION: on underside, ex-
cised cypher of conjoined *AR* in a
circle; incised *1912*
Museum Purchase. 16.4.25
Photograph by Jane Courtney
Frisse.

205. **Vase, 1905**
Porcelain, with pale aqua blue
crystalline glaze; carved three-
footed base with tan and blue
glazes
HEIGHT: 8¼″ (21.0 cm.)
INSCRIPTION: on underside, ex-
cised cypher of conjoined *AR* in a
circle; glazed pale aqua blue
Museum Purchase. 16.4.26
(Color plate **11**)

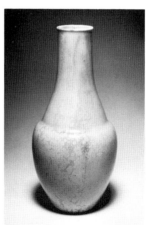

206. **Vase, 1914**
Porcelain, with iridescent blue
and green crystalline glazes; white
glaze on rim and interior
HEIGHT: 6¾″ (17.2 cm.)
INSCRIPTION: on underside,
cypher indiscernible; incised *14*
Museum Purchase. 16.4.27
Photograph by Jane Courtney
Frisse.

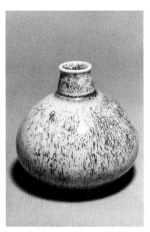

207. Miniature Vase, 1915
Porcelain, with green glaze;. streaks of red glaze
HEIGHT: 2¾″ (7.0 cm.)
INSCRIPTION: on underside, excised cypher of conjoined AR; incised *1915; 2*
Museum Purchase. 16.4.29
Photograph by Jane Courtney Frisse.

208. Vase, 1912
Porcelain, with white, blue, and pink iridescent glazes; white crystalline glaze
HEIGHT: 7⅛″ (18.1 cm.)
INSCRIPTION: on underside, excised cypher of conjoined AR in a circle; incised *12*
Museum Purchase. 16.4.31
(Color plate **12**)

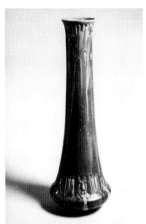

209. Vase, n.d.
Porcelain, with incised decoration of scarabs; tan and brown matte glazes; streaks of green glaze; tan crystallization
HEIGHT: 12⅛″ (30.8 cm.)
INSCRIPTION: on underside, excised cypher of conjoined *AR* in a circle; incised *506*
Gift of the Artist. 16.4.32
Photograph by Jane Courtney Frisse.

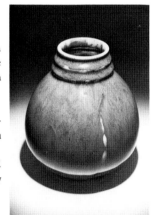

210. Vase, 1928
Porcelain, with red and green glossy glazes; streaks of black glaze
HEIGHT: 6¼″ (15.9 cm.)
INSCRIPTION: on underside, incised cypher of conjoined *AR* in a circle; *1928*
Museum Purchase. 30.4.37
Photograph by Jane Courtney Frisse.

211. Miniature Vase, 1927
Porcelain, with incised decoration; black, green, and grey metallic glazes; buff colored glaze on rim and interior
HEIGHT: 2¾″ (7.0 cm.)
INSCRIPTION: on underside, excised cypher of conjoined *AR* in a circle; incised *1927*
Museum Purchase. 30.4.38
Photograph by Jane Courtney Frisse.

212. Miniature Vase, n.d.
Porcelain, with light blue and green iridescent glazes
HEIGHT: 1⅞″ (4.7 cm.)
INSCRIPTION: on underside, excised cypher of conjoined *AR* in a circle; incised *12*
Museum Purchase. 30.4.39
Photograph by Jane Courtney Frisse.

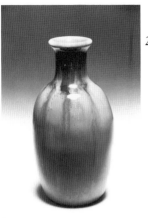

213. **Miniature Vase, 1927**

Porcelain, with blue green glaze and turquoise streaks; light aqua on rim and interior
HEIGHT: 2¾″ (7.0 cm.)
INSCRIPTION: on underside, excised cypher of conjoined *AR* in a circle; incised *1927*
Museum Purchase. 30.4.40
Photograph by Jane Courtney Frisse.

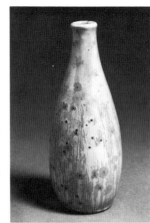

214. **Miniature Vase, n.d.**

Porcelain, with grey and cream mottled and streaked matte glazes
HEIGHT: 2⅞″ (6.7 cm.)
INSCRIPTION: on underside, excised cypher of conjoined *AR* in a circle
Museum Purchase. 30.4.41
Photograph by Jane Courtney Frisse.

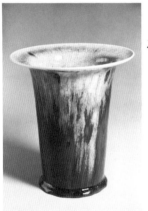

215. **Vase, 1927**

Porcelain, with dark red glaze; streaks of pale green crackle glaze
HEIGHT: 7⅜″ (18.2 cm.)
INSCRIPTION: on underside, excised cypher of conjoined *AR* in a circle; incised *1927*
Museum Purchase. 30.4.42
Photograph by Jane Courtney Frisse.

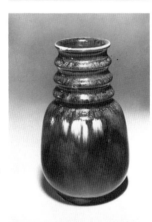

216. **Vase, 1926**

Porcelain, with dark red matte glaze; streaks of maroon, black, and pale green
HEIGHT: 6¼″ (15.9 cm.)
INSCRIPTION: on underside, excised cypher of conjoined *AR* in a circle; incised *1926*
Museum Purchase. 30.4.44
Photograph by Jane Courtney Frisse.

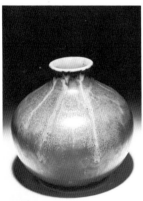

217. **Vase, 1927**

Porcelain, with iridescent brown semimatte glaze; metallic cream glaze dripping from neck
HEIGHT: 4″ (10.2 cm.)
INSCRIPTION: on underside, excised cypher of conjoined *AR* in a circle; incised *1927*
Museum Purchase. 30.4.45
Photograph by Jane Courtney Frisse.

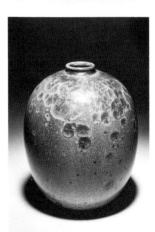

218. **Vase, 1910**

Porcelain, with olive green crystalline glaze; brown blue crystal with pale blue edges
HEIGHT: 4⅝″ (12.4 cm.)
INSCRIPTION: on underside, excised cypher of conjoined *AR* in a circle; incised *UC; 8; 1910*
Museum Purchase. 30.4.4
Photograph by Jane Courtney Frisse.

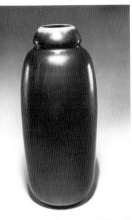

219. Vase, 1926
Porcelain, with metallic black glaze; pale yellow green glaze around rim breaking to black with dark green streaks
HEIGHT: 12¹³/₁₆″ (32.5 cm.)
INSCRIPTION: on underside, excised cypher of conjoined *AR* in a circle; incised *1916*
Museum Purchase. 30.4.47
Photograph by Jane Courtney Frisse.

220. Threshold Plaque, 1923
Stoneware, with incised decoration; light grey, tan, brown, aqua, and blue glazes
DIAMETER: 15¼″ (38.8 cm.)
INSCRIPTION: on underside, excised cypher of conjoined *AR* in a circle; incised *1923*; inscribed in brown glaze *THRESHOLD*
Museum Purchase. 30.4.48
(Plate 31)

221. Gourd Vase, 1926
Porcelain, with incised decoration; grey green and mottled grey matte glazes; bronze black matte glaze
HEIGHT: 8″ (20.3 cm.)
INSCRIPTION: on underside, excised cypher of conjoined *AR*; incised *1926*
Museum Purchase. 30.4.49
Photograph by Jane Courtney Frisse.

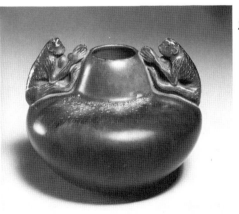

222. Low Vase with Monkey Handles, n.d.
Porcelain, with incised and excised decoration; brown and black matte glazes breaking to green glaze
HEIGHT: 4″ (10.2 cm.)
INSCRIPTION: on underside, incised cypher of conjoined *AR* in a circle; incised *139*
Museum Purchase. 30.4.50
Photograph by Jane Courtney Frisse.

177

223. Miniature Vase, n.d.
Porcelain, with iridescent pale blue and green crystalline glazes; pale ochre glaze
HEIGHT: 2¹¹/₁₆″ (6.9 cm.)
INSCRIPTION: on underside, excised cypher of conjoined *AR* in a circle
Museum Purchase. 30.4.51
Photograph by Jane Courtney Frisse.

224. Miniature Vase, n.d.
Porcelain, with black brown matt glaze; white matte glaze on interio and dripping over rim
HEIGHT: 2⅞″ (6.7 cm.)
INSCRIPTION: on underside, excised cypher of conjoined *AR* in circle
Museum Purchase. 30.4.5
Photograph by Jane Courtne Frisse.

225. Miniature Vase, n.d.
Porcelain, with brown matte glaze; white crystalline glaze on interior and dripping over neck
HEIGHT: 2¼″ (5.7 cm.)
INSCRIPTION: on underside, excised cypher of conjoined *AR* in a circle
Museum Purchase. 30.4.53
Photograph by Jane Courtney Frisse.

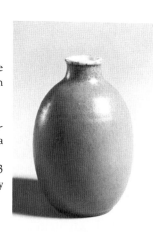

226. Miniature Vase, n.d.
Porcelain, with violet blue matt glaze
HEIGHT: 2¾″ (7.0 cm.)
INSCRIPTION: on underside, excised cypher of conjoined *AR* in circle
Museum Purchase. 30.4.5
Photograph by Jane Courtne Frisse.

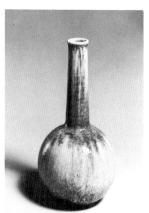

227. Small Bottle, 1928
Porcelain, with maroon and grey glazes
HEIGHT: 5⅞″ (14.5 cm.)
INSCRIPTION: on underside, excised cypher of conjoined *AR* in a circle; incised '28; glazed
Museum Purchase. 30.4.56
Photograph by Jane Courtney Frisse.

228. Miniature Vase, 1927
Porcelain, with iridescent, metallic green glaze
HEIGHT: 3¹¹/₁₆″ (9.4 cm.)
INSCRIPTION: on underside, excised cypher of conjoined *AR* in circle; incised *1927*
Museum Purchase. 30.4.5
(Plate 121)

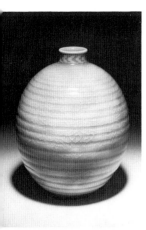

229. **Small Bottle, 1928**
Porcelain, with incised decoration; light green crackle glaze
HEIGHT: 5⅜″ (13.8 cm.)
INSCRIPTION: on underside, excised cypher of conjoined *AR* in a circle; incised *28*; glazed
Museum Purchase. 30.4.58
Photograph by Jane Courtney Frisse.

230. **Miniature Bowl, 1928**
Porcelain, with brown matte glaze breaking to blue and yellow; pale cream yellow crystalline glaze on interior
HEIGHT: 1½″ (3.8 cm.)
INSCRIPTION: on underside, excised cypher of conjoined *AR* in a circle; incised '*28*
Museum Purchase. 30.4.59
Photograph by Jane Courtney Frisse.

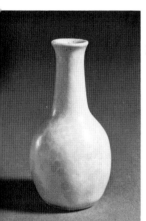

231. **Miniature Vase, n.d.**
Porcelain, with iridescent cream yellow crystalline glaze
HEIGHT: 2⅞″ (7.5 cm.)
INSCRIPTION: on underside, excised cypher of conjoined *AR* in a circle; glazed
Museum Purchase. 30.4.60
Photograph by Jane Courtney Frisse.

232. **Miniature Vase, n.d.**
Porcelain, with pale yellow cream crystalline glaze; raised dots form horizontal band around body
HEIGHT: 2½″ (6.3 cm.)
INSCRIPTION: on underside, excised cypher of conjoined *AR* in a circle
Museum Purchase. 30.4.61
Photograph by Jane Courtney Frisse.

233. **Vase, 1928**
Stoneware, with incised decoration; bronze black matte glaze; white crackle glaze on interior
HEIGHT: 7½″ (19.0 cm.)
INSCRIPTION: on underside, excised cypher of conjoined *AR* in a circle; incised *1928*
Museum Purchase. 30.4.62
(Plate 42)

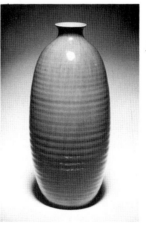

234. **Vase, 1927**
Porcelain, with grey green iridescent glaze; brown glaze on interior
HEIGHT: 6¹¹/₁₆″ (17.0 cm.)
INSCRIPTION: on underside, excised cypher of conjoined *AR* in a circle; incised *1927*
Museum Purchase. 30.4.63
Photograph by Jane Courtney Frisse.

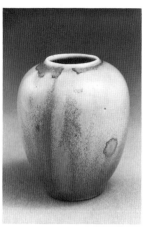

235. **Miniature Vase, n.d.**
Porcelain, with pale green crystalline glaze
HEIGHT: 2″ (5.0 cm.)
INSCRIPTION: on underside, incised cypher glazed and indiscernible
Museum Purchase. 30.4.64
Photograph by Jane Courtney Frisse.

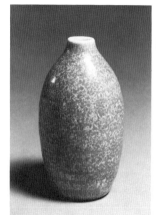

236. **Miniature Vase, n.d.**
Porcelain, with grey semimatte glaze; white glaze on rim and interior
HEIGHT: 2¹⁵/₁₆″ (7.5 cm.)
INSCRIPTION: on underside, excised cypher of conjoined *AR* in a circle
Museum Purchase. 30.4.65
Photograph by Jane Courtney Frisse.

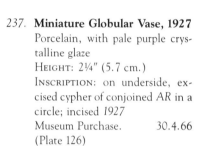

237. **Miniature Globular Vase, 1927**
Porcelain, with pale purple crystalline glaze
HEIGHT: 2¼″ (5.7 cm.)
INSCRIPTION: on underside, excised cypher of conjoined *AR* in a circle; incised *1927*
Museum Purchase. 30.4.66
(Plate 126)

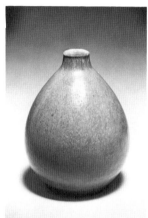

238. **Miniature Vase, n.d.**
Porcelain with rust colored matte glaze
HEIGHT: 2¹¹/₁₆″ (6.8 cm.)
INSCRIPTION: on underside, excised cypher of conjoined *AR* in a circle
Museum Purchase. 30.4.6
Photograph by Jane Courtney Frisse.

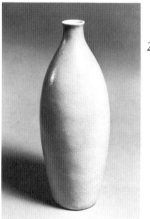

239. **Bottle, 1927**
Porcelain, with lavender crackle glaze
HEIGHT: 7¾″ (19.7 cm.)
INSCRIPTION: on underside, excised cypher of conjoined *AR* in a circle; incised *1927*
Museum Purchase. 30.4.68
Photograph by Jane Courtney Frisse.

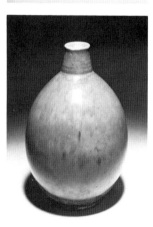

240. **Vase, n.d.**
Porcelain, with iridescent green, brown, and grey glazes
HEIGHT: 6″ (15.3 cm.)
INSCRIPTION: on underside, excised cypher of conjoined *AR* in a circle
Museum Purchase. 30.4.69
Photograph by Jane Courtney Frisse.

241. Miniature Bottle, 1927
Porcelain, with rose pink crystalline glaze; black and white glazes
HEIGHT: 2⅝″ (6.6 cm.)
INSCRIPTION: on underside, excised cypher of conjoined AR in a circle
Museum Purchase. 30.4.70
(Plate 125)

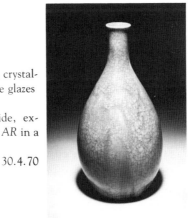

242. Vase, 1920
Porcelain, with green and red crackle glazes
HEIGHT: 7″ (17.8 cm.)
INSCRIPTION: on underside, excised cypher of conjoined AR in a circle; incised 22; 1920
Museum Purchase. 30.4.71
Photograph by Jane Courtney Frisse.

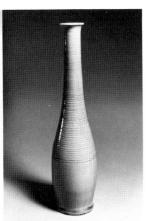

243. Bottle, 1928
Porcelain, with glossy, bright turquoise glaze; originally with elaborately carved stopper
HEIGHT: 12½″ (31.3 cm.)
INSCRIPTION: on underside, excised cypher of conjoined AR in a circle; incised 1928
Museum Purchase. 30.4.72
Photograph by Jane Courtney Frisse.

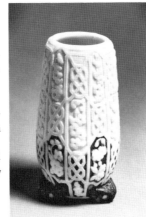

244. Miniature Vase, 1914
Porcelain, with incised decoration; three carved owl's head feet; white and dark brown glazes; originally with lid
HEIGHT: 3″ (7.6 cm.)
INSCRIPTION: on underside, excised cypher of conjoined AR in a circle; incised 1914; 25
Museum Purchase. 30.4.73
Photograph by Jane Courtney Frisse.

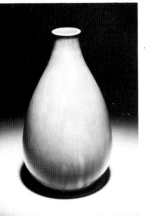

245. Vase, 1926
Porcelain, with blue glaze breaking to light tan glaze
HEIGHT: 6½″ (16.5 cm.)
INSCRIPTION: on underside, excised cypher of conjoined AR in a circle; incised 1926
Museum Purchase. 30.4.74
Photograph by Jane Courtney Frisse.

246. Small Bottle, n.d.
Porcelain, with violet blue crystalline glaze
HEIGHT: 5¾″ (14.6 cm.)
INSCRIPTION: on underside, excised cypher of conjoined AR in a circle
Museum Purchase. 30.4.75
Photograph by Jane Courtney Frisse.

247. Vase, n.d.
Porcelain, with incised decora
tion; brown glaze with flowing
blue, brown, green, and white
overglazes
HEIGHT: 5¹⁵/₁₆″ (15.0 cm.)
INSCRIPTION: on underside, ex
cised cypher of conjoined *AR* in a
circle
Museum Purchase. 30.4.76
Photograph by Jane Courtney
Frisse.

248. Scarab Vase (The Apotheosis of the Toiler), 1910
Porcelain, with incised and perfo-
rated decoration of scarabs and
geometric pattern; white and pale
aqua glazes; lid and pedestal base
of the same motif
HEIGHT: (with lid and base):16⅝″
(42.2 cm.)
INSCRIPTION: on underside of
vase, excised cypher of conjoined
AR in a circle; incised *THE
APOTHEOSIS OF THE
TOILER·60; 1910; MADE FOR
THE U.C. AMERICAN
WOMENS LEAGUE*; on inside
of lid, incised cypher of conjoined

AR; on underside of base, incised
cypher of conjoined *AR* in a cir-
cle; *1910; U.C.;* ∞
Museum Purchase. 30.4.78 a-c
(Color plate **3**, Plates 28, 112)

249. Cinerary Urn, n.d.
Porcelain, with excised decora-
tion; bronze black matte glaze;
white crackle glaze
HEIGHT: 33″ (83.8 cm.)
INSCRIPTION: on underside, ex-
cised cypher of conjoined *AR* in a
circle; stylized scarab; incised *De
"Profundis"Clamavi"; Adelaide
Alsop Robineau≈Born April 9
1865 Died February 18
1929 ≈Samuel Edouard
Robineau≈Born December 20
1856 Died* (not filled in)
Gift of Samuel E. Robineau.
30.4.79

(Plate 108)

250. Small Vase, possibly 1919
Porcelain, with olive green crys-
talline glaze
HEIGHT: 4½″ (11.4 cm.)
INSCRIPTION: on underside, ex-
cised cypher indiscernible; incised
date possibly *1919*; glazed
Museum Purchase. 30.4.80
(Plate 120)

251. Snake Bowl, 1919
Porcelain, with coiled snake and
carved snake head on rim; cream-
colored iridescent glaze; blue grey
overglaze in snakeskin motif
HEIGHT: 4½″ (10.8 cm.)
INSCRIPTION: on underside, ex-
cised cypher of conjoined *AR* in a
circle; incised *1919*
Museum Purchase. 30.4.81
(Color Plate **5**)

252. The Sea, 1927
Porcelain, with incised decoration
of mermaids; four carved mermen
handles; iridescent green and
brown matte glazes; white crackle
glaze on rim.
HEIGHT: 8⅝″ (22.0 cm.)
INSCRIPTION: on underside, ex-
cised cypher of conjoined *AR* in a
circle; incised *1927; THE SEA*
Museum Purchase. 30.4.82
(Plate 41)

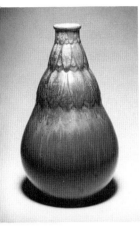

253. **Vase, n.d.**
Porcelain, with incised decoration
of leaves; brown green iridescent
glaze
HEIGHT: 6⅞″ (17.5 cm.)
INSCRIPTION: on underside, ex-
cised cypher of conjoined AR in a
circle
Museum Purchase. 30.4.83
Photograph by Jane Courtney
Frisse.

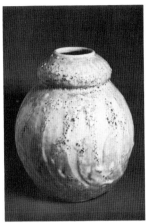

254. **The Night Has a Thousand Eyes, 1910**
Stoneware, with stenciled decora-
tion; blue, grey lava, and white
matte glazes
HEIGHT: 7⅞″ (20.0 cm.)
INSCRIPTION: on underside, ex-
cised cypher of conjoined AR in a
circle; incised *THE NIGHT HAS
A THOUSAND EYES*
Museum Purchase. 30.4.84
Photograph by Jane Courtney
Frisse.

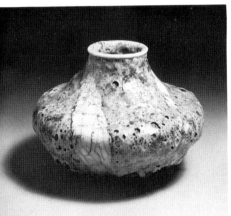

255. **Small Vase, 1910**
Porcelain, with white crackle
glaze; blistered red and green
glazes
HEIGHT: 4″ (10.2 cm.)
INSCRIPTION: on underside, ex-
cised cypher of conjoined AR in a
circle; incised *UC; 110; 1910*
Museum Purchase. 30.4.85
Photograph by Jane Courtney
Frisse.

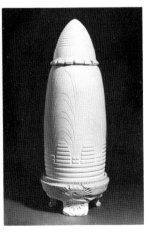

256. **Unfinished Vase, 1928**
Porcelain, with incised and ex-
cised decoration; unglazed
bisqueware; carved lid and pedes-
tal base
HEIGHT: (with lid and base): 14⅛″
(36.0 cm.)
INSCRIPTION: on underside, ex-
cised cypher of conjoined AR in a
circle; incised *1928*; on underside
of base, excised cypher of con-
joined AR in a circle
Museum Purchase. 30.4.87 a-c
Photograph by Jane Courtney
Frisse.

257. **Base, n.d.**
Porcelain, with excised floral de-
coration; three carved feet; white,
brown, black, and grey glazes
DIAMETER: 3⅜″ (8.6 cm.)
INSCRIPTION: on underside, ex-
cised cypher of conjoined AR in a
circle
Museum Purchase. 30.4.88

183

258. Vase, 1905

Porcelain, with pale rose, pink, and mauve glazes; with cream colored crystallization
HEIGHT: 6⅛″ (15.5 cm.)
INSCRIPTION: on underside, incised cypher indiscernible

30.4.90

259. Lamp Vase, 1921

Porcelain, with five ringed holes around base; light green yellow crystalline glaze
HEIGHT: 9″ (22.9 cm.)
INSCRIPTION: on underside, excised cypher of conjoined AR; incised 15
Gift of Helen Van Wagenen Eltinge Estate. 61.2.1a
Photograph by Jane Courtney Frisse.

260. Turtle Vase, 1913

Porcelain, with incised and perforated decoration in underwater motif; three carved turtle feet (one broken); yellow, light green, blue, and ochre glazes
HEIGHT: 21″ (53.3 cm.)
INSCRIPTION: on underside, excised cypher of conjoined AR in a circle; incised C; 1913

74.24

(Plates 43, 44, 45)

261. Miniature Vase, n.d.

Porcelain, with pale blue green glaze
HEIGHT: 2⅛″ (5.2 cm.)
INSCRIPTION: on underside, incised cypher of conjoined AR; glazed
Gift of Mrs. Miriam M. Pittman.

79.26

Photograph by Jane Courtney Frisse.

262. Peruvian Serpent Bowl, 1917
Porcelain, with molded design of coiled serpent; brown and white glazes; incised decoration of six legs of crouching Peruvian grotesques; dark brown matte glaze
HEIGHT: 2⅝″ (6.7 cm.)
DIAMETER: 6⅞″ (17.5 cm.)
INSCRIPTION: on underside, excised cypher of conjoined AR in a circle; incised 1917
Museum Purchase, Edward C. Moore, Jr., Gift Fund. 23.145
Courtesy of The Metropolitan Museum of Art.

263. Covered Jar, 1913
Porcelain, with green crystalline glaze; cover with incised geometric pattern, button finial; green glaze
HEIGHT: 4¼″ (10.8 cm.)
INSCRIPTION: on underside, excised cypher of conjoined AR in a circle; incised 1913
Museum Purchase, Edward C. Moore, Jr., Gift Fund. 22.205 a-b
Courtesy of The Metropolitan Museum of Art.

264. Bowl, 1924
Eggshell porcelain, with pierced and excised floral decoration; pale green, yellow, and white glazes
HEIGHT: 2¾″ (7.0 cm.)
DIAMETER: 5⅝″ (14.3 cm.)
INSCRIPTION: on underside, excised cypher of conjoined AR in a circle; incised 1924
Museum Purchase, Edward C. Moore, Jr., Gift Fund. 26.37
Courtesy of The Metropolitan Museum of Art.

265. Vase, 1919
Porcelain, with molded fretwork decoration; blue glaze; white crystalline glaze
HEIGHT: 2″ (5.0 cm.)
INSCRIPTION: on underside, excised cypher of conjoined *AR* in a circle; incised *1919*
Museum Purchase, Edward C. Moore, Jr., Gift Fund. 22.223
Courtesy of The Metropolitan Museum of Art.

266. Vase with Cover and Stand, n.d.
Porcelain, with green and brown crystalline glazes; cover with pierced decoration; four-footed stand with molded decoration and black matte glaze
HEIGHT: (with cover and stand): 3⅜″ (8.6 cm.)
INSCRIPTION: on underside, incised cypher of conjoined *AR*; 68; on underside of base, incised cypher of conjoined *AR*; 1923; on inside of lid, incised cypher of conjoined *AR*
Museum Purchase, Edward C. Moore, Jr., Gift Fund. 23.52 a-c
Courtesy of The Metropolitan Museum of Art.

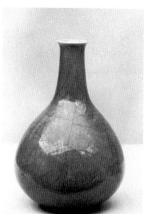

267. Vase, 1923
Porcelain, with blue green crackle glaze
HEIGHT: 6¾″ (17.1 cm.)
INSCRIPTION: on underside, excised cypher of conjoined *AR* in a circle; incised *1923; 2*
Museum Purchase, Edward C. Moore, Jr., Gift Fund. 23.87.2
Courtesy of The Metropolitan Museum of Art.

268. Vase, 1927
Porcelain, with lavender, terracotta colored and light grey blue crackle glazes
HEIGHT: 7¼″ (18.4 cm.)
INSCRIPTION: on underside, excised cypher of conjoined *AR* in a circle; incised *1927*
Museum Purchase, Edward C. Moore, Jr., Gift Fund. 29.130.3
Courtesy of The Metropolitan Museum of Art.

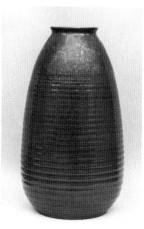

269. Vase, 1928
Porcelain, with molded decoration of shallow, graduated rings; green and brown glazes
HEIGHT: 9⅛″ (23.2 cm.)
INSCRIPTION: on underside, excised cypher of conjoined *AR* in a circle; incised *1928*
Museum Purchase, Edward C. Moore, Jr., Gift Fund. 29.130.4
Courtesy of The Metropolitan Museum of Art.

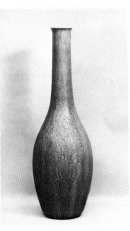

270. **Vase, 1926**
Porcelain, with incised scroll and flower decoration; finely crackled turquoise glaze
HEIGHT: 14¼″ (36.2 cm.)
INSCRIPTION: on underside, excised cypher of conjoined *AR* in a circle; incised *1926*
Museum Purchase, Edward C. Moore, Jr., Gift Fund. 30.17
Courtesy of The Metropolitan Museum of Art

271. **Vase, 1926**
Porcelain, with excised decoration; blue, white, and green brown matte glazes; white crackled slip on interior, and dripping over outside of neck
HEIGHT: 6¾″ (17.1 cm.)
INSCRIPTION: on underside, excised cypher of conjoined *AR* in a circle; incised *1926*
Gift of S. E. Robineau. 30.35
Courtesy of The Metropolitan Museum of Art.

187

NEWARK MUSEUM

Newark, New Jersey

272. **Vase, 1924**
Porcelain, with white crackle
and greenish tan glazes
HEIGHT: 13½"
INSCRIPTION: on underside, ex-
cised cypher of conjoined *AR* in
a circle; incised *3; 1924*
Collection of the Newark
Museum.

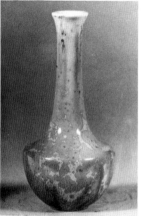

273. **Vase, 1914**
Porcelain, with blue crystalline
glaze
HEIGHT: 6¼"
INSCRIPTION: on underside, ex-
cised cypher of conjoined *AR* in a
circle; incised *251*
Collection of the Newark
Museum 14.933

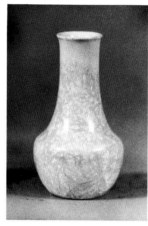

274. **Vase, 1914**
Porcelain, with yellow crystalline
glaze
HEIGHT: 4½"
INSCRIPTION: on underside, ex-
cised cypher of conjoined *AR* in a
circle; incised *684*
Collection of the Newark
Museum. 14.932

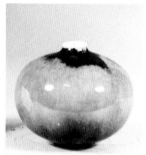

275. **Miniature Vase, 1914**
Porcelain, with green glaze spot-
ted with red glaze
HEIGHT: 2⅞"
INSCRIPTION: on underside, ex-
cised cypher of conjoined *AR* in a
circle
Collection of the Newark
Museum. 14.931

OHIO STATE UNIVERSITY

Columbus, Ohio

276. **Test Vase, n.d.**
Porcelain, with mottled green,
grey, and copper red crystalline
glazes
HEIGHT: 2⅝" (6.5 cm.)
INSCRIPTION: on underside, in-
cised *II-X* or *X-II*
CA-1

277. **Test Vase, n.d.**
Porcelain, with pale blue crystalline glaze
HEIGHT: 2¼" (5.5 cm.)
INSCRIPTION: on underside, incised cypher of conjoined *AR*; *35*
CA-2

278. **Test Vase, n.d.**
Porcelain, with yellow green matte glaze; pale olive green and grey white crystalline glaze
HEIGHT: 2⅜" (6.0 cm.)
INSCRIPTION: on underside, possibly inscribed *40; 300; 63; 60*
CA-3

279. **Test Vase, n.d.**
Porcelain, with pale blue, beige, and white streaked and crystalline glazes
HEIGHT: 2⅜" (6.0 cm.)
INSCRIPTION: on underside, incised *RVT; D*
CA-4

280. **Test Vase, n.d.**
Porcelain, with dark green and grey green cyrstalline matte glaze
HEIGHT: 2⅜" (6.0 cm.)
INSCRIPTION: on underside, incised *40; X*
CA-5

281. **Test Vase, n.d.**
Porcelain, with olive green and grey green glaze
HEIGHT: 2¼" (5.5 cm.)
INSCRIPTION: on underside, incised *30; a or o*
CA-6

282. **Test Vase, n.d.**
Porcelain, with rust colored, green, and grey glaze
HEIGHT: 2" (5.0 cm.)
INSCRIPTION: on underside, inscribed *30; C2*
CA-7

283. **Test Vase, n.d.**
Porcelain, with grey, green, and blue glazes
HEIGHT: 2¼" (5.5 cm.)
INSCRIPTION: on underside, incised *8*; inscribed in blue glaze *2*; inscribed in graphite *117C with 114A over*
CA-8

284. **Test Bottle, n.d.**
Porcelain, with yellow crystalline glaze
HEIGHT: 2⅜" (6.0 cm.)
INSCRIPTION: on underside, excised cypher of conjoined *AR* in a circle; incised *1919*
CA-9

285. **Test Vase, n.d.**
Porcelain, with yellow green and olive green crystalline glaze
HEIGHT: 2⅜" (6.0 cm.)
INSCRIPTION: on underside, incised *B*
CA-10

286. **Test Vase, n.d.**
Porcelain, with mottled dark grey green glaze
HEIGHT: 2" (5.0 cm.)
INSCRIPTION: on underside, incised cypher of conjoined *AR*; *DIF*
CA-11

287. **Test Vase, n.d.**
Porcelain, with white crystalline glaze
HEIGHT: 2⅝" (6.5 cm.)
INSCRIPTION: on underside, incised cypher of conjoined *AR*; glazed
CA-12

288. **Test Vase, n.d.**
Porcelain, with gold, brown, and beige crystalline glaze
HEIGHT: 2⅝" (6.5 cm.)
INSCRIPTION: on underside, incised *11*; additional marks obscured by glaze
CA-13

289. **Test Vase, n.d.**
Porcelain, with white and pale green crystalline glaze
HEIGHT: 2″ (5.0 cm.)
INSCRIPTION: on underside, incised cypher of conjoined *AR; V*
CA-14

290. **Test Vase, n.d.**
Porcelain, with mottled forest green and grey glaze
HEIGHT: 2⅜″ (6.0 cm.)
INSCRIPTION: on underside, incised *40; III-III; 3*
CA-15

291. **Test Vase, n.d.**
Porcelain, with dark grey brown metallic glaze
HEIGHT: 2″ (5.0 cm.)
INSCRIPTION: on underside, incised *Sc; W*
CA-16

292. **Test Vase, n.d.**
Porcelain, with yellow green and grey green crystalline glaze
HEIGHT: 2¼″ (5.5 cm.)
INSCRIPTION: on underside, incised *37*
CA-17
(Plate 127)

293. **Test Vase, n.d.**
Porcelain, with blue black crystalline glaze
HEIGHT: 2¼″ (5.5 cm.)
INSCRIPTION: on underside, incised *IV; VII* or *VIII*
CA-18
(Plate 127)

294. **Test Vase, n.d.**
Porcelain, with mottled pale grey green glaze
HEIGHT: 2¼″ (5.5 cm.)
INSCRIPTION: on underside, incised *A* or *D*
CA-19
(Plate 127)

295. **Test Vase, n.d.**
Porcelain, with metallic black matte glaze
HEIGHT: 1¾″ (4.5 cm.)
INSCRIPTION: on underside, incised *Sc; W*
CA-20
(Plate 127)

296. **Test Vase, n.d.**
Porcelain, with black crystalline glaze
HEIGHT: 2¼″ (5.5 cm.)
INSCRIPTION: on underside, incised *XXIII*
CA-21
(Plate 128)

297. **Test Vase, n.d.**
Porcelain, with metallic black crystalline glaze
HEIGHT: 2¼″ (5.5 cm.)
INSCRIPTION: on underside, incised *XI* or *IX*
CA-22
(Plate 128)

298. **Test Vase, n.d.**
Porcelain, with olive brown glaze
HEIGHT: 2¼″ (5.5 cm.)
INSCRIPTION: on underside, incised *40; e*
CA-23
(Plate 128)

299. **Test Vase, n.d.**
Porcelain, with light gold, brown, and green crystalline glazes
HEIGHT: 2¼″ (5.5 cm.)
INSCRIPTION: on underside, incised *11*
CA-24
(Plate 128)

300. **Test Vase, n.d.**
Porcelain, with rust colored, ochre, and blue black glazes
HEIGHT: 2½″ (6.2 cm.)
INSCRIPTION: on underside, incised *11-111* or *111-11*
CA-25

301. **Test Vase, n.d.**
Porcelain with mottled grey green crystalline glaze
HEIGHT: 2⅜″ (6.0 cm.)
INSCRIPTION: on underside, incised 40; E or F
CA-26

302. **Test Vase, n.d.**
Porcelain, with mottled grey green and brown glazes
HEIGHT: 2¼″ (5.5 cm.)
INSCRIPTION: on underside, incised 40; d
CA-27

303. **Test Vase, n.d.**
Porcelain, with mottled pinkish beige and grey olive green glazes
HEIGHT: 2⅜″ (6.0 cm.)
INSCRIPTION: on underside, incised 40; s
CA-28

304. **Test Vase, n.d.**
Porcelain, with white crackle glaze
HEIGHT: 2¼″ (5.5 cm.)
INSCRIPTION: on underside, incised Cx
CA-29

305. **Test Vase, n.d.**
Porcelain, with white crackle glaze
HEIGHT: 2¼″ (5.5 cm.)
INSCRIPTION: on underside, incised A; *white*
CA-30

306. **Test Vase, n.d.**
Porcelain, with white glaze
HEIGHT: 2¼″ (5.5 cm.)
INSCRIPTION: on underside, incised A
CA-31

307. **Test Vase, n.d.**
Porcelain, with oxblood red glaze; dark red streaks
HEIGHT: 2¼″ (5.5 cm.)
INSCRIPTION: on underside, possibly incised A or *vn* D
CA-32

308. **Test Vase, n.d.**
Porcelain, with mottled and streaked white and pale blue glazes
HEIGHT: 2⅜″ (6.0 cm.)
INSCRIPTION: on underside, incised T
CA-33

309. **Test Vase, n.d.**
Porcelain, with streaked dark red glaze; blue and white glazes
HEIGHT: 2⅜″ (6.0 cm.)
INSCRIPTION: on underside, inscribed in blue AR
CA-34

310. **Test Vase, n.d.**
Porcelain, with dark oxblood red glaze shading to purple and blue; white glaze on rim and interior
HEIGHT: 2⅜″ (6.0 cm.)
INSCRIPTION: on underside, incised cypher of conjoined AR; s; 1; 2; FT
CA-35

311. **Test Vase, n.d.**
Porcelain, with peach pink and grey white glazes
HEIGHT: 2″ (5.0 cm.)
INSCRIPTION: on underside, incised Sc; S5
CA-36

312. **Test Vase, n.d.**
Porcelain, with pale pink crackle glaze
HEIGHT: 2¼″ (5.5 cm.)
INSCRIPTION: on underside, incised S.1; inscribed in blue x
CA-37

313. **Test Vase, n.d.**
Porcelain, with mottled beige and grey blue glazes
HEIGHT: 2⅜″ (6.0 cm.)
INSCRIPTION: on underside, incised *40; b* or *8*
CA-38

314. **Test Vase, n.d.**
Porcelain, with mottled and streaked yellow green, beige, and blue glazes
HEIGHT: 2⅜″ (6.0 cm.)
INSCRIPTION: on underside, incised *40; t*
CA-39

315. **Test Vase, n.d.**
Porcelain, with mottled green, beige, and brown glazes
HEIGHT: 2¼″ (5.5 cm.)
INSCRIPTION: on underside, incised cypher of conjoined *AR; CI-VI* or *CI-VII; II-VII; .04* or *'04*
CA-40

316. **Test Vase, n.d.**
Porcelain, with turquoise, white, and grey glazes
HEIGHT: 2⅜″ (6.0 cm.)
INSCRIPTION: on underside, incised *40; T*
CA-41

317. **Test Vase, n.d.**
Porcelain, with rust colored glaze breaking to streaked black glaze
HEIGHT: 2⅜″ (6.0 cm.)
INSCRIPTION: on underside, incised cypher of conjoined *AR; C; II-I; IV-VII* or *IV-CII; '04*
CA-2

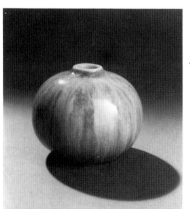

318. **Jar, 1919**
Porcelain, with white, gold, and blue crackled and running glazes
HEIGHT: 2¼″ (5.5 cm.)
INSCRIPTION: on underside, excised cypher of conjoined *AR* in a circle; incised *1919*
CA-45
Photograph by Roger Phillips.

319. **Miniature Vase, n.d.**
Porcelain, with dark maroon glaze breaking to black crystalline glaze
HEIGHT: 2¼″ (5.5 cm.)
INSCRIPTION: on underside, incised *52*
CA-46
(Plate 124)

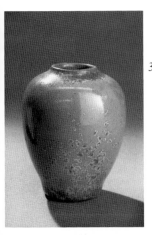

320. **Miniature Vase, n.d.**
Porcelain, with dark apple green and grey brown crystalline glaze
HEIGHT: 2¼″ (5.5 cm.)
INSCRIPTION: on underside, incised *I*
CA-47
Photograph by Roger Phillips.

321. **Miniature Vase, n.d.**
Porcelain, with pale green gold, and blue crystalline glazes
HEIGHT: 2¼″ (5.5 cm.)
INSCRIPTION: on underside, incised cypher of conjoined *AR*; *4*; *½*; *Co*; glazed
CA-48
Photograph by Roger Phillips.

322. **Miniature Vase, n.d.**
Porcelain, with pale gold and aqua green crystalline glazes
HEIGHT: 2″ (5.0 cm.)
INSCRIPTION: on underside, incised cypher of conjoined *AR*; *Y*
CA-49
Photograph by Roger Phillips.

323. **Miniature Vase, n.d.**
Porcelain, with dark apple green and grey brown crystalline glaze
HEIGHT: 2″ (5.0 cm.)
INSCRIPTION: on underside, incised *9*; *N*; *4*; *Q*
CA-50
Photograph by Roger Phillips.

324. **Miniature Vase, n.d.**
Porcelain, with olive green crystalline glaze
HEIGHT: 2″ (5.0 cm.)
INSCRIPTION: on underside, inscribed in graphite *MATTE CRYSTAL; COPPER 2; RARE*; additional marks are indiscernible
CA-51
Photograph by Roger Phillips.

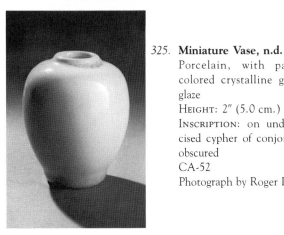

325. **Miniature Vase, n.d.**
Porcelain, with pale peach colored crystalline glaze; ivory glaze
HEIGHT: 2″ (5.0 cm.)
INSCRIPTION: on underside, incised cypher of conjoined *AR* is obscured
CA-52
Photograph by Roger Phillips.

326. Miniature Vase, n.d.
Porcelain, with pale peac
colored crystalline glaze; ivo
cream glaze
HEIGHT: 2½″ (5.5 cm.)
INSCRIPTION: on underside, ir
cised 06 or 90
CA-53
Photograph by Roger Phillips.

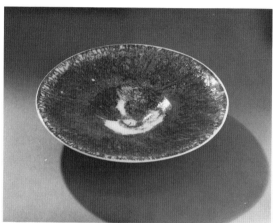

327. Bowl, 1927
Porcelain, with red, blue, an
purple glazes
DIAMETER: 6¾″ (17.0 cm.)
INSCRIPTION: on underside, ex
cised cypher of conjoined *AR* in
circle, incised *1927*
CA-54
Photograph by Roger Phillips.

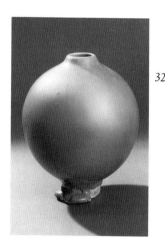

328. Small Vase, n.d.
Porcelain, with green matte glaze
HEIGHT: 4⅞″ (12.4 cm.)
INSCRIPTION: on underside, ex-
cised cypher of conjoined *AR* in a
circle
CA-55
Photograph by Roger Phillips.

329. Small Vase, n.d.
Porcelain, with copper red crackl
glaze
HEIGHT: 4¾″ (12.0 cm.)
INSCRIPTION: on underside, ex
cised cypher of conjoined *AR* in
circle
CA-56
Photograph by Roger Phillips.

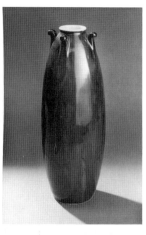

330. **Vase, n.d.**
Porcelain, with four projections at the rim; glossy dark blue black brown opaque glaze
Height: 11" (28.0 cm.)
Inscription: on underside, excised cypher of conjoined *AR* in a circle
CA-57
Photograph by Roger Phillips.

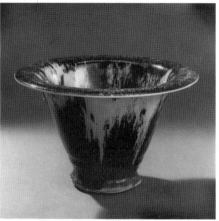

331. **Small Bowl, n.d.**
Porcelain, with copper red glaze
Height: 4⅜" (11.0 cm.)
Inscription: on underside, excised cypher of conjoined *AR* in a circle
CA-58
Photograph by Roger Phillips.

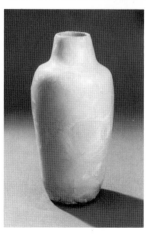

332. **Vase, 1910**
Porcelain, with yellow crystalline glaze
Height: 6¾" (17.2 cm.)
Inscription: on underside, excised cypher of conjoined *AR* in a circle; incised *12; U; C; 1910*
CA-59
Photograph by Roger Phillips.

333. **Wisteria Vase, n.d.**
Porcelain, with excised decoration of wisteria; mottled and streaked ochre and rust colored glazes; white, blue, and green matte glazes; three carved snail feet
Height: 7¼" (18.5 cm.)
Inscription: on underside, excised cypher of conjoined *AR* in a circle; incised *661*
CA-60
(Plate 102)

195

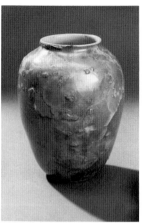

334. Vase, 1910
Porcelain with peach to apricot colored crystalline glaze
HEIGHT: 5½" (14.0 cm.)
INSCRIPTION: on underside, excised cypher of conjoined *AR*; incised *15; U; C; 1910*
CA-61
Photograph by Roger Phillips.

335. **Small Vase, 1919**
Porcelain, with incised decoration; rose pink to maroon crystalline glaze; mottled grey green and black matte glazes
HEIGHT: 4" (10.0 cm.)
INSCRIPTION: on underside, excised cypher of conjoined *AR* in a circle; incised *1919*
CA-62
(Plate 123)

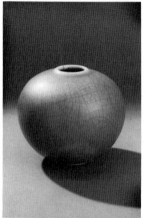

336. Small Vase, 1920
Porcelain, with translucent aqua green crackle glaze; white glaze
HEIGHT: 3¾" (9.5 cm.)
INSCRIPTION: on underside, incised cypher of conjoined *AR; 43; 1920*
CA-63
Photograph by Roger Phillips.

337. **Doorknob, n.d.**
Porcelain, with excised decoration of conjoined *AR* in a circle; dark green and tan matte glazes
DIAMETER: 2¼" (5.7 cm.)
INSCRIPTION: on back side, incised *S 11*
CA-64
(Plate 22)

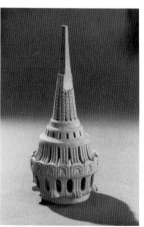

338. Unfinished Bottle Stopper, n.d.
Porcelain, with incised and perforated decoration; unglazed bisqueware
HEIGHT: 4" (10.0 cm.)
INSCRIPTION: none
CA-65
Photograph by Roger Phillips.

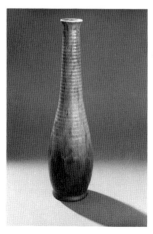

339. **Vase, 1927**
Porcelain, with light blue, metallic green, purple, red, and black glazes
HEIGHT: 11¾" (29.0 cm.)
INSCRIPTION: on underside, excised cypher of conjoined *AR*; incised *1927*
CA-66
Photograph by Roger Phillips.

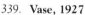

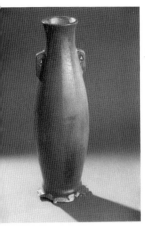

340. **Vase with Handles, 1928**
Porcelain, with olive green and brown glazes
HEIGHT: 11⅝" (29.6 cm.)
INSCRIPTION: on underside, excised cypher of conjoined *AR*; incised '28
CA-67
Photograph by Roger Phillips.

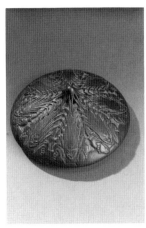

341. **Lid, n.d.**
Porcelain, with incised and pierced decoration; metallic black matte stain
DIAMETER: 3½" (8.3 cm.)
INSCRIPTION: on underside, incised cypher of conjoined *AR*
CA-68 (see CA-69)
Photograph by Roger Phillips.

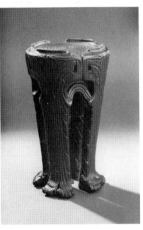

342. **Base, n.d.**
Stoneware, with incised decoration; four carved feet; metallic black matte stain; intended for vase (present location unknown), and lid (CA-68)
INSCRIPTION: none visible
CA-69
Photograph by Roger Phillips.

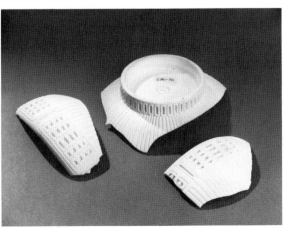

343. **Shards of Translucent Bowl, 1928**
Eggshell porcelain, with incised and excised decoration; unglazed
INSCRIPTION: on underside, excised cypher of conjoined *AR* in a circle; incised *1928*; 6
CA-70
Photograph by Roger Phillips.

197

344. **Shards of Translucent Bowl, 1927**
Eggshell porcelain, with excised and perforated floral decoration; translucent blue, and clear gloss glazes
CA-71
(Plate 24)

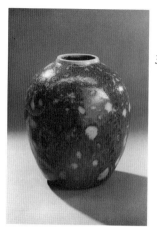

345. **Jar, 1927**
Porcelain, with copper red and white glazes
HEIGHT: 5⅞″ (15.0 cm.)
INSCRIPTION: on underside, excised cypher of conjoined *AR*; incised *1927*
CA-72
Photographed by Roger Phillips.

346. **Tile, n.d.**
Porcelain, with excised decoration; copper red and green mottled glazes
HEIGHT: 2½″ (6.3 cm.)
WIDTH: 1¾″ (4.5 cm.)
INSCRIPTION: excised cypher of conjoined *AR* in a square
CA-73

347. **Tile, n.d.**
Porcelain, with excised decoration of wisteria; mottled and streaked ochre and rust colored glazes; white, blue, and green matte glazes
HEIGHT: 8⅞″ (22.6 cm.)
DIAMETER: 8⅞″ (22.6 cm.)
INSCRIPTION: on reverse, excised cypher of conjoined *RA* (sic) in a square; incised cypher of conjoined *AR* in a circle
CA-74

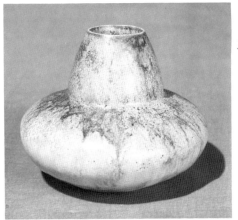

**MUSEUM OF ART
PENNSYLVANIA STATE
UNIVERSITY**

University Park, Pennsylvania

348. **Miniature Vase, 1904**
Porcelain, with light blue, brown, and beige matte glazes
HEIGHT: 3¼" (8.2 cm.)
INSCRIPTION: on underside, incised cypher of conjoined *AR; IV-II; C; '04; I-VIII* in a circle
Gift of Class of 1974, Museum of Art, Pennsylvania State University. 76.53

**THE SAINT LOUIS ART
MUSEUM**

St. Louis, Missouri

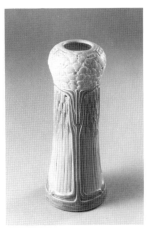

349. **Vase, 1910**
Porcelain, with incised floral decoration; grey green and tan matte glazes; some excised areas filled with glaze.
HEIGHT: 6⅛" (15.6 cm.)
DIAMETER (base): 2¾" (7 cm.)
INSCRIPTION: on underside, excised cypher of conjoined *AR* in circle with *U* and *C* (University City on either side of circle; date 1910 incised below, *B*, (or 13) incised above.
The St. Louis Art Museum, Bequest of Elsa K. Bertig in memory of Joseph and Elsa Bertig. 471:1979

199

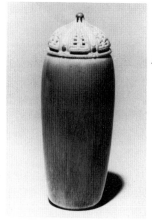

350. **Vase with Lid, 1904–1916**
Porcelain, with green mottled glaze; carved openwork lid
HEIGHT: (with lid) 5⅝″ (14.3 cm.)
INSCRIPTION: cypher of conjoined "AR" in a circle
59.606.

351. **Vase, ca. 1910**
Porcelain, with black matte glaze
HEIGHT: 2⁵/₁₆″ (6.6 cm.)
INSCRIPTION: incised "IX"
Anonymous donation. 75.163

352. **Vase, ca. 1910**
Porcelain, with pale green matte glaze speckled with grey
HEIGHT: 2⅜″ (6.0 cm.)
INSCRIPTION: incised "C"
Anonymous donation. 75.164

353. **Vase, ca. 1910**
Porcelain, with blue matte glaze
HEIGHT: 2⁵/₁₆″ (6.6 cm.)
INSCRIPTION: incised "N"
Anonymous donation. 75.165

354. **Vase, ca. 1910**
Porcelain, with olive green glaze over aqua satin glaze
HEIGHT: 2¼″ (5.7 cm.)
INSCRIPTION: incised "I"
Anonymous donation. 75.166

355. **Vase, ca. 1910**
Porcelain, with glossy yellow green glaze
HEIGHT: 2¼″ (5.7 cm.)
INSCRIPTION: incised "O"
Anonymous donation. 75.167

356. **Vase, ca. 1910**
Porcelain, with speckled, glossy tan glaze
HEIGHT: 2¼″ (5.7 cm.)
INSCRIPTION: incised "I"
Anonymous donation. 75.170

357. **Vase, ca. 1910**
Porcelain, with pale green satin glaze
HEIGHT: 2⁵/₁₆″ (6.6 cm.)
INSCRIPTION: incised "D/AR"
Anonymous donation. 75.171

358. **Pastoral, 1910**
Porcelain, with incised decoration of daisies in three sections; sections divided by vertical strip of grey, with incised daisies and masques of satyrs; incised daisies on cover with daisy finial
HEIGHT: 9¼″ (23.5 cm.)

INSCRIPTION: impressed cypher of conjoined "AR" in a circle; incised "2"; "C"; "U"; "PASTORAL"; "1910"
Bequest of Priscilla R. Kelly, daughter of Adelaide A. Robineau. 1979.0104.01 a, b
(Plate 47)

UNIVERSITY CITY PUBLIC LIBRARY

University City, Missouri

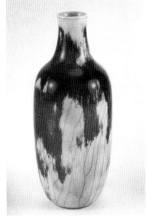

359. Vase, 1910
Porcelain, with light blue under-glaze; dark red and purple irides-cent overglaze
HEIGHT: 6⅝″ (17.2 cm.)
INSCRIPTION: on underside, in-cised cypher of conjoined *AR* in a circle; *29; u; c; 1910;* within larger circle
Photograph by Jack Savage.

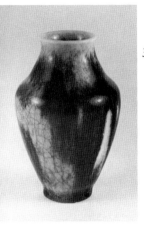

360. Vase, 1910
Porcelain, with streaked red crackle glaze
HEIGHT: 4½″ (11.6 cm.)
INSCRIPTION: on underside, in-cised cypher of conjoined *AR* in a circle; *28; u; c; 1910;* within larger circle
Photograph by Jack Savage.

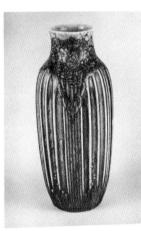

361. Vase, n.d.
Porcelain, with incised floral dec-oration and excised vertical rib-bing; red crackle, blue and green glazes
HEIGHT: 7½″ (19.1 cm.)
INSCRIPTION: on underside, in-cised cypher of conjoined *AR* in a circle; *620;* within larger circle
Photograph by Jack Savage.

NOTE: This inventory was created on the basis of questionnaires mailed to known repositories of Robineau's work and to institutions throughout the United States particularly noted for their collections of decorative arts. Information concerning Robineau's work in institutions not included in this survey will be gladly received in the hope of adding to any future edition of this book.

Notes

1—Adelaide Alsop Robineau

1. From a letter written by Adelaide Alsop Robineau to Fernando Carter, November 12, 1915 (Robineau Archive, Everson Museum of Art) (Plate 40) text below. Carter was then director of the Syracuse Museum of Fine Arts, now the Everson Museum of Art of Syracuse and Onondaga County. The material presented in this chapter is the result of research conducted over a period of several years. Portions have been previously published by the author in *Heresies* (Winter 1978):52–53, and in the *Everson Museum Bulletin* (February 1976). Although Robineau hyphenated her last name (Alsop-Robineau) in *Keramic Studio,* she did not do so in her correspondence. Perhaps because of this, the unhyphenated form of her name has become standard in the literature and in museums. Therefore we have elected to follow the conventional usage in this book.

> Four Winds Cottage
> Robineau Road
> Syracuse, N.Y.
> November 12, 1915

My dear Mr. Carter,

 In the days of the ancient Chinese potters—Europeans paid fabulous prices for examples of their work—and the nobility vied with each other to possess each piece which came perfect from the potter's hands. All through the ages Kings and wealth have been patrons and eager purchasers of art crafts, not only of former times but of contemporary artists—It remained for young America, who has been too busy just growing, to neglect contemporary and native arts and crafts so that no country is so lacking in native craftsmen and crafts work. When, by chance, a craftsman does arrive, he has a hard struggle for recognition. Those who have acquired money, not having as a rule, acquired culture along with it. Patriotic and cultured men from time to time have given to museums, collections of art crafts of the passed ages, in the dim hope that American talent might be inspired to follow the good examples. But they have failed to see that contemporary talent has to be encouraged by purchase of the best in native work. Of late years the Directors of Museums are beginning to awaken to this necessity but the movement has not grown yet to an appreciable extent in this country. Though abroad, as always, examples of contemporary and native work are continually being purchased by the governments, or directors of museums for the inspiration of other craft workers. It has been a great pleasure to me to hear you express a desire for a permanent collection of my work in the Syracuse Museum and also, a delightful surprise to have your opinion that your committee is so liberal minded as to be likely to agree with you on the advisability of making a choice collection of my porcelains for that purpose. I know only one member of your committee, but that one a gentleman of acknowledged culture and one whose direct inheritance is a knowledge of objects of art. But that your other directors were equally interested I did not guess. All Museum committees are not so unanimous or progressive.

 If there remains any doubt in the mind of any one of your directors I should like to remove it by suggesting to him as I did to you in our recent conversation, that as a simple matter of "boosting" Syracuse such a collection might be a drawing card. When a city wishes to be called to sit up high in the seats of honor—like a good business man she should put her best foot forward, if she has anything above the average, she writes it in large letters, if she has anything unique, she blazens it abroad. Syracuse has *at least* two unique boasts to make. There is the salt which gives its savor. And there are the Robineau Porcelains!

 You asked me to put in writing the gist of our recent conversation in regard to placing a permanent exhibit of my porcelains in the Syracuse Art Museum. I am sending with this one of my catalogues, marking the

page which gives the awards my work has received, also a tentative list of a small collection to act as a nucleus to such a collection as you suggest. I should judge that a final investment of two thousand dollars, with the pieces I should present to the museum would make a completely representative collection of the very choicest pieces. A collection that can never be duplicated anywhere, even approximately.

My proposition is as follows—If your committee should make an initial purchase of one thousand dollars, I should select, possibly six of the very best pieces for that amount. Then I should place in the collection smaller pieces of various types, all from the San Francisco exhibit which received the Grand Prize, to the amount of five hundred dollars. Then when the museum is ready to invest a second thousand, I would replace the gift collection or certain units—by more important pieces of the same type and add others to the amount of five hundred dollars more. Making a collection valued at three thousand dollars. In this way Syracuse will have such a collection as no other museum will ever have the opportunity of purchasing even for double the amount.

And when the Syracuse Art Museum is quoted in future articles as having a fine example of the work of this or that artist it will be added that Syracuse's unique glory is its collections of the porcelains of its townswoman the only individual maker of art porcelain in this country one of the few—the *very* few in the world and the only *woman* to attain such prominence in ceramics. All of which sounds very conceited from me but which is true nevertheless.

I would add that I should be glad if the committee could make a decision before my porcelains return from San Francisco for if I send them to Macbeth's for exhibit I should wish that the special ones intended for Syracuse Museum might be so marked in order that no one by chance should spoil the ensemble of the collection by purchasing one of the important pieces. Also as a notice to the art world that Syracuse is alive and up to date, not to mention that it might have a felicitous effect on other sales, a matter of self interest, I admit.

Thanking you for your interest and trusting that your directors may find this satisfactory.

I remain, Sincerely

Adelaide Alsop Robineau

November 12, 1915.

2. The actual Robineau collection of the Everson Museum today totals seventy-seven pieces, including gifts by other donors over the years. From the original collections only three or four pieces seem to have been either lost or broken beyond repair, while three pieces have been deaccessioned. For a detailed list, see the Inventory of Robineau Works in Public Collections in the United States.

3. See David Tatham, "George Fisk Comfort," *The Courier* (Syracuse University Library Associates) 11 (Fall 1973):2–16.

4. The most accurate source to date on the early activity of Gustav Stickley is the unpublished master's thesis by Sally J. Kinsey, "Gustav Stickley and the Early Years of *The Craftsman* 1901–1906" (Syracuse University, 1972), from which the information presented here has been gleaned.

5. On Harvey Ellis, see the catalog *A Rediscovery–Harvey Ellis: Artist, Architect* (Memorial Art Gallery, Rochester, N.Y., Dec. 8, 1972–Jan. 14, 1973), with essays by Jean R. France, Howard S. Merritt, and Blake McKelvey. See also the entries for Robineau, Stickley, Hubbard, and Ellis in *The Arts and Crafts Movement in America 1876–1916*, ed. Robert Judson Clark (Princeton, N.J.: Princeton University Press, 1972).

6. See also Cleota Reed Gabriel, *The Arts and Crafts Ideal: The Ward House–An Architect and His Craftsmen*, exhibition catalog with Foreword by Peg Weiss (Gallery Association of New York State, 1978).

7. According to a note found in Adelaide Robineau's genealogy scrapbook (copy in the collection of Elisabeth Lineaweaver), Charles R. Alsop attended Yale College but did not graduate. He later surveyed for the Northern Pacific Railroad and was the "inventor of devices for the early Colt's Revolver and Victor Sewing Machine, steam engines, etc." Adelaide's elder sister, Margaret, was born in 1863 but died in the early 1880s shortly after her marriage to Webster Langdon. Her youngest sister, Clarissa, was born in 1882 and thus does not appear in the city directories which record the Alsop family's first appearance in Syracuse. Unfortunately little more is known at the present time about Adelaide Robineau's life prior to her marriage to Samuel Robineau. Previously published accounts, however, have proven to be unreliable when compared with the memoirs provided by members of the Robineau family and such records as the Syracuse City Directories. Errors which have crept into the literature over the years have often been repeated. Every effort has been made in the present account to double check the record and to correct misinformation wherever possible. The biographical material presented here is largely based on the memoir prepared by Samuel Robineau at the request of Anna Olmsted (then director of the

Syracuse Museum of Fine Arts) in 1935 in preparation for the book she hoped to publish on Robineau. An article by Samuel Robineau which appeared in *Design* magazine as a memorial to his wife at her death in 1929 has also been invaluable ["Adelaide Alsop Robineau" by S. E. Robineau, *Design* 30, No. 11 (April 1929):201–209]. Mrs. Elisabeth Robineau Lineaweaver prepared a personal memoir of her mother at the request of the present author which has been invaluable for the light it sheds on Adelaide Robineau's personality and character, and for the insights it provides into the family's hitherto little-known home life. Mrs. Lineaweaver has also been unfailingly generous and supportive in sharing information during innumerable conversations with the author in preparation for this book. Letters surviving in the archive of the Pewabic Pottery at Michigan State University have also been helpful. For further biographical sources, please see the bibliography.

8. For a general introduction to the history of art pottery in America, see Martin Eidelberg, "Art Pottery," *Arts and Crafts Movement in America,* pp. 119–86. See also Kirsten Hoving Keen, *American Art Pottery 1875–1930,* exhibition catalog (Delaware Art Museum, March 10–April 23, 1978). Paul Evans, *Art Pottery of the United States — An Encyclopedia of Producers and Their Marks* (New York: Scribner's, 1974); Herbert Peck, *The Book of Rookwood Pottery* (New York: Bonanza Books, 1968).

9. The information that Robineau was already a connoisseur of Chinese porcelains by the time he met Adelaide Alsop is recorded by Ethel Brand Wise in "Adelaide Alsop Robineau — American Ceramist," *The American Magazine of Art* 20, No. 12 (December 1929):687–91. This account appears to have been based on a personal interview with Samuel Robineau after Adelaide's death. It was published at the time of the Memorial Exhibition of her work at the Metropolitan Museum of Art. According to information supplied by Elisabeth Lineaweaver, Samuel Robineau was born in Angers, France, on December 20, 1856, the son of Pierre Marcellin Robineau, a Huguenot pastor, and his wife Hélène Stapfer Robineau. At the age of twenty, in 1876, Samuel emigrated to New Orleans where he first was employed at the cotton exchange. (In the same year, 1876, Degas's great painting *Portraits in an Office — Cotton Exchange in New Orleans,* was exhibited at the second group exhibition of the Impressionists in Paris; was this perhaps Robineau's inspiration?) He later moved on to North Dakota where he owned a ranch and "farming interests." It seems likely that he met Mrs. Alsop and her daughters during their sojourn in Moorhead, Minn., directly across the Red River from Fargo, N.D., in the early 1880s. According to Mrs. Lineaweaver, he seems first to have known Adelaide's sister, Margaret, who died of tuberculosis at an early age.

10. The immediate success of *Keramic Studio* attested to Samuel's business acumen. The magazine continued to thrive under Adelaide's editorship, and in 1924, she determined to transform it into a more general educational magazine to serve the teaching of art from the viewpoint of design. With volume 26, May 1924, the magazine became *Design—Keramic Studio,* and eventually just *Design.* After her death in 1929, Felix Payant took over as publisher and editor. *Design* survives today, published in Indianapolis. The Robineaus also published a magazine for collectors called *Old China,* from 1901 to 1904.

On the Robineaus' New York apartment, see Harriet Cushman Wilkie's article in *The Modern Priscilla* 13 (October 1899):1–3. The address, 114 East 23rd St., was the same given for lessons offered by Charles Volkmar in advertisements published in *Keramic Studio* in July and September of 1900.

11. In letters to their friend Mary Chase Perry, founder of the Pewabic Pottery, Samuel Robineau described the wartime difficulties of the magazine and mentioned Frederick Hurten Rhead's problems with *The Potter.* Samuel Robineau to Mary Chase Perry, June 7, 1917, and June 21, 1917 (Pewabic Pottery Archives, Michigan State University, Detroit, Michigan).

12. See for example, the conjunction of Bonnie Cashin's illustrated article, "Modern Design in Dress," with Jetta Ehlers' plate designs in *Keramic Studio* 30, No. 1 (May 1928):10–12.

13. Adelaide Alsop Robineau, editorial in *Keramic Studio* 17, No. 11 (March 1917).

14. "Ceramics at the Paris Exposition" ran regularly in *Keramic Studio* from 27, No. 7 (December 1925) through 28, No. 10 (November 1926), and was richly illustrated.

15. See note 10, above.

16. From an undated letter (ca. 1935) from S. E. Robineau to Carlton Atherton, who was then preparing his essay for the Robineau book planned by Olmsted. The passage is almost identical to his description of the same incident in the memoir Robineau also prepared at about the same time for Olmsted (see note 7, above). However, at a distance of thirty years, Samuel's memory was a little hazy on some details. For example, as Martin Eidelberg has pointed out, Charles Volkmar did not move to New Jersey until 1903; thus it seems clear that this

1901 visit with Volkmar was in New York. Indeed, her acquaintance with Volkmar dated from before the turn of the century. An article by Volkmar was published in *Keramic Studio* in 1899, and he was actually giving lessons at her studio on 23rd St. in the spring of 1901 [see advertisement in *Keramic Studio* 2, No. 1 (May 1900), and Chapter 2 of this book].

17. Doat's book was later published in its entirety in Robineau's translation as *Grand Feu Ceramics* (Syracuse, N.Y.: Keramic Studio Publishing Co., 1905).

18. In only two weeks with Binns, it was said, she picked up the fundamentals and then set out on her own. While it has previously been thought that her experience with Binns took place in the summer of 1903, more recent research indicates that she must have attended Binns' summer school at Alfred the previous year (see M. Eidelberg, Chapter 2 of this book). Indeed, a series of articles by Binns on pottery making had begun appearing in *Keramic Studio* as early a November 1902, and it is also clear from editorial comments in the magazine that the Robineaus were in touch with Doat by that early date.

19. Described in Kinsey, "Gustav Stickley," p. 11, citing the catalog of the 1893 auction of the contents of Crouse stables.

20. M. Martin spoke on "The Gothic Churches of France" and illustrated his talk with lantern slides. Kinsey speculates that Syracuse University's Professor Irene Sargent, the leading contributor to *The Craftsman*, may have been the interpreter on this occasion, but it seems equally plausible that the bilingual Samuel Robineau might have performed this function.

21. *Ibid.*, p. 12. The exhibition later travelled to Mechanics Institute in Rochester, N.Y., now the Rochester Institute of Technology. The *Keramic Studio* review of the show appeared in 5, No. 2 (June 1903): 36–38. See also *The Craftsman* 3 (January 1903):260–61; (February 1903):326; and (March 1903):390–91.

22. S. E. Robineau, "Memoir."

23. According to Louise Shrimpton, Catharine Budd was a New York architect whom Robineau had met when they were both students of William Merritt Chase at Shinnecock, Long Island ["An Art Potter and Her Home," *Good Housekeeping* (January 1910):57–63]. The dates given in Shrimpton are, however, unreliable.

24. Grace Wickham Curran, "An American Potter, Her Home and Studio," *American Homes and Gardens* (September 1910):364–66.

25. S. E. Robineau, undated letter to Carlton Atherton.

26. The distinction between Adelaide's creative work in inventing forms, glazes, and decoration and in making the actual pieces, and Samuel's able but distinctly advisory role as firing technician has been underscored by their daughter, Elisabeth Lineaweaver, in interviews with the author. In Samuel Robineau's memoir, however, he particularly noted that at University City (where both he and Adelaide were on the payroll), he "was doing the firings and developing some new interesting glazes" (S. E. Robineau, "Memoir"). As Mrs. Lineaweaver emphasizes, her father's steadfast support of Adelaide's work was crucial to her success. Mrs. Lineaweaver believes that his devoted and selfless assistance as firing technician contributed to the ultimate loss of his eyesight.

27. According to Samuel Robineau's memoir, a bed of pure white kaolinic clay was discovered in Texas in 1906 or 1907, and Robineau was able to obtain a supply of it which she then used sparingly over the years, saving it for her best efforts. Samuel relates that this clay was used for the *Scarab Vase,* the *Pastoral*, the eggshell coupes and for the *Cinerary Urn* (Plate 108) ("an example of the remarkable feats of throwing which could be done with this remarkable clay"). According to Carlton Atherton, Robineau first began using the Texas kaolin in 1909 (C. Atherton, "Robineau," unpublished ms., Robineau Archive, Everson Museum of Art; see note 30, below).

28. Charles F. Binns, "Refined by Fire," ca. 1935, unpublished ms., Robineau Archive, Everson Museum. The article by Binns was also prepared for the Robineau book planned by Olmsted; see note 30, below.

29. In his memoir, Atherton observed: "In the case of the eggshell bowls which were excised to paper thinness and also pierced, the skill, patience, and delicacy of touch necessary were almost superhuman." The piece that was broken in Detroit, wrote Atherton, "measured about ten inches in width, four inches in height and weighed but three and one-half ounces." Some fragments, preserved by Atherton, remain in the collection at Ohio State University (Plate 24). See S. E. Robineau, "Memoir," and Atherton, "Robineau" ms., also F. H. Rhead, Chapter 3 of this book, for another account of this incident. But Elisabeth Robineau Lineaweaver provides the most poignant description of this misfortune in her unpublished memoir. She had accompanied her mother to the ceramics convention in Detroit and on the evening following the appearance of the eggshell coupe at the

exhibition, Elisabeth returned to their hotel room rather late to find her mother waiting up for her: "That in itself was unusual. One look at her told me something was very wrong. Then she told me—how she had shown the coupe, how it had been admired, gasped over—how she had repacked it with the greatest care in its little box, tied it with a string—how she had picked it up by the string. The string slipped, the box fell, and there was nothing left of the coupe but fragments. Never before or after had I ever seen my mother cry, but she cried then, heart-breakingly. I put my arms around her and we cried together. The story of the broken eggshell coupe has been told before, but not the story of the aftermath in our hotel room."

30. Carlton Atherton, "Adelaide Alsop Robineau," unpublished memoir, ca. 1935 (Robineau Archive, Everson Museum of Art). This memoir was prepared by Atherton at the request of Anna Wetherill Olmsted, then director of the Syracuse Museum of Fine Arts, succeeding Fernando Carter at his death in 1931. She solicited contributions from Royal Cortissoz, art critic of the New York *Herald-Tribune,* who had considered Robineau a "virtuoso" and leader among American ceramists; from Charles Binns, Robineau's teacher and noted head of the New York State School of Clayworking and Ceramics at Alfred, N.Y.; from ceramist Frederick H. Rhead, who worked with Robineau at University City; from Clyde H. Burroughs, director of the Detroit Museum of Arts; from H. W. Kent, secretary of the Metropolitan Museum of Art, and Richard F. Bach, also of the Metropolitan; from Taxile Doat, the famous Sèvres ceramist whose writings on high-fire porcelain had been an inspiration to Robineau and with whom she had worked at University City; and from Felix Payant, editor of *Design* magazine, the successor to Robineau's *Keramic Studio.* Unfortunately, and apparently because of the financial crisis brought on by the Depression, the book was never realized. However, the materials collected by Olmsted, including the memoir by Samuel E. Robineau, and related documents, have provided an invaluable research source for the present volume.

31. See Evans, *Art Pottery of the United States,* pp. 243–49, and note 10, p. 248. See also *Robineau Porcelains* (New York: Tiffany & Co., Agents, n.d., ca. 1907) (Robineau Archive, Everson Museum of Art). According to a notation found on an old photograph in the family archive, her work was also sold through Macbeth's Gallery in New York.

32. This magazine was intended to reach beyond the *Keramic Studio* audience to oil painters, watercolorists, and artists involved in the other crafts. Robineau arranged for Charles C. Curran, a well-known New York painter, to edit and write contributions on oil painting, while Rhoda Holmes Nicholls contributed articles on watercolor, and Emily F. Peacock, a jewelry designer, edited the crafts section. It was not as quickly a financial success as *Keramic Studio* had been, and the Robineaus welcomed the opportunity offered by the arrangement with Lewis. The magazine did not survive the League's demise, however.

33. Described in detail by Adelaide Alsop Robineau in an article, "American Pottery," *The Art World* 3 (November 1917):153–55. For further information and a modern assessment of the *Scarab,* see Chapter 4 of this book by Richard Zakin. As previously noted the scarab motif had appeared on one of her earliest pieces. Furthermore, an article on "Egyptian Symbolism" (from Walter Scott Perry's *From Egypt, the Land of the Temple Builders)* appeared in *Keramic Studio* 7, No. 1 (May 1905):18, and was followed in 7, No. 5 (September 1905):15, by a full page of beetles, both naturalistic and stylized.

34. Fortunately, Samuel Robineau, sensing the financial instability of the erratic Mr. Lewis, had requested and been granted a mortgage on the collection of Robineau works (including the *Scarab* and many other master works) which had been sent to the 1910 exhibition in Turin, Italy. When the League foundered the following year, he was then in a position to secure the return of the prize collection.

35. See editorial comment in *Keramic Studio* 11, No. 1 (May 1913):1.

36. Her belief in the "philanthropic" goals of the League were expressed in several editorials in which she explained that subscriptions to *Keramic Studio* acquired under the auspices of the League resulted in a loss of revenue for the magazine: "But we accept the League orders to help along what seems to us a philanthropic movement," *Keramic Studio* 12, No. 4 (August 1910):1.

37. The full passage reads: "And now what are we going to do about the domestic problem, those of us who have homes and children and husbands and still feel called to follow the lure of art? For four long weeks the editor has been struggling with the mysteries of breakfast, lunch, dinner, sewing on buttons and darning, sweeping and dusting and otherwise trying to cling to some shreds of decency and order in her household while a two hundred and fifty dollar order stands, needing only a few hours to finish and suspended ideas in porcelain are fading in the dim distance and others are crying to be put in execution. This is a periodical discipline that never fails as a

chastener and the periods are coming with momentarily lessening intervals. If only some good whole-souled woman with a love for art but talent only in the way of caring for a household and children would have the inspiration to take the home in charge and make it possible for the artist to devote her entire energies to doing something worth while in her art, heaven would have come upon earth, and, between you and me, the honor of the artistic achievement would belong to her almost as much as to the artist herself. It is because of the children and the home that we cannot and will not give up, that the woman can never hope to become as great in any line as man. Art is a jealous mistress and allows no consideration whatever to interfere with her supremacy. Such dreams can never be realized; but in the meantime where are gone all those good old fashioned cooks and helpers who grew to love the family and became indispensable and faithful friends of a life time? Gone alas! like a dream, too soon." *Keramic Studio* 15, No. 1 (May 1913):1.

 38. *Ibid.* "Elsewhere will be found the advertisement of our 'Four Winds Pottery Summer School,' but we would just like to say a word here about it for we feel that our dream of a really American school of ceramic design and decoration is beginning to come true, and not only that, but the opening wedge of another dream, of an Arts and Crafts village on top of 'Robineau Hill.'"

 39. *Ibid.* See also 13, No. 12 (April 1912):1, and 14, No. 2 (June 1912):1.

 40. Seventy-one pieces by Robineau were shown at the Metropolitan from November 18, 1929, to January 11, 1930; an illustrated catalog accompanied the exhibition with a text by Joseph Breck. Royal Cortissoz, who had been captivated by the Robineau works included in the "International Exhibition of Ceramic Art" at the Metropolitan Museum the preceding October, mourned the passing of a "virtuoso" artist: "Craftsmanship like Mrs. Robineau's is a blending of precious qualities—of knowledge, skill, judgment, taste and, above all, the sense of beauty," *New York Herald-Tribune,* February 24, 1929, also quoted in S. E. Robineau, *Design.* The international exhibition, with catalog introduction by Charles R. Richards, had circulated to Philadelphia, Minneapolis, Cleveland, Baltimore, Detroit, Newark, and Pittsburgh.

 41. The Ceramic Nationals begun in 1932 provided the foundation for the remarkable collection of modern ceramics now in the collections of the Everson Museum.

 42. According to S. E. Robineau, *Design* (p. 206). He records in his memoir that at her death, only forty to fifty completely finished pieces were left unsold. The few pieces left that were unfinished, but already carried her monogram, were glazed and fired by Atherton. These included the *Cinerary Urn,* which in fact may have been substantially altered by Atherton after her death. This may be deduced by comparison of the present piece (Plate 108) with its description by Irene Sargent in her article "Clay in the Hands of the Potter," *The Keystone* 57, No. 1 (September 1929):141. According to Sargent: "The excised ornament . . . consists of long, tongue-like flames, between whose convolutions faintly outlined human figures are passing, as if for purification." Sargent, a professor of art history at Syracuse University whose prolific writings had been published in *The Craftsman* as well as in *Keramic Studio,* published two other articles on Robineau in *The Keystone:* "An American Maker of Hard Porcelain—Adelaide Alsop Robineau," 27, No. 1 (June 1906):921–24, and "American Wonder Worker in the Ceramic Field," 45, No. 1 (June 1918):65–69.

 43. For the full text of this letter, see note 1.

 44. Adelaide Alsop Robineau, "American Pottery," *The Art World* 3 (November 1917):155

 45. Carlton Atherton, "Robineau" ms. (Robineau Archive, Everson Museum of Art).

 46. Royal Cortissoz, Robineau obituary (in which Cortissoz quotes his review of the October exhibition, see note 40, above). See also Joseph Breck, *A Memorial Exhibition of Porcelain and Stoneware by Adelaide Alsop Robineau 1865–1929,* exhibition catalog (The Metropolitan Museum of Art, November 18, 1929 to January 19, 1930).

2 — Robineau's Early Designs

 1. I am grateful to Dr. Peg Weiss for her aid and patience, and to Dr. James Stubblebine, who made helpful suggestions. I am particularly indebted to Margarette and Frederick Heintz, in whose country home I wrote the first draft of this essay.

 2. I. Sargent, "An American Maker of Hard Porcelain, Adelaide Alsop-Robineau," *Keystone* 27 (June 1906):923. S. E. Robineau, "Adelaide Alsop-Robineau," *Keramic Studio* 30 (April 1929):201.

3. E.g., L. Cellière, *Traité élémentaire de peinture en céramique* (Paris, 1878); E. Delamardelle and F. Goupil, *Practical Lessons in Painting on China, Porcelain, Earthenware, Faience and Enamel,* trans. G. Bouvier (London, 1877); L.C.A. Desloges and F. Goupil, *Traité général des peintures vitrifiables sur porcelaine* (Paris 1866); E. C. Hancock, *The Amateur Pottery and Glass Painter...* (London, 1879); A. Lacroix, *Des couleurs vitrifiables et de leur emploi pour la peinture sur porcelaine, faience, vitraux, &* (Paris, 1872); F. Lewis, *China Painting* (London and New York, 1883); F. Miller, *Pottery-painting* (London, 1885); A. H. Osgood, *How to Apply Bronze and Matt Colors to China* (New York, 1888); M. E. F. Reboulleau, *Nouveau manuel complet de la peinture sur verre, sur porcelaine et sur email* (Paris, 1843); J. C. L. Sparkes, *A Handbook to the Practice of Pottery Painting* (S. T. Whiteford: London, 1877).

4. Sargent, "An American Maker of Hard Porcelain," p. 923.

5. E.g., see Anthea Callen, *Women Artists of the Arts and Crafts Movement, 1870–1914* (Pantheon: New York, 1979).

6. See note 2 above. As will be seen (e.g., note 47 below), Samuel Robineau's account is often inaccurate.

7. Seen on the New York market, ca. 1976.

8. She acknowledged her use of Racinet and Jones in *Keramic Studio* 1 (August 1899):65. Dolmetsch's book is recommended in the September 1899 issue, p. 1.

9. The vase decorated with a Renaissance page boy set among Rococo scrolls is illustrated in *Keramic Studio* 1 (September 1899):98. Her hock glass is illustrated in the August 1899 issue, p. 72.

10. Robineau's finished pitcher (called a "tankard") was illustrated in her very first issue of *Keramic Studio* 1 (May 1899):7, thus suggesting that it had been executed well before that date. In the next month's issue (p. 28) she provided line drawings of these motifs for her subscribers to follow and she acknowledged them to be "adapted from designs" in the *Dekorative Vorbilder.* They are really not adapted but copied directly save for the substitution of a potted plant below the steward boy serving the boar's head, the change of a minor motif in the arabesque above him, and the addition of a connecting link between the two panels. Another of Robineau's vases with a Renaissance costumed boy, illustrated in *Keramic Studio* 1 (September 1899):98, was similarly copied from a design in *Dekorative Vorbilder* 1 (1890), Plate 21.

11. As frequently happened, Robineau used her personal experience to teach others, and thus used these figures as well as others in a design lesson which appeared in *Keramic Studio* 1 (September 1899):94. She had been attracted to the French artist's work by an exhibit in New York which she discussed in the June 1899 issue, pp. 37–39.

12. Likewise, her vase with a nymph in a water lily pond also evokes Waterhouse's style and can be compared with his painting *Hylas and the Nymphs,* which was illustrated in *The Art Journal* 59 (1897), facing p. 180.

13. *Keramic Studio* 2 (October 1900):119–23. But designs in an Art Nouveau style had already been proposed, as, for example, the cup and saucer with a stylized poppy motif illustrated in *Keramic Studio* 1 (September 1899):107; see our Plate 80.

14. These designs can be seen more clearly in the drawings she prepared for her readers: *Keramic Studio* 1 (February 1900):206; 2 (October 1900):122.

15. She copied Habert-Dys's design of storks—*Fantaisies décoratifs,* Plate 40; *Keramic Studio* 1 (February 1900):207—and his designs of poppy plants—*Fantaisies décoratifs,* Plates 10, 19; *Keramic Studio* 1 (November 1899):148—and in both instances noted her indebtedness to the French designer. In another instance she used his designs of flying swallows—*Fantaisies décoratifs,* Plate 30; *Keramic Studio* 1 (January 1900):178—but did not acknowledged whose invention it really was.

16. These ornamented initials were the prize-winners in a design contest sponsored by the magazine: "Nos concours. Lettres ornées," *Art et décoration* 5 (1899):123–28. Robineau used seventeen of them and each made its first appearance as follows: *Keramic Studio* 1 (August 1899): p. 65—"I" by A. de Riquer; p. 72—"T" by Maurice Dufrène; p. 75—"T" by R. Ostman; (September 1899), p. 94—"A" by Dufrène; p. 102—"B" by Cauvy; (February 1900), p. 197—"F" by Ad. Cossard; p. 200—"C" by Cauvy; p. 212—"D" by Dufrène; p. 217—"T" by Paul Follot; (March 1900), p. 222—"R" by H. Rattier; 2 (May 1900), p. 2—"F" by Jaubert; (June 1900), p. 36—"E" by Dufrène; (July 1900), p. 51—"O" by Follot; (September 1900), p. 103—"L" by Dufrène; (October 1900), p. 119—"A" by Dufrène; (February 1901), p. 205—"C" by Cossard; 3 (June 1901), p. 27—"S" by Ostman.

17. A vignette with stylized crocus flowers and leaves appeared in *Art et décoration* 7 (1900), at the end of the "Table de matières," and in *Keramic Studio* 2 (December 1900):173. The other vignette, of circular form with tulips, appeared in *Art et décoration* 7 (1900):117, and then in *Keramic Studio* 2 (June 1900):48.

18. E.g., most of her text and all of her illustrations in "The Sevres Exhibit at Paris," *Keramic Studio* 2 (August 1900):88–89, are taken from the very recent "La manufacture nationale de Sèvres en 1900," *Art et décoration* 7 (1900):179–88. Likewise, the text and illustrations of her "European Potteries," *Keramic Studio* 2 (March 1901):234–35, are based on "La céramique à l'Exposition," *Art et décoration* 8 (1900):184–96.

19. The two drawings by Privat Livemont appeared on opposite pages in *Art et décoration* 7 (1900):58–59, and likewise on opposite pages in *Keramic Studio* 2 (May 1900):8–9. Robineau also copied Privat Livemont's poster for Van Houten Chocolate—*Art et décoration* 7 (1900):60—for the central image of a series of *femmes-fleurs*—*Keramic Studio* 2 (January 1901), color supplement.

20. That she read *The Studio,* one of the most popular magazines in America at that time, is demonstrated by her knowledge of Waterhouse's painting, as shown above. Her knowledge of *The Artist* (which, like *The Studio,* had a special American edition) is indicated by her borrowing illustrations of Danish porcelains from it, as demonstrated below.

21. *Keramic Studio* 1 (August 1899):65; and 2 (May 1900):1. Although A. E. Lilley and W. Midgley's *A Book of Studies in Plant Form* was printed in New York in 1896, just a year after its publication in London, Robineau did not include it among her list of recommended books until April 1901 in *Keramic Studio* 2:1.

22. The vignette by A. Erdmann was published in *Dekorative Vorbilder* 10 (1899), Plate 52, and was first published upside down in *Keramic Studio* 1 (June 1899):32, and then right side up on p. 122. She also reprinted three vignettes by C. Adams (was he actually English or only anglophilic?) taken from *Dekorative Vorbilder* 10 (1899):60; they made their first appearances in *Keramic Studio* 1 (July 1899):44, 52; (August 1899):86.

23. E.g., one with decorative rosette designs by Erdmann which appeared in *Dekorative Vorbilder* 7 (1896), Plate 51, was reissued as the color supplement for *Keramic Studio* 2 (June 1900). A design with an exotic pheasant set among flowers by G. Sturm appeared in *Dekorative Vorbilder* 10 (1899), Plate 16, and was reissued as the color supplement for *Keramic Studio* 1 (January 1900).

24. The design by Beauclair appeared in *Dekorative Vorbilder* 10 (1900), Plate 57; Robineau's unannounced copy, together with one after Privat Livemont and inventions of her own, appeared as the color supplement in *Keramic Studio* 2 (January 1901).

25. There is a curious problem of chronology here: Robineau's design—*Keramic Studio* 1 (September 1899):107—would seem to predate the publication of Huber's in *Dekorative Vorbilder* 11 (1900), Plate IV. While it is always possible that Huber's design appeared elsewhere as well and was seen by Robineau, this is an unlikely solution, particularly since she relied on the German publication in so many other instances. Huber's design is dated "99." Perhaps Robineau had access to it in advance of its publication before its official release. This is possible because it was just about then that she must have been negotiating with the German firm to reprint some of their plates for her magazine (see note 23).

26. A. A. Robineau, "The Potato Blossom," *Keramic Studio* 4 (January 1903):193–94.

27. *Loc cit.*

28. *Idem.,* "Modern Design—Pond Lilies," *Keramic Studio* 2 (October 1900):121.

29. *Keramic Studio* 2 (October 1900):125. The National League of Mineral Painters as a whole received a Bronze Medal.

30. *Keramic Studio* 3 (December 1901):174.

31. S. E. Robineau, "Adelaide Alsop-Robineau," *Design* 30 (April 1929):201–202.

32. As will be seen, Samuel Robineau's memory was faulty on other points as well; see notes 2, 47.

33. A. B. Leonard, "Pottery and Porcelain at the Paris Exposition," *Keramic Studio* 2 (August 1900):73–75; M. Fry, Jr., "Notes from the Paris Exposition," *ibid.* 2 (September 1900):98–99.

34. *Keramic Studio* 2 (June 1900):40.

35. "Royal Copenhagen Ware," *Keramic Studio* 2 (May 1900):2–3; "Royal Copenhagen Porcelain," *ibid.* 3 (May 1901):10–11. The illustrations for her first article were taken from *The Artist* 23 (1898):153–56, and from A. LeChatelier, "Ceramique d'art," *Art et décoration* 5 (1899):181, 187, 189. The photographs for her second article came directly from Mr. Dalgas of the Royal Copenhagen Manufactory.

36. The vases were illustrated apropos of their being exhibited at the New York Society of Keramic

Arts; *Keramic Studio* 2 (January 1901):184. They were also discussed apropos of their being on exhibit at the 1901 Buffalo Pan-American Exhibition; *Keramic Studio* 3 (November 1901):143.

37. This plate was illustrated in E. Garnier, "La décoration des assiettes," *Art et décoration* 10 (1901):82. Since Robineau's version of the design predates that publication, she must have relied on a different source. Perhaps a photograph of the plate was included in the set of photographs she obtained from the Royal Copenhagen's representative, Mr. Dalgas; see note 35.

38. Her design for a honey or marmalade jar was to be "carried out in Copenhagen Grey and Blue on white or some other monochromatic scheme," *Keramic Studio* 3 (February 1902):215. Her design for a chocolate set decorated with stylized sweet pea flowers has the suggestion: "Carry out this design in Copenhagen Blue on a white ground, or Copenhagen Grey with slightly darker outlines of the blue," *ibid.* 3 (March 1902):237.

39. E.g., a plate design by Anna Leonard was "intended to be carried out in pale grey blues, rather suggesting the tones of the pale blues and greys of the Royal Copenhagen," *Keramic Studio* 3 (May 1901):3. Robineau rightly noted apropos of one of Marshall Fry's works: "The vase with Bats suggests . . . the Copenhagen style of decoration," *Keramic Studio* 3 (February 1902):219.

40. "Copenhagen Porcelains—Bing & Grondahl," *Keramic Studio* 3 (July 1901):60–61.

41. *Ibid.*, p. 60.

42. E.g, *Keramic Studio* 2 (December 1900):161. Also see M. Fry, "The Value of Exhibitions," *ibid.* 3 (November 1901):73–74. "In the estimation of an artist-potter one is not a keramist who has no knowledge of clay bodies and glazes, and who cannot design, mould and fire his ware as well as decorate it."

43. C. Volkmar, "Hints on Underglaze," *Keramic Studio* 1 (May 1899):5.

44. Volkmar's classes and the location were announced in *Keramic Studio* 2 (May 1900):1, 17; (July 1900):61–62.

45. *Keramic Studio* 2 (December 1900):173; (January 1901):195; (February 1901):212. Mention of possible lessons in the use of a potter's wheel was made in the above notices. Also relevant is the appearance of an article by Volkmar, "The Potter's Wheel," *Keramic Studio* 2 (December 1900):168–69; as always, Robineau's choice of editorial material reflected her own preoccupations and work in progress. See also note 55 below.

46. *Keramic Studio* 3 (November 1901):143.

47. In a letter Samuel Robineau wrote to Carlton Atherton in 1935 (a copy is on file in the Everson Museum), he recalled what he thought were the circumstances behind the creation of this vase: "In 1901 one day she went to visit her friend Chas. Volkmar in his little pottery in New Jersey and there she took a little clay and made by hand a shapeless little cup, then decorated it with three carved beetles on the edge. Volkmar baked it and later in her own pottery Mrs. R. marked the date 1901, her initials A. R. and glazed the cup in blue and the beetles in white. I have the piece yet, it is very interesting not only because of the date, the first piece of pottery she made, but because in that decoration of beetles she instinctively and unknowingly showed the kind of carved decoration in relief which she was going to use so much later on." As he himself acknowledged in this same letter, his "79 years memory is not as fresh and lively as it was in that far away time." In 1901 Volkmar's studio was in Corona, Long Island, and he did not open a studio in New Jersey until 1903; see *International Studio* 19 (1903):cxxxii. While it is possible that Robineau made this vase in Volkmar's Corona studio, it is more likely that she made it in her own studio when Volkmar was teaching there.

48. The work of the Brush Guild would have been well known to Robineau; it was exhibited, for example, in the studio of her co-editor, Anna B. Leonard, *Keramic Studio* 3 (May 1901):35. Mrs. Doremus, one of the Brush Guild's prominent participants and a member of the National League of Mineral Painters, won a Bronze Medal at the Buffalo Pan-American Exhibition, *Keramic Studio* 3 (December 1901):174.

49. *Keramic Studio* 2 (April 1901):257; (May 1901):6.

50. *Keramic Studio* 2 (May 1901):6.

51. M. Fry, "Alfred Summer School of Ceramic Art," *Keramic Studio* 3 (December 1901):166–67. For some sense of the mounting anticipation of the program see *ibid.* 2 (October 1900):117–18; (November 1900):149; (December 1900):173; (January 1901):183.

52. S.S. Frackelton, "Organized Effort," *Keramic Studio* 3 (September 1901):100–101; also "Frackelton's Blue and Grey," *Keramic Studio* 3 (December 1901):166.

53. "Roblin Ware of Mrs. Linna Irelan," *Keramic Studio* 3 (1901):190–91; *ibid.* 2 (October 1900):125.

54. "The National Arts Club Exhibit of Porcelain and Pottery at the Pan-American," *Keramic Studio* 3 (November 1901):143.

55. *Keramic Studio* 3 (December 1901): V. By March 1902, the magazine was also selling a spraying apparatus for glazing.

56. "Work of the Summer School at Alfred," *Keramic Studio* 4 (October 1902):119–21.

57. These vases were illustrated in *Keramic Studio* 5 (June 1903):37–38, apropos of an exhibition that had been staged in the spring of that year at the Craftsman Building in Syracuse.

58. It is curious that Robineau rarely used *pâte-sur-pâte* decoration. Apropos of the technique, she wrote: "it is a process which does not appeal to Mrs. Robineau, and she uses it only occasionally for the raising of ornmental details. She prefers excising, not only because it is more artistic, but also because it is more difficult. In her work she seems to enjoy more than anything else the struggle against difficulties," *Panama Pacific Exposition, Robineau Porcelains* (n.p.:1915). Although she was soon to follow Taxile Doat's manuscript in most matters concerning the production of porcelain, she eschewed his principal means of decoration. Interestingly enough, when she worked with Doat at University City she tried *pâte-sur-pâte* on a limited basis, as on the satyr masks of the *Pastorale* vase (Plate 47).

59. *Keramic Studio* 5 (May 1903):1.

60. Sargent, "An American Maker of Hard Porcelain," p. 924.

61. "Royal Copenhagen Porcelain," *Keramic Studio* 3 (May 1901):11.

62. *Keramic Studio* 3 (July 1901):49. Interestingly, when Robineau first took over editorship of the magazine she evidently requested articles from the leading china decorators, including McLaughlin. The latter declined in a letter which also gave hints of her new work in making porcelain, published in *Keramic Studio* 1 (August 1899):65. The Cincinnati artist first exhibited her porcelains in her home city but was unable to send them to the exhibition of the National League of Mineral Painters in Chicago; nor, apparently, did she send them to New York City as originally planned. However, she did send a dozen pieces to the Paris World's Fair of 1900.

63. L. McLaughlin, "Losanti Ware," *Keramic Studio* 3 (December 1901):178–79.

64. Robineau's opinions of McLaughlin's work can only be inferred from two brief reviews: "some experiments in color and inlaid glaze...that were very interesting....As yet she has no rival in this country in the making of true porcelain. The only criticism that we would make is that the relief decoration is sometimes a little heavy and not always interesting. But we understand that she has been applying her energies rather to the technical perfecting of her bodies and glazes," "Pottery at the Arts and Crafts Exhibit, Craftsman Building, Syracuse," *Keramic Studio* 5 (June 1903):36. "She has developed the first low fire porcelain (cone 7) in America. Her exhibit...was creditable in the extreme....It is with regret that we hear that she does not at present intend to push her work farther on account of trouble with her kiln and because of her other interests," "Louisiana Purchase Exposition Ceramics," *Keramic Studio* 6 (March 1905):251–52.

65. Robineau's original photograph bears this information on the verso.

66. "Royal Copenhagen Porcelain," *Keramic Studio* 3 (May 1901):11. For a history of the two factories' crystalline glazes see M. Bodelsen, "Sèvres—Copenhagen, Crystal Glazes and Stoneware at the Turn of the Century," *The Royal Copenhagen Porcelain Manufactory 1775–1975* (Copenhagen, 1975), pp. 59–88.

67. For a brief history of this venture see S. E. Robineau, "Adelaide Alsop-Robineau," *Design* 30 (April 1929):202–203.

68. Generally speaking, Robineau did not imitate Doat's forms directly. There is at least one interesting exception: her tall fuselé vase of 1907, first illustrated in *Keramic Studio* 9 (December 1907):177, and said to be "suggested by the summer squash" (p. 181), copies a form used by Doat, even down to the idea of having the stopper carved in the form of a sea shell; cf. the Doat vases illustrated in *Keramic Studio* 8 (December 1906):171, and in *Art et décoration* 10 (1901):151. One might also compare Doat's miniature vase, illustrated in *Keramic Studio* 8 (December 1906):171, and Robineau's version, illustrated in *ibid.* 13 (August 1911):83.

69. Her first version of the *Viking Vase* was evidently made in 1905 and was illustrated in *The Sketch Book* 5 (January 1906):232. The vase in the Everson Museum (Color plate **4**) although not bearing a year mark, was dated 1908 when it was exhibited at the San Francisco Pan-American Exposition, 1915, no. 2. It was pronounced to be "the last of two vases made with this decoration" when it was illustrated in *Glass and Pottery World* 17 (March 1909):11.

Nordic themes were popular throughout English and Scandinavian design at the turn of the century. Bing & Grondahl issued at least one vase whose design offers interesting parallels with Robineau's; it is illustrated in *Deutsche Kunst und Dekoration* 2 (1898):225.

70. *Keramic Studio* 1 (August 1899):72.

71. "The Cicada. From Art et décoration," *Keramic Studio* 6 (November 1906):152–53. These designs were offered in preparation for a contest whose results were later published: H. Froehlich, "Decoration for a Cup and Saucer from a Cicada Motif," *Keramic Studio* 6 (March 1905):240–50. While Froehlich's analysis of the winning designs is interesting, it is even more noteworthy that almost none of the designs approach the French ones but, rather, rely on blocked out forms resembling stencils and use a simple, repetitive progression.

72. Dow actually taught in Robineau's studio; see *Keramic Studio* 2 (April 1901):256; 3 (May 1901):6. See also, "A Class in Design," *ibid.* 3 (August 1901):75–80. She began recommending Dow's *Composition* some time before: *ibid.* 2 (July 1900):1.

73. Interestingly, included in the Japanese exhibit at the St. Louis World's Fair was a cylindrical vase decorated with pendant wisteria blossoms and with snails in high relief near the lip; illustrated in *The Illustrated Catalogue of the Japanese Fine Art Exhibit in the Art Palace at the Louisiana Purchase Exposition.*

74. "Mrs. Robineau is gradually developing new glazes, some of which are similar to some of the old Chinese glazes. Very promising experiments have been made in reds of copper and other colors of reduction," in "A True Porcelain Art Pottery," *Glass and Pottery World* 17 (March 1909):13. Her experiments had begun several years earlier; see Sargent, "An American Maker of Hard Porcelain," p. 923: "the untiring experimentalist is constantly making new trials; her efforts at the present time being directed with much promise to the *flammé* reds of copper." See also the undated (ca. 1908?) catalog, *Porcelains from the Robineau Pottery* (New York: Tiffany), p. 27: "Mrs. Robineau is constantly experimenting on new glazes and is now making promising experiments on flammé reds of copper." Finally, "Ceramics at the Art Institute, Chicago," *Keramic Studio* 10 (March 1909):251: "Several new glazes were shown . . . for the first time finished pieces in rouge flambé."

75. A. Robineau, "American Pottery. Artistic Porcelain-Making," *The Art World* 3 (1917):154. Her first *craquelé* glazes seem to have been made in 1910; see *Robineau Porcelains — Pan Pacific Exposition Catalogue* (1915), no. 11: "Vase. Grey craquelé glaze. Made in 1910 . . . [$] 25.00," with an annotation that it was sold to the Detroit Museum. Also, there is a vase in the Everson Museum (inv. no. P.C. 30.48.5) which has both white *craquelé* and traces of a copper reduction glaze. Indeed, Robineau's interest in *craquelé* glazes seems to have developed from her search for a *sang de boeuf*: "I have found that, after trying the oxblood color in my first reducing firing and generally getting nothing but failures, I can, by refiring in different conditions, obtain from the failed pieces a certain number of interesting and sometimes very beautiful vases of varied colors and curious crackles," A. Robineau, "American Pottery," p. 154.

76. The bowl is illustrated in *Keramic Studio* 9 (December 1907):178. According to the artist, "The little covered tea cup, Japanese style, is of egg shell porcelain, of which delicate material only a few pieces have yet been attempted, this work still being in the experimental stage. It is carved with a little border of plum blossoms" (p. 180).

77. The coupe at Cranbrook, undated in their records, was listed in the catalog *Robineau Porcelains — Pan Pacific Exposition Catalogue* (1915), no. 56, as having been executed in 1911. It was illustrated (in only its bisque state) in *Keramic Studio* 15 (August 1913):74.

78. Grueby's remark is quoted in "A True Porcelain Art Pottery," *Glass and Pottery World* 17 (March 1909):13.

79. S. Robineau, "The Robineau Porcelains," *Keramic Studio* 13 (August 1911) reprinted from the February 1911 issue of *Pottery and Glass*, p. 82. Also A. Robineau, "American Pottery. Artistic Porcelain-Making," *The Art World* 3 (1917):154: "I have made and lately used to some extent an interesting series of semi-opaque glazes which are very similar in character to the bulk of Chinese monochrome glazes. This type of glaze was first used on the Scarab vase, colored in green with copper, and since then I call this composition my Scarab glaze."

80. The program of the vase was described by S. Robineau, "The Robineau Porcelains," *Keramic Studio* 13 (August 1911):84: "The motif is taken from the beetle or scarab pushing a ball of food, symbolizing the toiler and his work. The interpretation of the design is as follows: the toiler, taking pride and pleasure in his work, holds it up, striving always toward the ideal, typified by the carved sphere within sphere which surmount the cover." Either this is a naive misunderstanding of the emblem or a euphemistic retelling of the legend which eschews mention of the ball of dung which is at the core of the tale. The explanation of the scarab which is given by A. C. A. Racinet in *Polychromatic Ornament* (London, 1873), p. 6, is the correct one: the beetle implants its egg into a

ball of kneaded excrement which is then hardened by the sun and then buried by the beetle in the ground; the larva emerge from the earth and the cycle of generation begins again. This legend is especially appropriate for a ceramist since, like the beetle, the ceramist kneads the earth, implants it with a "vital germ," bakes it in the heat of a fiery kiln and sees new life emerge. The concept of ultimate apotheosization recalls the popular adage: "Ars longa, vita brevis."

3 — The University City Venture

1. *The Potters Herald* (hereafter cited as *Herald*), March 28, 1935, p. 6.

2. *Herald,* August 15, 1935, p. 6.

3. *Herald,* June 28, 1934, p. 6.

4. *Herald,* July 19, 1934, p. 6.

5. Samuel Robineau noted in *Keramic Studio* (April 1929) that in 1903 he secured from Taxile Doat a series of articles. "These articles ... gave all the processes and formulas used at Sèvres in the making of what is called Cone 9 porcelain baked at a temperature of 2400° Fahrenheit, the same temperature at which most of the old Chinese porcelains were fired. Mrs. Robineau's decision was immediate, she *would* make porcelain" (p. 202). [For a revised dating of Robineau's earliest porcelain making activity, see Chapters 1 and 2. Ed.]

6. *Herald,* June 28, 1934, p. 6.

7. For a concise history of the League, People's University, and the University City Pottery, see P. Evans, *Art Pottery,* pp. 289–91. A more extensive—though not unbiased—study is contained in Sidney Morse, *The Siege of University City: The Dreyfus Case in America* (St. Louis, Mo.: University City Publishing, 1912); and Curtis R. Thomas, "Drawn from the Kilns of University City," master's thesis, University of Missouri, 1974.

8. Rhead's work in Zanesville and elsewhere is covered in detail in *Art Pottery;* see p. 235 and index.

9. Association at Oyster Bay was with William P. Jervis, see *Art Pottery,* pp. 133–35.

10. This building alone was erected at a cost of $157,000, after plans furnished by Messrs. Eames and Young.

11. Entitled *Studio Pottery,* this was published in 1910 by the People's University Press, University City.

12. *Herald,* August 15, 1935, p. 6.

13. Purchased by the Art Museum of St. Louis, each piece of the collection was different in subject, color, and technique. Doat felt they best represented his various methods in porcelain and stoneware, and hence were important teaching aids. A considerable portion of this collection was later sold by the museum, and there are now eighteen pieces remaining in its possession.

14. "I sometimes wonder," wrote Rhead (*Herald,* June 27, 1935, p. 6), "if Mrs. Robineau would have produced her porcelains if she had been living under conditions where she could not at all times depend upon her husband's assistance, encouragement, and enthusiasm. His interest in her work was such that nothing else mattered much. Business affairs in connection with *Keramic Studio* and other activities were conducted quietly and efficiently, but there was no intrusion or disturbing element to interfere with the job at hand, and any pot in process, of any size, was considered an important undertaking. While discussing together immediate projects and future problems, he seemed to instinctively spot where he could play a very necessary second fiddle." The Robineaus' daughter, Elisabeth Lineaweaver, has also underscored this important place of her father. In a published letter to *Spinning Wheel* (April 1971, p. 43) she noted that "Poppa seldom got any credit, but without his help and encouragement Mother would never have accomplished what she did, nor become what she was. . . . He dedicated his life to Mother, assisting in every phase of her work from the publishing of the magazine to the development of glaze formulas."

15. *Herald,* August 29, 1935, p. 6.

16. *Herald,* September 26, 1935, p. 6

17. Rhead's grand exhibition piece produced at University City in 1911 was of earthenware, about twelve inches in height. Presently in a private collection, it is the largest known example of reticulated earthenware. The *Cavalier Vase* is incised and decorated with inlaid glazes, the vase's subject being an adaptation of a Roseville *Della Robbia* design executed by Rhead while art director at the Zanesville, Ohio, pottery. In addition to being dated 1911, the piece bears the A.W.L. mark and Rhead's conjoined initials.

18. Rhead, because of personal dislike of the piece, makes little mention of work on the *Scarab Vase*. Samuel Robineau, writing in *Design* (April 1929, pp. 205–206), records that in 1910 "the famous *Scarab Vase* was made. It took Mrs. Robineau over one thousand hours to carve and glaze that vase, the most elaborate piece she ever made. It was done for the American Woman's League, as it is marked on the base, and I did not like the idea that it would not belong to us. As I was firing it Mr. Lewis came in the kiln room and I offered him $1,000 for the vase, not knowing whether it would come out good or bad. Mr. Lewis refused the offer. The next day we opened the kiln, and to our great dismay the precious vase was found with two or three big, gaping cracks all around the base. It appeared to be a complete failure. Mr. Doat declared that there was nothing to do, the only thing was to fill the cracks with some kind of paste, color them and keep the vase, imperfect. Mrs. Robineau never left a good piece imperfect, it always had to go in the fire again. She went to work, carefully filling the cracks with ground porcelain, reglazed the vase and on the second firing it came out perfect, as it is today. It is impossible to detect the places which were cracked in the first firing. Fortunately this beautiful piece came back to us when the American Woman's League failed, owing us money, which was secured by mortgage on the *Scarab Vase* and other pieces." Rhead in another place (*The Potter,* February 1917, p. 87) does note that "I have seen the *Scarab Vase* in all its stages of construction, and I know the labor and patience involved. Many times during the carving, Mrs. Robineau would work all day, and on an otherwise clean floor there would be about enough dry porcelain dust to cover a dollar piece, and half an inch more carving on the vase."

19. *Herald,* November 1, 1934, p. 6.

20. *Herald,* November 8, 1934, p. 6.

21. *Herald,* December 20, 1934, p. 7.

22. *Herald,* January 17, 1935, p. 6.

23. *Herald,* February 7, 1935, p. 6.

24. *Herald,* January 24, 1935, p. 6.

25. The disorganization of the business affairs of the League was eventually responsible for its demise. By the fall of 1911, when the Robineaus had returned to Syracuse, S. Robineau wrote to Rhead that "although we wish success to the League and will watch with interest future developments, we are extremely anxious to keep out of it as long as it is in such bad odor" (see note 42 below). The *Keramic Studio* of February 1911 (p. 207) divorced the magazine from the University City venture: "We do not hold ourselves responsible in any way for any business arrangements [readers] make with the American Woman's League. We have recommended their ceramic courses, for we know that they are really good, being in charge of Mrs. [Kathryn E.] Cherry, Miss [Jetta] Ehlers, and Mr. Rhead, whom we have known so long and so well. But to speak well of a study course and to take upon ourselves any business responsibility in the matter are two different things.... We have no doubt that the League can and will straighten out their own affairs."

26. *Herald,* Setember 26, 1935, p. 6.

27. *Herald,* October 10, 1935, p. 6. [Cf. M. Eidelberg, Chapter 2, for revision of this assumption by Rhead. Ed.]

28. *Herald,* March 28, 1935, p. 6. [See note 5.]

29. *Herald,* May 9, 1935, p. 6.

30. *Herald,* May 16, 1935, p. 6.

31. *Herald,* May 23, 1935, p. 6.

32. Cf. F. H. Rhead, "Adelaide Alsop Robineau, Maker of Porcelains," *The Potter* (February 1917, pp. 85–86). [This personal opinion of Rhead's has been disputed by her students and other contemporaries. Ed.]

33. *Herald,* April 18, 1935, p. 6.

34. *Herald,* May 23, 1935, p. 6.

35. *Herald,* June 6, 1935, p. 6.

36. The catalog of Robineau porcelains for the 1915 Panama-Pacific International Exposition, San Francisco, offered the *Scarab Vase* with stand and cover for $1,500; the *Viking Ship Vase* (made in 1908), $75; the inlaid *Poppy Vase* (1910), $30; the *Crab Vase* (1908), $75; the *Cloudland Vase* (1914), $200; the *Lantern* (1908), $400; the *Pastorale Vase* (1910), $500; but on the whole, "ordinary" pieces ranged $10–$50.

37. *Herald,* October 10, 1935, p. 6.

38. *Herald,* October 17, 1935, p. 6.

39. *Herald,* October 24, 1935, p. 6.

40. *Herald,* August 23, 1934, p. 6.

41. *Herald,* October 24, 1935, p. 6.

42. Regarding the Turin International Exposition, Samuel Robineau wrote to Rhead in a letter dated 11 October 1911 [*Herald,* August 8, 1935, p. 6]: "We have just heard that the Turin lot was awarded by the Class Jury a Grand Prix to the League, which was the exhibitor, and another Grand Prix to Mrs. Robineau as artist. However, these provisional awards have to be accepted by the Superior Jury, and it is possible that the award to Mrs. R. will not be maintained, as it is contrary to rules to give a Grand Prix to artists. But I have no doubt that the Grand Prix to the League will be sustained and it is very gratifying, as, being unknown in Europe before this, we did not expect more than a gold medal. Lewis will be tickled to death and is going to have some flamboyant articles in the Weekly. The most remarkable part is that the jury passed over that lot while seventeen pieces, including the Lantern, were missing. They had been lost all summer and have been found only after the jury had looked the exhibit over. But I must say that even incomplete, the exhibit compared favorably with anything in the Exposition."

43. *Herald,* January 24, 1935, p. 6.

44. About half of the pieces sent to Turin were made at University City. The remainder were partially or entirely completed in Mrs. Robineau's Syracuse pottery. The Robineaus moved from St. Louis to Syracuse during the summer season and they would take with them a number of uncompleted works to finish and fire before returning to St. Louis in the fall.

45. Rhead recalled an incident as an example (*Herald,* October 24, 1935, p. 6): "During a convention of the American Ceramic Society being held in Detroit, Mrs. Robineau had been showing a very beautiful eggshell bowl, one of the largest and finest I have seen anywhere. This bowl was ordered by the Metropolitan Museum of New York and was to be delivered after it had been shown during the convention. Contrary to the extraordinary care and delicate handling which the pot would enjoy during the making process, she was repeatedly carrying this extremely delicate bowl under her arm and roughly wrapped in a newspaper. Any request to see the bowl would be met with a rush to her room in the hotel and the hurried return with the clumsy newspaper package. Her friends were alarmed at her carelessness and freely predicted that the bowl would be broken unless she packed it in a suitable cushioned box. Surely enough, during one of those trips from her room, the bowl slipped from the newspaper and was smashed to pieces. I will not say that she was not concerned, but I do know that she was the least disturbed person present. Now to the point. Later, while discussing the incident, I asked her how long it would take her to make another. She replied that she had no intention of ever attempting another eggshell piece of that size. She had succeeded in making a perfect piece of this type and that was that! But if the piece had been broken during the process of production, she would have stayed with it until the job was done."

46. *Herald,* October 24, 1935, p. 6.

47. *Herald,* November 4, 1935, p. 6.

4—Technical Aspects of the Work of Adelaide Alsop Robineau

1. In Chapter 5 Phyllis Ihrman discusses Adelaide Alsop Robineau's crystalline glazes.

2. A. Robineau, Editorial, *Keramic Studio* 7 (1906):1.

3. Melters are specially prepared ceramic compounds added to the alumina/silica mixture causing it to melt at a predicted temperature.

4. Ground silica often goes by the name "flint."

5. This is a naturally occurring mixture of silica, alumina, and alkaline melters.

6. *Grand feu* is the French term for high-fire. The term was in fairly common use during the early nineteen hundreds.

7. C. Binns, *The American Magazine of Art* 7 (1916):137.

8. At her death Robineau bequeathed her formulae to her assistant, Carlton Atherton. These, together with other Robineau documents, photographs, memorabilia, and his collection of Robineau porcelains were left, at his death, with the Art Department of Ohio State University in Columbus where he taught for many years. They have been cared for over the years by Professor Emeritus Margaret Fetzer who had taught there with Atherton.

9. Kona F4, a feldspar, is the only real deviation from the original formula. It is similar but not identical to the no longer available Eureka feldspar.

10. Professor Helen Williams who later taught crafts at Syracuse University was an especially valuable informant in this matter. Other Robineau students and acquaintances interviewed in the course of research for this chapter included: Ruth Randall (who later taught at Syracuse University), Hilda Putziger Levy, Naomi Case, Lewis Light, Montague Charman (also a former Syracuse University Professor of Art), Abby Bigelow, Walter K. Long (now Director of the Cayuga Museum of History and Art, Auburn, N.Y.), Miriam M. Pittman, and Richard K. Smith.

11. From an interview with Hilda Putziger Levy, a student of Robineau, 1924–28.

12. Watery coatings of colored clay.

13. Professor Helen Williams, who often saw Mrs. Robineau at work, states that her favorite carving tool was a sharpened crochet hook.

14. C. Atherton, "Robineau" ms. (Robineau Archive, Everson Museum of Art, Syracuse, N.Y.).

15. When a clay or glaze is fired to a point where it is hard, durable, and fairly non-water-permeable it is said to be mature.

16. The glaze formulae here attributed to Robineau are also among the Robineau documents at Ohio State University (see note 8, above).

17. To reliably obtain crystals in the glaze the potter fires to maturity, allows the temperature inside the kiln to fall a few hundred degrees and then stabilizes the temperature for a few hours. At this point crystals will grow.

18. T. Doat, *Grand Feu Ceramics*, trans. S. E. Robineau (Syracuse, N.Y.: *Keramic Studio*, 1904), p. 92.

19. *Ibid.*, p. 93.

20. According to Professor Helen Williams who studied with Robineau at Syracuse University from 1926 to 1929, and who later taught crafts at the university.

21. Doat, *Grand Feu Ceramics*, p. 179.

22. The special characteristics of Robineau's crystalline glazes are discussed by ceramist Phyllis Ihrman in Chapter 5. As Paul Evans points out in Chapter 3, F. H. Rhead often discussed crystal glazes in his letters to Robineau.

23. By active, it is meant that these fluxes bubble and boil in the fire.

24. A motorized revolving drum partially filled with sphereoid grinding stones. Liquids are ground in a ball mill if a very smooth and fine grind is required. I am indebted to Professor Emeritus Margaret Fetzer of Ohio State who gave me a copy of this formula, which she had learned directly from Atherton.

25. Charles F. Binns, "Refined by Fire," unpublished ms. (Robineau Archive, Everson Museum of Art, Syracuse, N.Y.).

26. *Ibid.*

27. Atherton, "Robineau" (Robineau Archive, Everson Museum of Art).

28. Clay bodies and glazes react to two factors during the kiln firing—the elapsed time of the firing and the temperature of the fire. During the period of the highest fire, it is difficult to see the condition of the ware inside the kiln. Therefore it is necessary to have consistent and reliable indicators so that the potter may know what is happening to the ware. The best indicator of conditions in the kiln would be an object made from ceramic materials that would react to the fire in the way that glazes react. Pyrometric cones are especially compounded indicating devices that do precisely this job. In form they are elongated, three-sided pyramids. They are compounded from fluxing materials, alumina and silica. When the combination of time and temperature is such that the glazes melt, the cone, also reacting to these time and temperature factors, bends. The cones are numbered, each number giving an indication of the effect that the heat in the firing chamber is having on the ceramic materials. Thus cones offer the potter the most reliable and consistent indication possible as to the changing conditions inside the otherwise rather inaccessible firing chamber.

29. F. H. Rhead, *Keramic Studio* 11 (November 1909):159–60.

30. Doat, *Grand Feu Ceramics*, p. 168.

31. *Ibid.*, p. 88.

32. The grog called for in this case is a finely ground calcined kaolin, and is not the common coarse-particled grog used for clay bodies.

33. Rhead, *Keramic Studio* 11 (November 1909).

34. See note 8, above.

35. Doat, *Grand Feu Ceramics*, p. 178.

36. *Ibid.*, p. 174.

37. *Ibid.*

38. P. Evans, *Art Pottery in the United States* (New York: Scribners, 1974), p. 249.

39. See note 8, above.

40. This stain is discussed on p. 127.

41. It is interesting to speculate on the question of parental influence, for Robineau's father was an inventor.

5—Robineau's Crystalline Glazes

1. Many of F. H. Rhead's letters to Adelaide Robineau were preserved by Carlton Atherton and are now in the collection of documentary materials at Ohio State University, Columbus, Ohio.

2. Robineau specifically referred to certain of these articles in one of her notebooks. Notebook Number 2, Ohio State, refers to "Crystal Glazes" by Ross C. Purdy and Junius F. Krehbiel in Transactions of *The American Ceramic Society* 9:319–407, published by the Society, Columbus, Ohio, 1907. Paper read and discussion at the meeting held at St. Louis, Missouri, February 4–7, 1907.

3. J. F. Krehbiel, letter to A. Robineau, November 24, 1928.

4. Documents in the Atherton collection at Ohio State (see Chapter 4, note 8).

5. The term "matrix" is used to describe the background of the crystalline glaze in which the crystal forms.

6. Among the documents in the Atherton collection (Ohio State) are letters to Robineau from Rhead and Krehbiel in which very extensive technical answers are given to her questions.

7. The term "base glaze" is used to describe a white or clear glaze before any forms of metal oxides have been added to give color. A base glaze is composed of ingredients whose percentages determine the maturing temperature and surface characteristics such as transparent or opaque, shiny or matte, smooth or textured.

8. Excerpt from Robineau Notebook Number 2, Ohio State. While not all of the notebooks in this collection are numbered, this one does bear the number "2." Rhead's warning about arsenic poisoning appears in his letter of March 10, 1927 (Ohio State).

9. "To frit" is a term used by potters meaning "to combine and fire." A frit is a combination of two or more glaze materials that have been fired to a point at which they melt and mix. Then they are cooled until solidification, and ground to a very fine powder. The fusion of the glaze ingredients allows chemical reactions to take place. This can render soluble materials insoluble, poisonous materials nonpoisonous, eliminate volatile gases which could cause bubbles and blisters, and gives better control over glaze fusion. A frit can be used as a total glaze or as a portion of a glaze. A frit kiln is used to make a fritted glaze. An undated letter written by S. E. Robineau to Carlton Atherton after Adelaide's death (Ohio State), indicates that Adelaide owned a frit kiln.

10. Stains are combinations of metal oxides that are fritted together. This is usually done to produce more stable colors. They are then added to the base glaze by themselves or in combination with other metal oxides for color. Rhead urged the use of a pink stain in a letter to Robineau dated January 13, 1928 (Ohio State). See also Rhead's letter to Atherton of April 11, 1929 (Ohio State), and Robineau Notebook Number 2.

11. This is a term often used by Doat and Rhead to distinguish the first glaze or foundation glaze, applied on a pot before a crystalline glaze was applied.

12. Royal Copenhagen is also mentioned in Robineau's Notebook Number 2 on her experiments in porcelain glazes, and in a seven-page paper titled "Crystal Glazes" by F. H. Rhead, found with the letters and notebooks at Ohio State.

13. Without actual chemical analysis of samples from any given piece under discussion, the exact chemical composition of the glazes cannot be determined with absolute precision. The suggestions offered here are based upon careful examination, study of the Robineau formulae in the Ohio State collection, and the author's long experience in crystal glaze experimentation.

14. P. Evans, *Art Pottery of the United States,* p. 245.

15. From the Robineau notebook "Cone 8–9 Glazes for Porcelains—Glazes Proven Good. 1914–1928, Samuel Robineau and Adelaide Robineau," in the Ohio State collection.

16. From a glaze sheet sent to Robineau by F. H. Rhead with letter of March 13, 1928 (Ohio State).

17. F. H. Rhead, letter to A. Robineau, March 22, 1928 (Ohio State).

18. From the Robineau notebook, "Glazes Proven Good" (note 15, above).

19. *Ibid.* "Golfe" is a term used by Robineau referring to a group of glazes called "Fixed Mattes—Golfe," found in her notebooks, including the notebook designated "Glazes Proven Good." There are also six typed pages of 52 glaze formulae and four frits, titled "Golfe Glazes" in the Ohio State archives.

20. From A. Robineau's index cards (Ohio State). See also Rhead's letter to Robineau of March 13, 1928 (Ohio State).

21. Herbert Sanders, *Glazes for Special Effects* (New York: Watson-Guptill, 1974), p. 39.

22. Doat, *Grand Feu Ceramics,* p. 181.

23. *Ibid.,* p. 172.

24. *Ibid.,* p. 173.

25. Robineau Notebook Number 2 (Ohio State)

26. J. W. Melor, "The Chemistry of the Chrome Tin Colors," *Transactions of the English Ceramic Society* 36, no. 1: 16–27.

27. Cullen W. Parmelee, *Ceramic Glazes,* 3rd ed. (Boston: Cakners, 1973), p. 494.

Bibliography

This bibliography is not intended to be all-inclusive, but rather a working bibliography for students of Robineau. For the full range of articles and editorials by Adelaide Alsop Robineau published over a period of thirty years, please see *Keramic Studio* and *Design —Keramic Studio.*

"Adelaide Alsop Robineau." *Design* 43, No. 4 (December 1941):8–9.

"The Adelaide Alsop Robineau Home." Descriptive brochure, n.d. (ca. 1975). Robineau Archive, Everson Museum of Art, Syracuse, N.Y.

Adler, Hazel H. "American Craftsmen." *Century Magazine* (October 1916):883–94.

The American Woman's Republic Founded by the American Women's League, University City, St. Louis, Mo. Undated booklet (ca. 1910). Collection of University City Public Library, St. Louis, Mo.

Art et décoration. Paris: 1897–1939.

The Artist. London: 1880–1902; American ed.: 1898–1902. English mag., ca. 1900.

Atherton, Carlton. "Adelaide Alsop Robineau." Unpublished memoir, ca. 1935. Robineau Archive, Everson Museum of Art, Syracuse, N.Y.

Bach, Richard F. "Adelaide Alsop Robineau. 1865–1929. Craftsman." Ms., 1934. Robineau Archive, Everson Museum of Art, Syracuse, N.Y.

Belot, Léon. *Taxile Doat Céramiste.* Paris: Albi Imprimerie Noguiès, 1909 (Extrait de la *Revue du Tarn,* 1909). Robineau Archive, Everson Museum of Art, Syracuse, N.Y.

Binns, Charles. "The Art of the Fire." *The Craftsman* 8 (May 1905):205–209.

———. "Pottery in America." *The American Magazine of Art* 7, No. 4 (February 1916):131–38.

———. "Refined by Fire." Unpublished memoir. Robineau Archive, Everson Museum of Art, Syracuse, N.Y.

Blasberg, Robert W. "American Art Porcelain: The Work of Adelaide Alsop Robineau." *The Spinning Wheel* (April 1971):40–42.

Boddoen, M. "Sèvres—Copenhagen, Crystal Glazes and Stoneware at the Turn of the Century." *The Royal Copenhagen Porcelain Manufactory 1775–1975.* Copenhagen: 1975, pp. 59–88.

Breck, Joseph. "Adelaide Alsop Robineau . . . " *A Memorial Exhibition of Porcelain and Stoneware by Adelaide Alsop Robineau 1865–1929.* Exhibition catalog. New York: The Metropolitan Museum of Art, November 18, 1929, to January 19, 1930. Robineau Archive, Everson Museum of Art, Syracuse, N.Y.

———. "A Memorial Exhibition." *Bulletin of the Metropolitan Museum of Art* (November 1929):279–81.

Burroughs, Clyde. "Robineau Porcelains in the Detroit Institute of Arts." Unpublished statement, ca. 1935. Robineau Archive, Everson Museum of Art, Syracuse, N.Y.

Callen, Anthea. *Women Artists of the Arts and Crafts Movement 1870–1914.* New York: Pantheon Books, 1979.

Carter, Fernando. Letter to Samuel Robineau, February 6, 1930. Robineau Archive, Everson Museum of Art, Syracuse, N.Y.

———. Letter to Samuel Robineau. August 25, 1930. Robineau Archive, Everson Museum of Art, Syracuse, N.Y.

Catalogue des Porcelaines Robineau—Exposition Internationale de Turin, Italie. St. Louis, Mo.: Ligue de la Femme, University, 1911. In French. Robineau Archive, Everson Museum of Art, Syracuse, N.Y.

Cellière, L. *Traité élémentaire de peinture en céramique.* Paris: 1878.

"Ceramics at the Art Institute, Chicago." *Keramic Studio* (March 1909):251.

"The Cicada, from *Art et décoration.*" *Keramic Studio* (November 1906):152–53.

Clark, Robert Judson, ed. *The Arts and Crafts Movement in America 1876–1916,* with texts by Martin Eidelberg, David A. Hanks, Susan Otis Thompson, and others. Princeton, N.J.: Princeton University Press, 1972.

Clement, Arthur W. *Our Pioneer Potters.* New York: privately printed, 1947.

A Collection of Robineau Porcelains, Arms, Curios and Medals, also Japanese Armor, at the Syracuse Museum of Fine Arts. Undated Catalog (ca. 1916). Robineau Archive, Everson Museum of Art, Syracuse, N.Y.

"Copenhagen Porcelains—Bing & Grondahl." *Keramic Studio* (July 1901):60–61.

Cortissoz, Royal. Foreword. Ms. ca. 1935. Robineau Archive, Everson Museum of Art, Syracuse, N.Y.

———. Letter to Anna W. Olmsted. May 25, 1935. Robineau Archive, Everson Museum of Art, Syracuse, N.Y.

———. Obituary notice for Adelaide Alsop Robineau. *New York Herald Tribune.* February 24, 1929.

The Craftsman. Syracuse, N.Y.: 1901–1916.

Crane, Walter. *The Basis of Design.* London: George Bell and Sons, 1909 (1898).

Curran, Grace Wickham. "An American Potter, Her Home and Studio." *American Homes and Gardens* (September 1910):364–66.

Day, Lewis F. *Anatomy of Pattern,* 4th ed. London: Batsford, 1895.

Dekorative Vorbilder. Stuttgart: J. Hoffman, 1890?

Delamardelle, E. and F. Goupil, translated by G. Bouvier. *Practical Lessons in Painting on China, Porcelain, Earthenware, Faience, and Enamel.* London: 1877.

Design; for arts in education. (Subtitle varies.) Indianapolis: Saturday Evening Post Co. (now Curtis International Ltd.), May 1930–date.

Design—Keramic Studio; a monthly magazine for the art teacher and designer. Syracuse, N.Y., May 1924–April 1930.

Desloges, L. C. A., and F. Goupil, *Traité général des peintures vitrifiables sur porcelaine.* Paris: 1866.

Doat, Taxile. "Adelaide Alsop Robineau." Unpublished memoir, ca. 1935. English translation by Samuel Robineau. Robineau Archive, Everson Museum of Art, Syracuse, N.Y.

———. *Grand Feu Ceramics.* Translated by Samuel E. Robineau. Syracuse, N.Y.: *Keramic Studio* Publishing Co., 1905.

———. Letter (New Year's greeting) to Anna W. Olmsted, January 3, 1936. Robineau Archive, Everson Museum of Art, Syracuse, N.Y.

———. Untitled manuscript, memoir of Adelaide A. Robineau, addressed to Anna W. Olmsted. August 15, 1935 (in French). Robineau Archive, Everson Museum of Art, Syracuse, N.Y.

Dolmetsch, *Ornamental Treasures,* 2nd ed. New York: Hessling, 1896–97.

Evans, Paul. "American Art Pottery: The Work of the University City Pottery." *Spinning Wheel* (December 1971):24–26.

———. *Art Pottery of the United States. An Encyclopedia of Producers and Their Marks.* New York: Charles Scribner's Sons, 1974.

"Exhibition of the New York Society of Keramic Arts." *Keramic Studio* 2, No. 9 (January 1901):157–58.

Frackelton, S. S. "Blue and Grey," *Keramic Studio* (December 1901):166.

———. "Organized Effort," *Keramic Studio* (September 1901):100–101.

———. *Tried by Fire.* 1886.

Froelich, H. "Decoration for a Cup and Saucer from a Cicada Motif." *Keramic Studio* (March 1905):240–50.

Fry, Marshal. "Alfred Summer School of Ceramic Art." *Keramic Studio* (December 1901):166–67.

———. "The Value of Exhibitions." *Keramic Studio* (November 1901):73–74.

Fry, Marshal, Jr. "Notes from the Paris Expositon," *Keramic Studio* (September 1900):98–99.

[Fryer, George G.]. Letter to Newell B. Woodworth, May 22, 1916 (concerning purchase of Robineau porcelains). Robineau Archive, Everson Museum of Art, Syracuse, N.Y.

Garnier, E. "La décoration des assiettes." *Art et décoration* 10 (1901):82.

Gosser, F. Letter to Samuel Robineau, March 18, 1912. Robineau Archive, Ohio State University, Columbus, Ohio.

Grasset, Eugene. *La plante et ses applications ornamentales.* Paris: Librairie Centrale des Beaux-Arts, 1897–99.

Habert-Dys, Jules. *Fantaisies decoratifs.* Paris: J. Rouam, 1886–87.

Hamilton, P. R. Letter to Adele [sic] Robineau, December 29, 1928. Robineau Archive, Ohio State University, Columbus, Ohio.

Hancock, E. C. *The Amateur Pottery and Glass Painter . . .* London: 1879.

Hard Porcelains and Grès Flammés Made at University City, Mo. Undated catalog, University City, Mo. (after 1915). Collection of University City Public Library, St.Louis, Mo.

Hull, William. "Some Notes on Early Robineau Porcelains." *Semi-Annual Bulletin, The Everson Museum of Art of Syracuse and Onondaga County* 22, No. 2 (1960).

"Index of *Design,*" edited by Felix Payant. Syracuse, N.Y.: Keramic Studio Publishing Co., May 1933. See Payant, F.

International Exhibition of Ceramic Art. Exhibition catalog of The American Federation of Arts. Portland, Me.: The Southworth Press, 1928. Robineau Archive, Everson Museum of Art, Syracuse, N.Y.

Jones, Owen. *Grammar of Ornament.* London: Day & Son, 1856.

Keen, Kirsten Hoving. *American Art Pottery, 1875–1930.* Exhibition catalog. Delaware Art Museum, 1978.

Kent, H. W. Letter to Anna W. Olmsted, February 2, 1934. Robineau Archive, Everson Museum of Art, Syracuse, N.Y.

———. Untitled. Unpublished statement, 1934. Robineau Archive, Everson Museum of Art, Syracuse, N.Y.

Keramic Studio. A monthly magazine for the china painter and potter. Syracuse, N.Y.: Keramic Studio Publishing Co., 1899–April 1930.

Krehbiel, J.F. Letter to Adelaide Alsop Robineau, November 24, 1928. Robineau Archive, Ohio State University, Columbus, Ohio.

Krehbiel, J. V., and Ross C. Purdy, "Crystal Glazes." Transactions of *The American Ceramic Society* 9 (Columbus, Ohio: The American Society, 1907):319–407.

Lacroix, A. *Des couleurs vitrifiables et de leur emploi pour la peinture sur porcelaine, faience, vitraux.* Paris: 1872.

LeChatelier, A. "Ceramique d'art." *Art et décoration* 5 (1899):181, 187, 189.

Leonard, A. B. "Pottery and Porcelain at the Paris Exposition." *Keramic Studio* (August 1900):73–75.

Levin, Elaine. "Pioneers of Contemporary American Ceramics: Charles Binns, Adelaide Robineau." *Ceramics Monthly* (November 1975):22–27.

Lewis, F. *China Painting.* London and New York: 1883.

Lilley, A. E., and W. Midgley. *A Book of Studies in Plant Form.* New York: 1896.

Lineaweaver, Elisabeth Robineau. Letter published in *Spinning Wheel* (April 1971):43.

———. "The Robineaus as I Remember Them." Robineau Archive, Everson Museum of Art, Syracuse, N.Y.

McCastline [?], Mae Wallace. "Lines to Cinerary Urn." Memorial poem, dated October 5, 1929. Robineau Archive, Everson Museum of Art, Syracuse, N.Y.

McLaughlin, M. Louise. *China Painting.* New York: Appleton & Co.; Boston: Stratford, 1923.

———. Letter to Adelaide A. Robineau. *Keramic Studio* (August 1899):65.

———. *Suggestions to China Painters.* Cincinnati, Ohio: R. Clarke [c. 1883], 1884.

———. "Losanti Ware." *Keramic Studio* (December 1901):178–79.

———. *Pottery Decoration under the Glaze.* Cincinnati, Ohio: Robert Clarke, 1880.

Mead, Franklin B. Letter to Adelaide Alsop Robineau, December 10, 1928. Robineau Archive, Ohio State University, Columbus, Ohio.

Melor, J. W. "The Chemistry of the Chrome Tin Colors." *Transactions of the English Ceramic Society* 36, No. 1 (n.d.).

A Memorial Exhibition of Porcelain and Stoneware by Adelaide Alsop Robineau 1865–1929. New York: Metropolitan Museum of Art, November 18, 1929, to January 19, 1930. Exhibition catalog. Robineau Archive, Everson Museum of Art, Syracuse, N.Y.

Miller, F. *Pottery-painting.* London: 1885.

Morse, Sidney. *The Siege of University City: The Dreyfus Case in America.* St. Louis, Mo.: University City Publishing, 1912.

The National Arts Club Exhibit of Porcelain and Pottery at the Pan-American." *Keramic Studio* (November 1901):143.

"Notes." *The Craftsman* 8 (June 1905). Review of A. A. Robineau reprinted from *The American Pottery Gazette.*

Old China. Syracuse: Keramic Studio Publishing Co., October 1901–September 1904, vols. 1–3.

Olmsted, Anna W. "The Memorial Collection of Robineau Porcelains." *Design* (December 1931):153.

———. "$25,000 Donated to Museum Fund for Robineau Gallery." *Syracuse Herald-American,* June 21, 1964.

———. Letter to Carlton Atherton, May 17, 1935. Robineau Archive, Everson Museum of Art, Syracuse, N.Y.

Osgood, A. H. *How to Apply Bronze and Matte Colors to China.* New York: 1888.

Palette and Bench, for the Art Student and Crafts-worker. Syracuse: Keramic Studio Publishing Co., October 1908–December 1910, 1–3, No. 3. Absorbed by *Arts & Decoration,* New York, February 1911.

Parmelee, Cullen W. *Ceramic Glazes,* 3rd ed. Boston, Mass.: Cakners Publishing Co., Inc., 1973.

Payant, Felix. "Adelaide Alsop Robineau, Editor." Unpublished ms., ca. 1935. Robineau Archive, Everson Museum of Art, Syracuse, N.Y.

———, ed. "Index of *Design.*" Syracuse, N.Y.: Keramic Studio Publishing Co., May 1933. A bibliography to articles in *Design,* 1924–1933. Robineau Archive, Everson Museum of Art, Syracuse, N.Y.

Racinet, A. C. A. *Polychromatic Ornament.* London: 1873.

Reboulleau, M. E. F. *Nouveau manuel complet de la peinture sur oeuvre, sur porcelaine et sur email.* Paris: 1843.

[Report on Purchase of Robineau Porcelains]. The Friends of American Art, n.d. (ca. February 1916). Robineau Archive, Everson Museum of Art, Syracuse, N.Y.

Rhead, Frederick Hurten. "Adelaide Alsop Robineau Maker of Porcelains." *The Potter, A monthly magazine devoted exclusively to those interested in Ceramics* 1, No. 3 (February 1917):81–88.

———. "Chats on Pottery." *The Potters Herald,* 1934–1935. East Liverpool, Ohio.

———. "Crystal Glazes." Ms. in Robineau Archive, Ohio State University, Columbus, Ohio.

———. Letter to Carlton Atherton, March 28, 1929. Robineau Archive, Ohio State University, Columbus, Ohio.

———. Letters to Adelaide Alsop Robineau, January 29, 1927; March 10, 1927; January 13, 1928; March 13, 1928; March 22, 1928; January 9, 1929. Robineau Archive, Ohio State University, Columbus, Ohio.

———. "Pottery Class." *Keramic Studio* (November 1909):159–61.

Richards, C. R. Letter to Adelaide Alsop Robineau, January 7, 1929. Robineau Archive, Ohio State University, Columbus, Ohio.

———. "Introduction." *International Exhibition of Ceramic Art.* Exhibition Catalog of The American Federation of Arts, 1928. Robineau Archive, Everson Museum of Art, Syracuse, N.Y.

Robineau, Adelaide Alsop. "American Pottery. Artistic Porcelain-Making." *The Art World* 3 (November 1917):153–55.

———. "Ceramics at the Paris Exposition." Published serially in *Keramic Studio* (December 1925–November 1926.)

———, ed. *Keramic Studio,* 1899–1929.

———. Letter to Fernando Carter, November 12, 1915. Robineau Archive, Everson Museum of Art, Syracuse, N.Y.

———. "Louisiana Purchase Exposition Ceramics." *Keramic Studio* (March 1905):251–52.

———. Notebooks in Robineau Archive, Ohio State University, Columbus, Ohio.

———. *Palette and Bench, for the Art Student and Craftsworker.* Syracuse, N.Y.: Keramic Studio Publishing Co., 1908–11.

———. "Pottery at the Arts and Crafts Exhibit, Craftsman Building, Syracuse." *Keramic Studio* (June 1903):36–38.

———, and Samuel E. Robineau, eds. *Old China.* Syracuse, N.Y.: Keramic Studio Publishing Co., 1901–1904.

"Robineau Farms on House Tour." *Syracuse Herald-Journal,* September 3, 1975, p. 17.

Robineau Porcelains. New York: Tiffany & Co., n.d. (ca. 1907).

Robineau Porcelains 1915. *Catalog for the Panama Exposition, San Francisco, 1915.* Annotated copy. Subtitled "High Fire Porcelains Adelaide Alsop Robineau — Potter." Syracuse, N.Y.: Keramic Studio Publishing Co., 1915. Robineau Archive, Everson Museum of Art, Syracuse, N.Y.

Robineau, Samuel E. "Adelaide Alsop Robineau." *Design* 30, No. 11 (April 1926):201–209.

————. Letters to Anna W. Olmsted, September 27, 1930; June 25, 1935; September 24, 1935; Robineau Archive, Everson Museum of Art, Syracuse, N.Y.

————. Letter to Carlton Atherton. Undated (after 1929). Robineau Archive, Ohio State University, Columbus, Ohio.

————. Letters to Carlton Atherton, May 17, 1935; n.d. (ca. 1935); Robineau Archive, Everson Museum of Art, Syracuse, N.Y.

————. Letters to Fernando Carter, August 26, 1929; September 12, 1929; September 18, 1929; January 15, 1930; January 21. 1930; January 29, 1930; February 12, 1930; April 10, 1930; August 22, 1930; September 27, 1930; October 17, 1930; Robineau Archive, Everson Museum of Art, Syracuse, N.Y.

————. Letter to Frederick H. Rhead, October 11, 1911. Quoted in *Potter's Herald,* August 8, 1935, p. 6.

————. Letters to Mary Chase Perry, June 7, 1917 and June 21, 1917. Pewabic Pottery Archives, Michigan State University, Detroit, Mich.

————. "The Robineau Porcelains." *Keramic Studio* (August 1911):80–84. Originally published in *Pottery and Glass* (February 1911).

"Robineau Show. Fine Pieces by a Famous CNY Ceramist." *The Downtowner* (Syracuse), August 21, 1977.

"Roblin Ware of Mrs. Linna Irelan." *Keramic Studio* 3 (1901):190–91.

"Royal Copenhagen Ware." *Keramic Studio* (May 1900):2–3.

"Royal Copenhagen Porcelain." *Keramic Studio* (May 1901):10–11.

Sanders, Herbert. *Glazes for Special Effects.* New York: Watson-Guptill, 1974.

Sargent, Irene. "An American Maker of Hard Porcelain—Adelaide Alsop Robineau." *The Keystone* 27, No. 1 (June 1906):921–24.

————. "American Wonder Worker in the Ceramic Field." *The Keystone* 45, No. 1 (January 1918): 65–69.

————. "Clay in the Hands of the Potter." *The Keystone* 57, No. 1 (September 1929):131–41.

Shrimpton, Louise. "An Art Potter and Her Home." *Good Housekeeping* (January 1910):57–63.

"Shrine of Ceramic Art—Robineau Ceramics Adorn Home." *Syracuse Herald-American,* June 29, 1947, p. 14.

Sparkes, J. C. L. *A Handbook to the Practice of Pottery Painting.* London: 1877.

The Studio. London: 1893.

"Syracuse Gets Robineau Memorial Group." *The Art Digest* (January 15, 1931):19.

Syracuse Museum of Fine Arts. Minutes of Meeting (excerpt from). February 1, 1916 (concerning purchase of Robineau Porcelains). Robineau Archive, Everson Museum of Art, Syracuse, N.Y.

Thomas, Curtis R. "Drawn from the Kilns of University City." Unpublished master's thesis, University of Missouri, 1974.

"A True Porcelain Art Pottery." *Glass and Pottery World* (March 1909):13.

Verneuil, M. P. "Taxile Doat." *Art et décoration* (September 1904):77–86.

Volkmar, Charles. "Hints on Underglaze." *Keramic Studio* (May 1899):5.

———. "The Potter's Wheel." *Keramic Studio* (December 1900):168–69.

Welling, Anna M. "Adelaide Alsop Robineau." Unpublished poem, n.d. Robineau Archive, Everson Museum of Art, Syracuse, N.Y.

Weiss, Peg. "Adelaide Alsop Robineau: Ceramist from Syracuse." *Heresies: A Feminist Publication on Art and Politics* 4 (Winter 1978):52–53.

———. "Adelaide Alsop Robineau. *Viking Ship Vase.*" Everson Museum Bulletin (February 1976).

———. Foreword. *The Arts and Crafts Ideal: The Ward House.* Exhibition catalog organized by Cleota Reed Gabriel, Syracuse, N.Y., 1978.

Whiteford, S. T. *A Guide to Porcelain Painting.* London: 1877.

Wilkie, Harriet Cushman. "A Day Among the Studios." *The Modern Priscilla* 13 (October 1899):1–3.

Wise, Ethel Brand. "Adelaide Alsop Robineau—American Ceramist." *The American Magazine of Art* 20, No. 12 (December 1929):687–91.

"Work of the Summer School at Alfred." *Keramic Studio* (October 1902):119–21.

Index

234

This clothbound edition of

Adelaide Alsop Robineau

is limited to five hundred copies.

This copy is number *162*

Adelaide Alsop Robineau

was composed in 11-point Merganthaler VIP Goudy Old Style and leaded two points
by Utica Typesetting Company, Inc.;
printed on 80-pound Warren Lustro dull by Salina Press, Inc.;
with a limited edition of 500 Smythe-sewn and bound over boards in Joanna Arrestox C,
and the remaining books adhesive bound with 12-point Lustro dull covers,
by Maple-Vail Book Manufacturing Group, Inc.;
and published by

SYRACUSE UNIVERSITY PRESS

SYRACUSE, NEW YORK 13210

INVENTORY 1983